Ronald Reagan

Also by James Spada

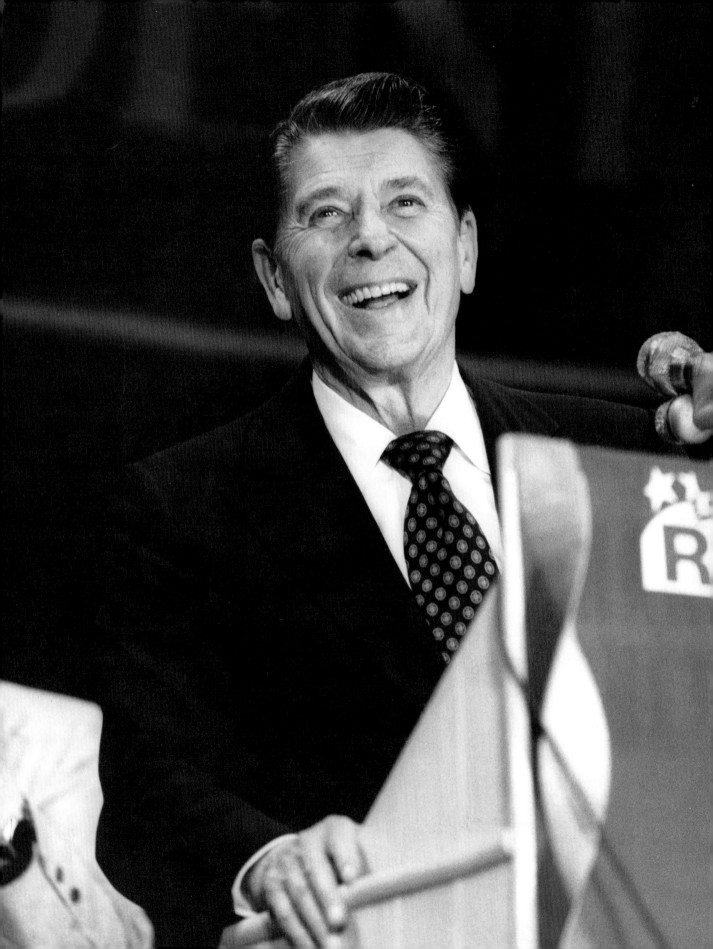

Ronald Reagan

HIS LIFE IN PICTURES

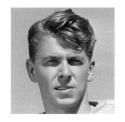

James Spada

ST. MARTIN'S PRESS ✿ NEW YORK

www.stmartins.com

Design by Gretchen Achilles

ISBN 0-312-26990-0

FIRST EDITION

10 9 8 7 6 5 4 3 2 1

For my father,
Joe Spada

CONTENTS

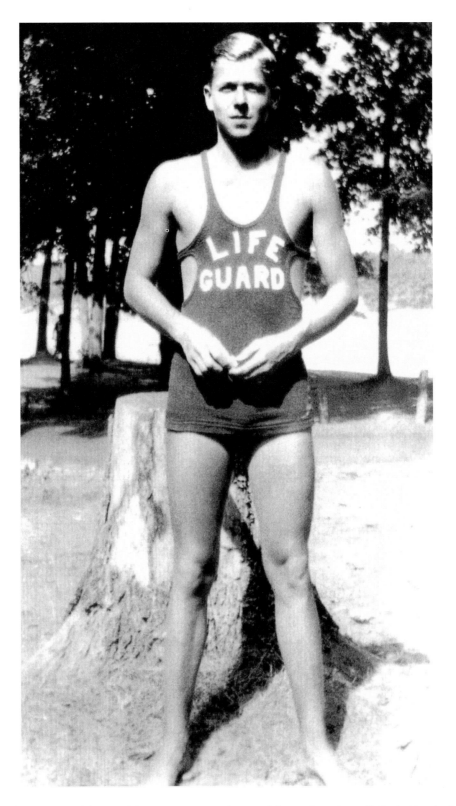

Eighteen-year-old Ronald Reagan at work as a lifeguard at Lowell Park Beach in Illinois, July 1929.

Heartland Hero

A lifetime later, he would recall his childhood as an idyll of American youth, *The Adventures of Huckleberry Finn* with towheaded Dutch Reagan in the title role. His Illinois boyhood's bucolic elements left him with the conviction that any of his country's later problems could be solved by a return to small-town values, patriotism, and religious piety.

Its darker elements—an alcoholic father, poverty, continual uprooting from town to town to town—created an emotional remoteness that shielded him from pain. Until the age of thirteen, when he put on his mother's eyeglasses and saw distant trees and clouds and flowers clearly for the first time, the larger world had been little more than a gauzy haze. Within this cocoon he had developed into a sensitive, creative young man, a writer of poetry, a sketcher of caricatures, and an actor in church and school plays.

With his newfound ability to see clearly, he excelled at sports, particularly swimming and football. His aquatic prowess led, at fifteen, to a job as a lifeguard. Over seven summers he saved seventy-seven lives, and he kept a record of each rescue with a notch on a log. It was a theme his life would repeat again and again—Ronald Reagan as rescuer.

It set him forth on one of the most extraordinary and successful lives in American history.

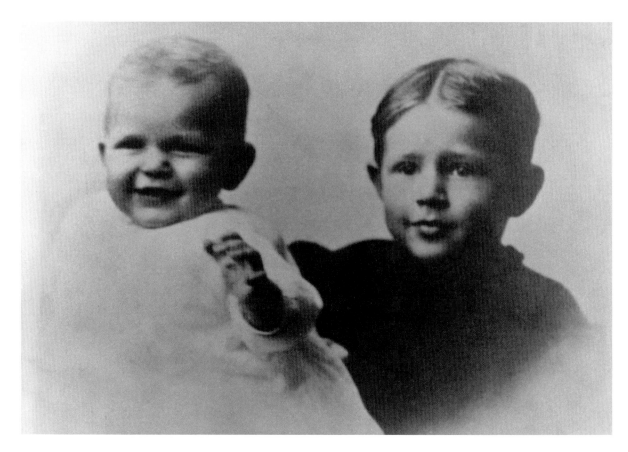

Nine-month-old Ronald Wilson Reagan and his four-year-old brother, Neil, photographed for Christmas 1911. Ronald had been born the prior February 6 to Jack and Nelle Reagan in their flat above a bank on Main Street in Tampico, Illinois. The apartment had no indoor toilet facilities, no central heat, and no running water. Nelle's labor was so long and difficult that Jack, fearing for her life, set out in a blizzard to find a midwife. Finally a doctor arrived to help deliver a plump baby boy who bawled so incessantly his father muttered, "For such a little bit of a fat Dutchman, he makes a hell of a lot of noise." Nelle countered, "I think he's perfectly wonderful."

"Those were their first opinions of me," Reagan later said. "As far as I know, they never changed during their lifetimes."

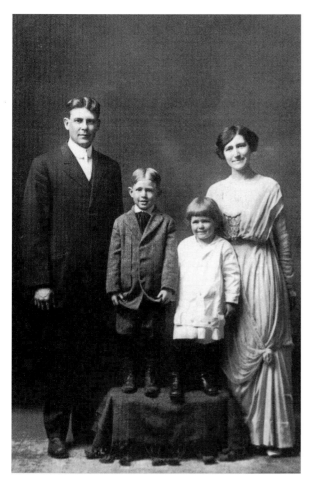

Two years later, the Reagans pose for a formal family portrait. Jack Reagan was a handsome, well-built black Irishman with "a wry, mordant humor," his younger son recalled, the best raconteur he ever heard. Jack sold shoes for a living and loved his work. "He even . . . spent hours studying the bones of the foot." His father might have carved out an unusually successful career in his field, Reagan felt, but Jack had "a weakness"—alcohol. He worked hard when he was sober, but his tumbles off the wagon made him unreliable. He lost job after job.

Nelle Reagan, small, blue-eyed, strongly religious, and steely in the face of adversity, struggled to keep her family stable. She took in sewing to supplement their income when Jack was out of work, and hauled water and coal up rickety back steps several times a day to keep her babies washed and fed. Unflinchingly optimistic, his mother had "a talent for happiness," Reagan later said.

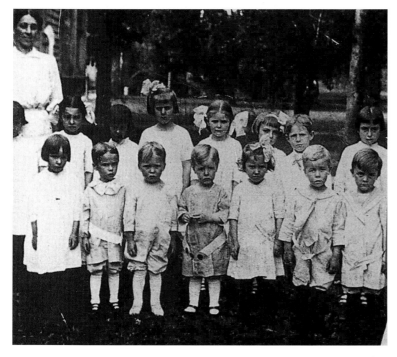

Nelle Reagan, far left, served as Sunday-school teacher for the Church of Christ in Tampico. Her four-year-old son is second from the right in the first row in this photograph, taken in 1915. Nelle was a strict disciplinarian who kept her charges well in tow. She and her son both performed in church plays.

Seven-year-old Ronald, bottom row left, poses for an informal portrait with his extended family, circa 1918. Identifiable in this photograph are his father, Jack, middle row left; his brother, Neil, bottom row second from right; his mother, Nelle, top row second from left, and his maternal aunts Vina, Emily, and Jennie, top row left to right. Not long after Ronald's birth, the Reagans had moved to a small white-frame bungalow with indoor toilet facilities and modern plumbing. It was, however, very close to a railroad station, and one day Nelle came out the front door to find her two sons crawling under a stopped train just as its whistle blew to signal that it was about to leave the station. The boys were only trying to get to an ice cream wagon on the other side of the tracks, and were safely clear of the train before it began to move.

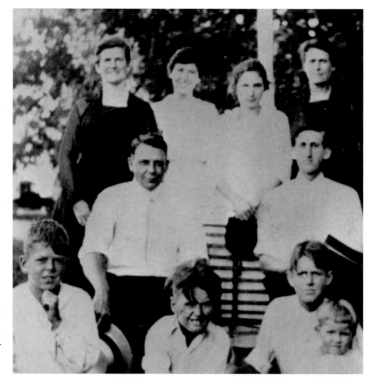

Ten-year-old "Dutch" Reagan (far left) with the Dixon, Illinois, YMCA marching band early in 1921. Ronald hadn't thought his given name masculine enough, so he had asked everyone to call him Dutch, since his father continued to call him the Dutchman. The nickname stuck. The Reagans now lived in a rented three-bedroom house on South Hennepin Avenue in Dixon, Illinois, about twenty miles northeast of Tampico, their fifth new town in five years. Reagan later acknowledged that his family's nomadic life left "a mark" on him. "I was introverted and probably a little slow in making friends. In some ways I think this reluctance to get close to people never left me completely...."

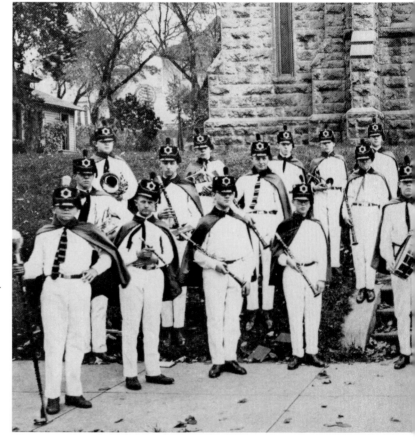

The Reagan family remained in Dixon throughout Dutch's adolescence, allowing him to carve out a memorable high-school career. He had failed at sports until the age of thirteen, when he realized that his eyesight was so poor he hadn't been able to see the ball. In high school, he excelled at athletics and became something of a Renaissance boy with strong interests in dramatics, writing, drawing, and school politics. His junior year at North Dixon High School in 1926–27, Reagan played guard for the varsity football team, which went 4–3–1 for the season. The caption for this picture of him in the 1927 school yearbook *Dixonian* read, "'Dutch,' the lightest but fastest guard on the team, won his letter through sheer grit. With 'Dutch' returning to the squad, things look good for Dixon in 1927."

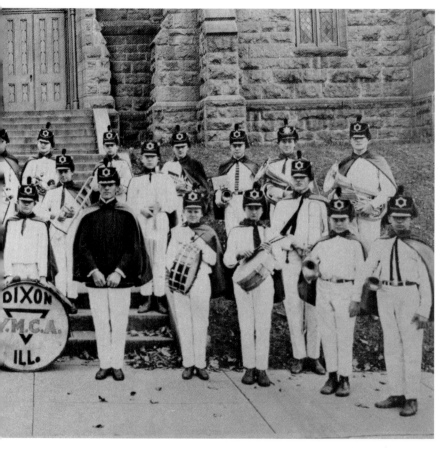

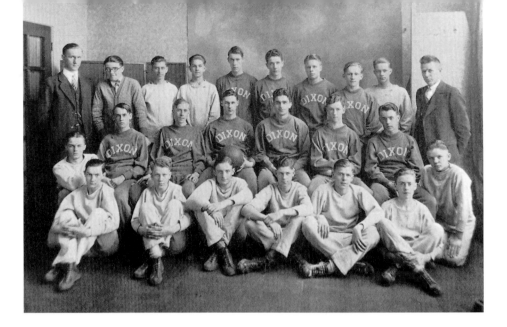

ABOVE He also won a letter on North Dixon's "Lightweight" basketball team, pictured here (Reagan is in the front row, second from the right). The team played opening games at each of the varsity team's contests, winning three and losing eight. But, the yearbook explained, "in almost every game they were greatly outweighed and outsized by the opposing team. . . . They played hard and fast and will make good players for Dixon in the future."

BELOW Unlike many jocks, however, Dutch read "voraciously," got excellent grades, and evinced a sensitive, artistic side as well. He wrote dozens of short stories and poems, and acted in school plays. Also in his junior year at Dixon, Reagan was elected Sergeant-at-Arms of the Dramatic Club, and is shown here with the group, top row, fourth from the right. "This club is perhaps the most interesting in school," the yearbook noted. "The club is divided into groups of five, six, or seven members each. Every second Tuesday the club meets and one of these groups presents a play."

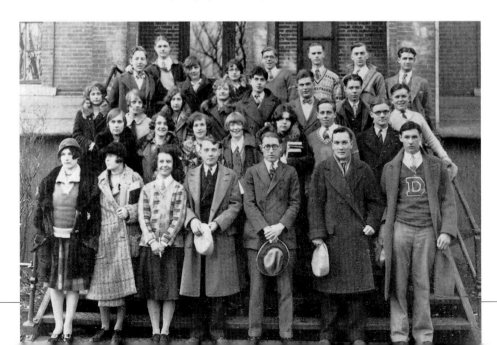

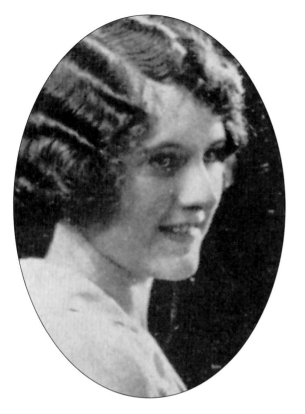

LEFT Reagan's high-school sweetheart, Margaret "Mugs" Cleaver, shown here in her senior-year photograph, 1928. Described by the yearbook as "Our popular all-around everything," she was short, pert, and pretty, and apparently possessed a dominant personality that reportedly intimidated even Dutch's "tough guy" big brother, Neil, now known as Moon.

On April 29 and 30, 1927, the junior class presented Philip Barry's play *You and I*. Dutch and Mugs got top billing playing ingenue sweethearts. They are shown sitting on the sofa in the top picture; Dutch is kneeling and playing banjo in the bottom photograph.

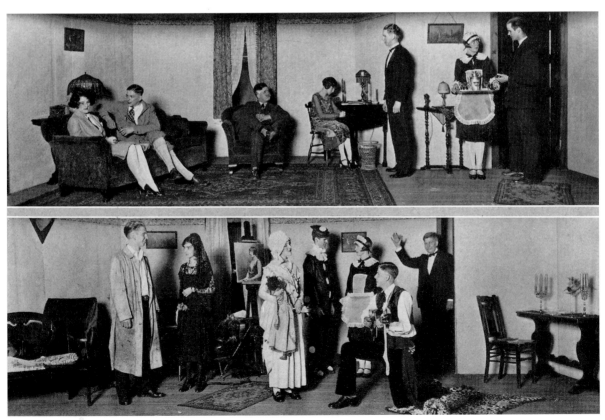

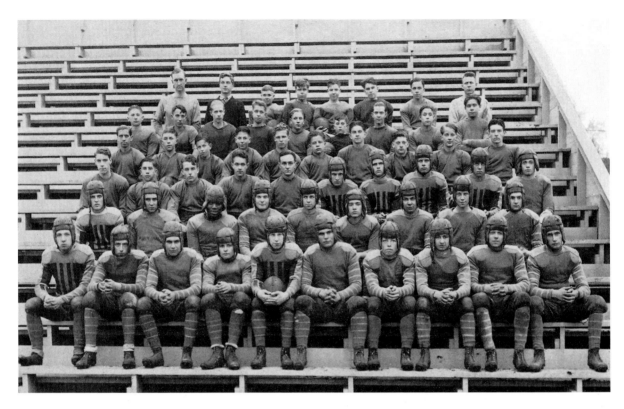

By his senior year of 1928, Dutch was, in the words of his friend Bill Thompson, "the perfect specimen of an athlete—tall, willowy, muscular, brown, good-looking." He again won a letter in football, this time as a tackle. He is second from the right in the front row in this photograph of the team, which went 2–5 for the season.

"'Dutch' proved to be one of the strong factors in the line this year," the caption accompanying this photo of Reagan in his football uniform stated. "He took care of his tackle berth in a creditable manner, and certainly had the true 'Dixon Spirit.'"

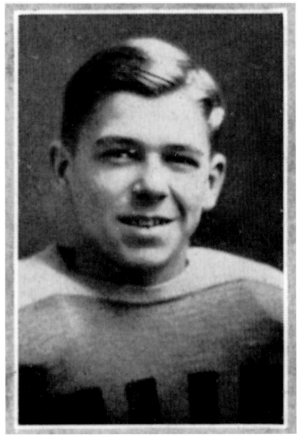

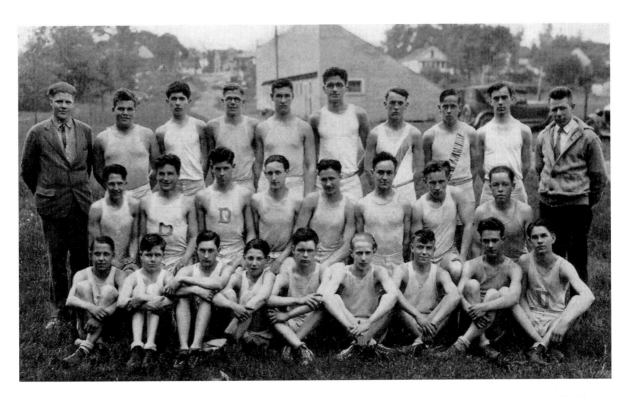

TOP Track replaced basketball for Reagan his senior year, although he did not letter in the sport. The team finished third in the Rock River Conference standings. Dutch is fourth from the left in the top row in this photograph.

BOTTOM Reagan won election as president of the Dramatics Club his senior year. Soon thereafter a new constitution was drawn up for the club, and members voted to open their meetings to the public "and by so doing encourage interest in the dramatic side of school life." He is fourth from the right in the front row in this photo.

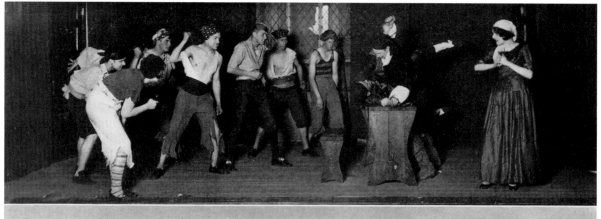

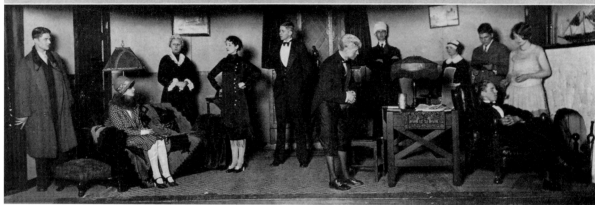

Reagan played the villain in the senior-class play, George Bernard Shaw's *Captain Applejack*, on January 30 and 31, 1928. He is fifth from the left in the top photo, and seen wearing a tuxedo in the middle of the bottom image. He much preferred to play heroes, and his enjoyment of dramatics "commenced to create in me a personality schizo-split between sports and the stage. The fact was, I suppose, that I just liked showing off."

As further evidence of his artistic side, Dutch served as the art director of the senior-class yearbook. His design and drawings are remarkably predictive of his future course in life: Described as the "Cinema Number," the book was designed with sections illustrated so that the campus was the "Studio," the teachers were "Directors," the students the "Cast," their activities the "Stage," and athletics "Filming." The literary section was called "Sub-titles," and Reagan contributed two short stories and a poem, more than any other student. The first stanza of Dutch's poem, "Life," spelled out a credo he would live by all his life: "I wonder what it's all about and why/We suffer so, when little things go wrong?/We make our life a struggle/When life should be a song."

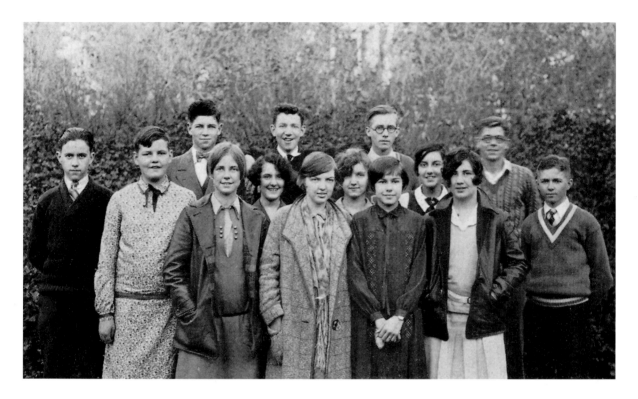

And there was still another facet to the high-school boy Dutch Reagan: the politician. He was elected president of the Dixon student council and is shown here with the group, at far right in the back row. He was also president of the senior class and vice president of the boys' Hi-Y Club, the stated goal of which was to promote "Clean Speech, Clean Sports, Clean Living, and Clean Scholarship."

Reagan's senior-class portrait. A typo in the yearbook listed him as "Donald" Reagan, and under the name there appeared this assessment of him from his classmates: "Life is just one grand sweet song, so start the music."

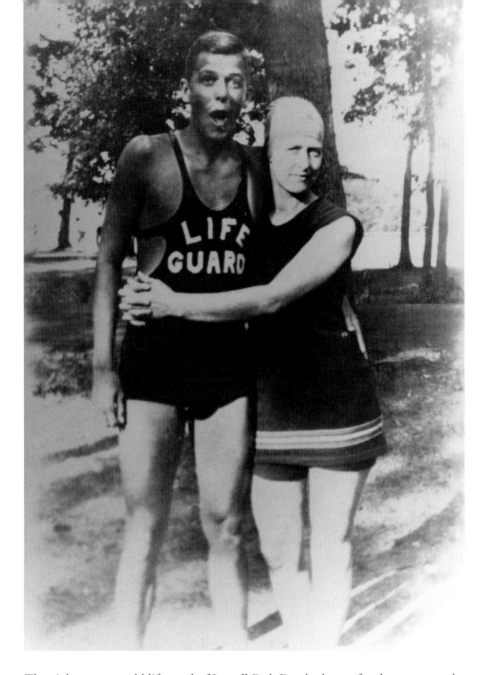

The eighteen-year-old lifeguard of Lowell Park Beach clowns for the camera as he poses with a female friend. Beginning when he was fifteen, Reagan worked summers at the beach, a bucolic swimming spot on the Rock River two miles upstream from Dixon. It was here that the local legend of Dutch Reagan, hero, first took hold. During his seven years as a lifeguard, Reagan was credited with seventy-seven rescues, several of which made the front page of the Dixon *Telegraph*. PULLED FROM THE JAWS OF DEATH, screamed one headline on August 3, 1928.

Bronzed, well muscled, handsome, keenly on the lookout for swimmers in distress, this teenaged demigod cut quite a figure at Lowell Park, and he took great pride in saving lives. On a nearby log he carved a notch for each rescue with his jackknife.

ABOVE In September 1928, Reagan enrolled at Eureka College in Illinois, a small school run by the Disciples of Christ, a church whose credos his mother had embraced: good works, the all-encompassing power of a Supreme Being, and—perhaps most tellingly for the wife of an alcoholic—temperance. A football hero of Dutch's had attended the bucolic college, and his sweetheart Margaret Cleaver was also enrolled (her father was a Disciples of Christ minister). "I wanted to get in that school so badly that it hurt when I thought about it," Reagan said. College attendance in this era was rare; Reagan was able to afford tuition only because he had saved four hundred dollars from his summer jobs, got a scholarship for half of the tuition expenses, and worked for his board.

In this photo taken in his sophomore year, Dutch is photographed, third from left, with his fellow members of Alpha Epsilon Sigma, the dramatic fraternity. Mugs Cleaver is in the front row, far left, and Reagan's brother, Neil, a freshman, is second from the right in the top row.

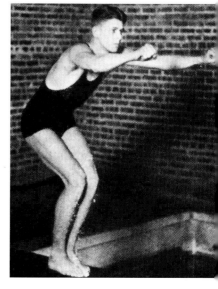

ABOVE RIGHT Reagan helped create, coached, and captained the Eureka swim team. When he got to the school, Dutch had wasted no time becoming a Big Man on Campus. He majored in economics and sociology, joined the Tau Kappa Epsilon fraternity, played first-string guard on the football team, worked on the school newspaper and yearbooks, became president of the Booster Club, was captain of the basketball cheerleaders, "copped the lead in most plays," served as a member of the student council for two years, and became its president for one.

Reagan, at left, played the shepherd Thyris in Edna St. Vincent Millay's anti-war drama *Aria da Capo*, which Alpha Epsilon presented as part of the Northwestern University one-act play contest on March 30, 1930. The cast won third place, and Reagan received special commendation.

Dutch (center) and Mugs Cleaver (left) in the French comedy *The Art of Being Bored*, performed at Eureka on May 2, 1930. Mugs and Dutch had "gone steady" through high school, and he gave her an engagement ring in college. Their friends fully expected that within a few years of their graduation, the couple would marry.

A portrait of Reagan in his sophomore year, 1930. He was a features writer for the 1931 *Prism*, the school's yearbook. His senior class did not have a yearbook because by 1932 America's Great Depression had grown so deep, the college couldn't afford to produce one.

Reagan as a member of the Eureka football team, the Golden Tornadoes, during his junior year, 1931. "Reagan was one of the best offensive guards on the squad," the *Prism* noted. "Big things are expected of Dutch next year."

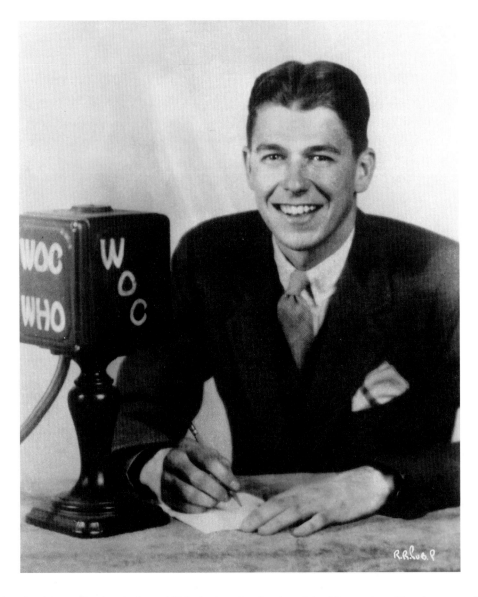

Four months after his graduation in June 1932, during the depths of the Depression, Dutch set out for Chicago to try to get a job as a radio sports announcer. His lack of experience worked against him, but a sympathetic programmer suggested he try smaller markets. After a new round of quick rejections, he got a chance to audition for WOC (World of Chiropractic) Radio in Davenport, Iowa. He was told to call fifteen minutes of play-by-play of an imaginary football game. He used his memories of one of his own games, an exciting contest against Western State University that the Eureka team won in the final twenty seconds, 7–6, with a sixty-five-yard touchdown run and dropkick by their quarterback.

The station owner was impressed. He hired Reagan temporarily, for five dollars a game, to call four University of Iowa contests, then gave Dutch a permanent job at the station at one hundred dollars a month. After a few rocky months at WOC, he won a better job at their larger sister station, WHO in Des Moines. "Those were wonderful days," he recalled. "I was one of a profession just becoming popular and common—the visualizer for the armchair quarterback." He remained on the job for four years, calling play-by-play for both football and baseball games.

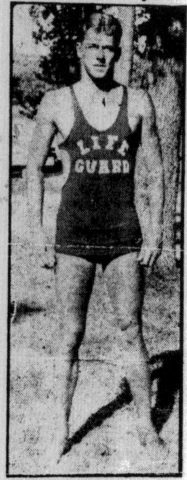

Ronald "Dutch" Reagan, (above) son of Mr. and Mrs. John Reagan, 107 Monroe avenue, Dixon, has signed a six-months' contract with the Warner Brothers motion picture studio, according to word received by his parents yesterday. A 7-year option clause is included in the contract. While a life guard at Lowell park beach at Dixon, Reagan saved 71 lives in six seasons.

Reagan, a Dixon high school and Eureka college graduate, left Dixon about three years ago, and has been employed as a sports announcer at a Des Moines, Ia., radio station. He took a successful screen test while in California covering spring training activities of the Chicago Cubs.

ABOVE Ronald Reagan in 1936—a strapping young man of twenty-five whose voice had become familiar to hundreds of thousands of Midwest radio listeners. His departure from Dixon, and a year Margaret Cleaver spent abroad, doomed their love affair. Margaret wrote Dutch from France to say that she had become engaged to a young man in the U.S. Consular Service, James Waddell Gordon Jr. "I was kinda floored," Reagan admitted. "He was very sad," Cleaver later recalled. Cleaver and Gordon married in 1935 and remained together for the rest of their lives.

ABOVE RIGHT Local boy makes good. An announcement in the Dixon *Telegraph* in June of 1937 lets everyone back home know that Dutch Reagan, local celebrity, is about to "go Hollywood."

A publicity still for Ronald Reagan's twenty-second movie, *Tugboat Annie Sails Again*, 1940.

"The Errol Flynn of the B Pictures"

On his way to Catalina and the Cubs' spring training in 1936, Dutch visited some acquaintances at the Warner Bros. studio lot, and Hollywood called to him like a siren. Sports announcing had been, in his mind, just a stepping-stone to an acting career. He took a screen test, and on celluloid he looked like a leading man—six feet tall, handsome in a clean-cut, all-American way. The acting he had done to make sports events as vivid as possible served well to prepare him for his line readings. He got his Hollywood contract, for an astonishing two hundred dollars a week.

He played the lead role in his first film, married a beautiful starlet, received an avalanche of fan mail, and won a million-dollar contract after ten years at Warner Bros. By 1946, Ronald Reagan had lived the epitome of the American dream.

Over the next five years, it all turned around. Jane Wyman left him and took the children. His studio let his contract lapse, and no one offered him a parting handshake. His financial situation grew so bleak he attempted to sell autographed pictures of himself through the mail.

Matters didn't remain this way for long. As the 1950s unfolded, Ronald Reagan would rescue himself.

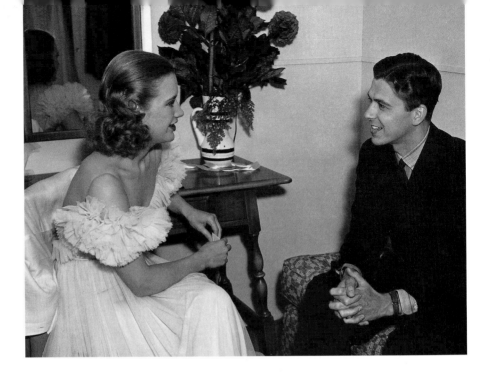

On a tour of the Warner Bros. studio shortly after his arrival on the lot in June 1937, Reagan met the starlet Priscilla Lane, a native of Indianapolis. They reminisced about Midwestern life.

Reagan had registered well on film during his screen test for Warner Bros., which needed a new "all-American type." Reagan nicely filled the bill, and when the agent who had arranged the test wired him the studio's offer—a seven-year contract starting at two hundred dollars a week—Reagan wired back, SIGN BE-FORE THEY CHANGE THEIR MINDS.

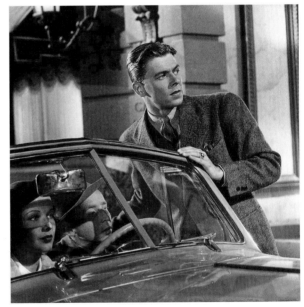

Warner Bros. put Reagan to work immediately with a starring role opposite June Travis in *Love Is on the Air*, a "B" picture shot in three weeks for $119,000. ("B" pictures, or "programmers," were low-budget quickies intended as the second feature on a program with a major film.) Few newcomers get the lead role in their first film, but the studio figured Reagan could handle the part of a small-town radio announcer—and besides, he could supply his own wardrobe. Here he's shown with Travis and Eddie Acuff.

Despite a case of nerves "like nothing I ever experienced," Reagan played the part of Andy McLeod with easy charm. He waited what seemed an interminable four months for the picture's release on November 10, then "raced around town" picking up newspapers to read his first reviews. In large part, they were favorable. *The Hollywood Reporter* called him "a natural, giving one of the best first-picture performances Hollywood has offered in many a day." A few days later, the studio renewed his option and gave him a small raise.

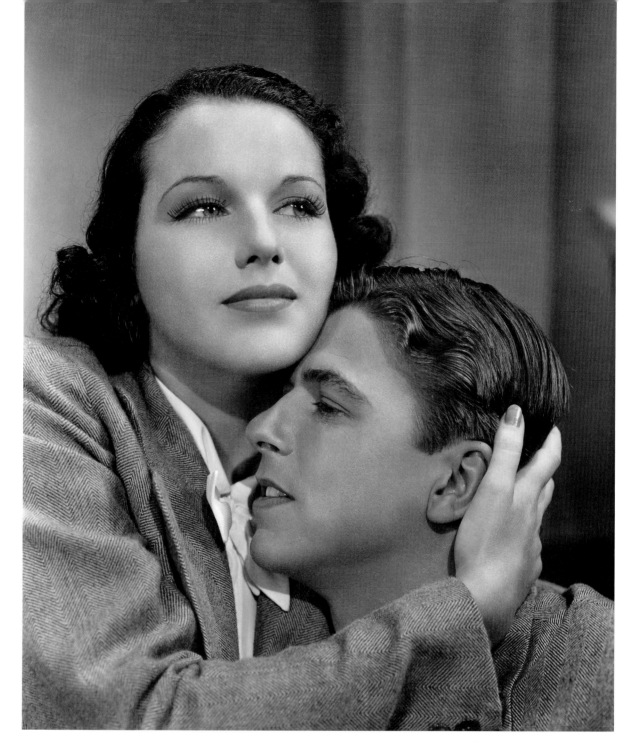

Like many actors, Reagan succumbed to what he later called "leadingladyitis" and began an intense off-screen romance with the lovely, athletic, green-eyed June Travis. For the three weekends during filming, they were inseparable. They rode horseback and competed to see who could down the most clay pigeons at a shooting gallery on the Santa Monica Pier (she consistently beat him). Once filming wrapped, however, the relationship ended. Later Reagan gave this advice to aspiring actors: "Don't marry your leading lady . . . until you've done another role opposite someone else. . . . It is an infatuation that won't hold up once the play is over and you each go back to playing yourselves."

Eighteen-year-old Mary Maguire joins Reagan for a radio broadcast in the spring of 1938 to promote their film *Sergeant Murphy,* the true story of a cavalryman's dedication to his horse and the animal's resultant triumph in Britain's Grand National steeplechase race. The horse played the title role, but Dorothy Masters, reviewing the film for the New York *Daily News,* opined breathlessly that the best thing about the movie was that it brought audiences into "palpitating proximity" to Reagan's "looks and personality."

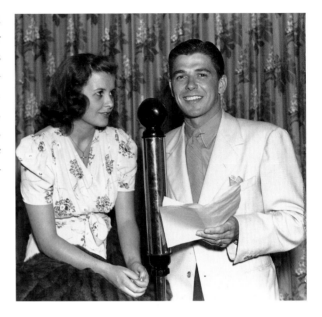

A 1937 portrait. The hairdressers, tailors, and cosmeticians at Warner Bros. had despaired when they saw Reagan his first day on the lot. "I still had my Harold Teen haircut," he recalled, "short and parted down the middle." His broad shoulders and short neck made his head appear disproportionately small, they told him, and he would have to wear specially designed "Jimmy Cagney collars" to correct the problem. Makeup maestro Perc Westmore was concerned about a crevice across the bridge of Reagan's nose caused by his eyeglasses and a lazy eye that tended to wander when he grew tired. Westmore used makeup to camouflage the crevice and instructed the camera department not to photograph him full face during close-ups.

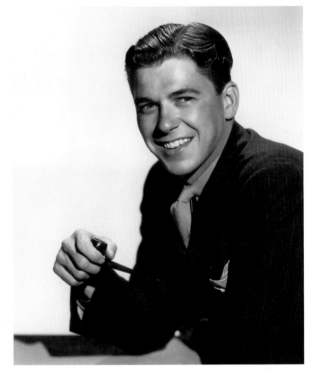

OPPOSITE A sultry 1938 study of Jane Wyman, the woman who would soon become Mrs. Ronald Reagan. A twenty-four-year-old contract player in the process of ending her first marriage after seventeen months, Wyman met Reagan on the set of *Brother Rat,* his ninth film, in which she appeared in a small role as a college coed. At first he didn't seem to notice her much. "Ronnie was always going around with his college frat brothers," Wyman recalled. "He never seemed to have time for girls . . . yet I was drawn to him at once. He seemed such a sunny person."

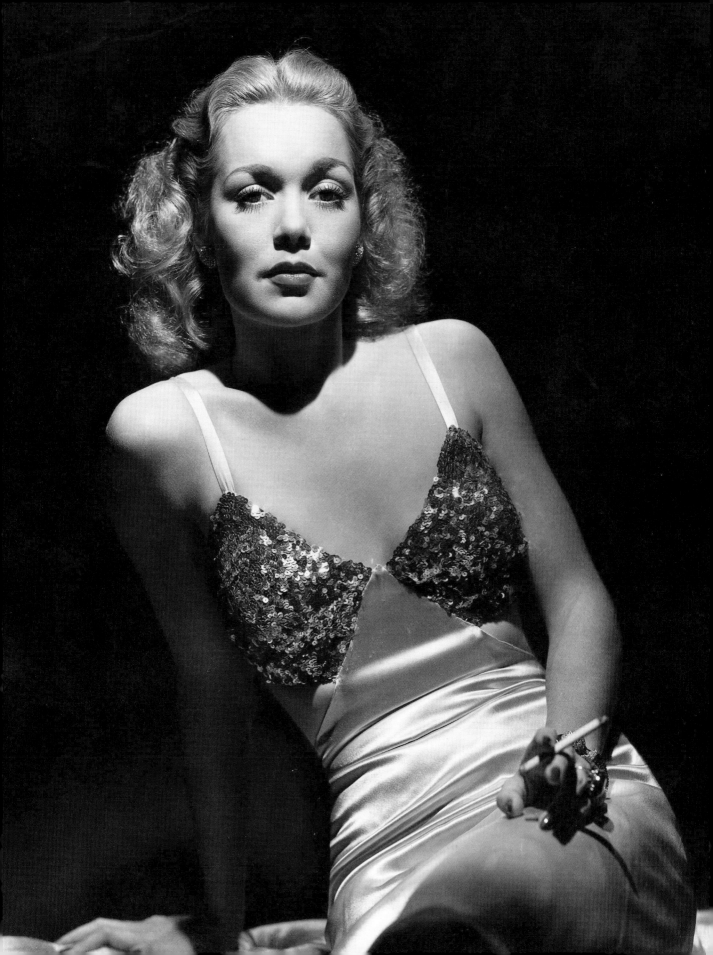

Reagan with George Brett and Geraldine Fitzgerald in a scene from *Dark Victory*, released April 1939. With a dozen films to his credit, a pattern had emerged in Ronald Reagan's career: He was cast either as the lead in routine programmers or in smaller roles in A pictures. *Dark Victory,* a big-budget Bette Davis weepie, fell into the latter category. He played an alcoholic dilettante whose intimate friend, a socialite played by Davis, is dying of a brain tumor.

Reagan's one big dramatic scene takes place in a nightclub, where Davis has gone to drown her sorrows after learning of her malignancy. He had gained a reputation as one of the easiest actors to direct, but he had a rare disagreement with director Edmund Goulding over how to play this scene. "[He] wanted me to play the character as if he were the kind of guy . . . who wouldn't care if a young lady were undressing in front of him," Reagan recalled delicately in 1990. "And he wanted me to encourage Bette to get even drunker. I felt that this man had real affection for Bette and would have done just the opposite." These "creative differences" resulted in a stilted performance from Reagan, who was judged to have blown his chance at big-time stardom and was promptly sent back to programmer purgatory.

Code of the Secret Service, one of four luridly jingoistic films Reagan made in 1938 and 1939 in which he played Lieutenant "Brass" Bancroft, a U.S. Treasury Department agent fighting crime, cast him with Eddie Foy Jr. in a tale of American counterfeiters operating in Mexico. The film was so bad Reagan pleaded with the studio not to release it. (They didn't in Los Angeles, where Reagan stood to be most embarrassed.) In the heartland, studio publicity trumpeted the Bancroft films as "but thinly disguised dramatizations of actual adventures" designed to restore "dignity and public confidence" in American law enforcement. Promotional strategies included "crime clue boxes" in theater lobbies into which concerned citizens could drop the names of suspicious neighbors, and Ronald Reagan as commander-in-chief of the Junior Secret Service Clubs. Young club members willing to keep a lookout for foreign saboteurs received a card bearing Reagan's signature, and the studio suggested that one way to attract recruits would be to hold marksmanship contests at local rifle clubs.

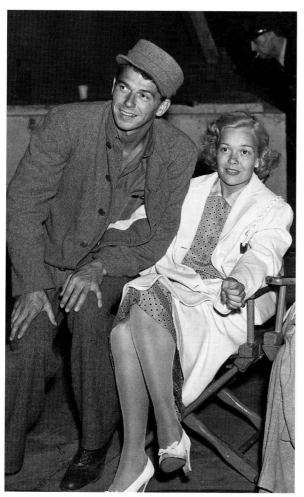

Jane Wyman visits Reagan on the set of *Smashing the Money Ring,* the third of his Brass Bancroft epics. Although these films were largely awful, Reagan preferred to play heroic figures rather than sexually confused socialites. Studio press books described Bancroft as a man with "smashing fists . . . when guns are not handy!" and maintained that Reagan himself wasn't that much different. When he arrived on the set of *Code of the Secret Service,* the studio averred, the first thing he said after "Hello" was "When do I fight, and whom?" After the first scene, Reagan reputedly "had five skinned knuckles, a bruised knee, and a lump half the size of an egg on his head." The press book chose not to pass along the information that Reagan's hearing was permanently impaired when a fellow actor fired a blank .38 caliber cartridge too close to his right ear.

This publicity buildup of Ronald Reagan's testosterone quotient worked. Soon, he later joked, "I was the Errol Flynn of the B pictures."

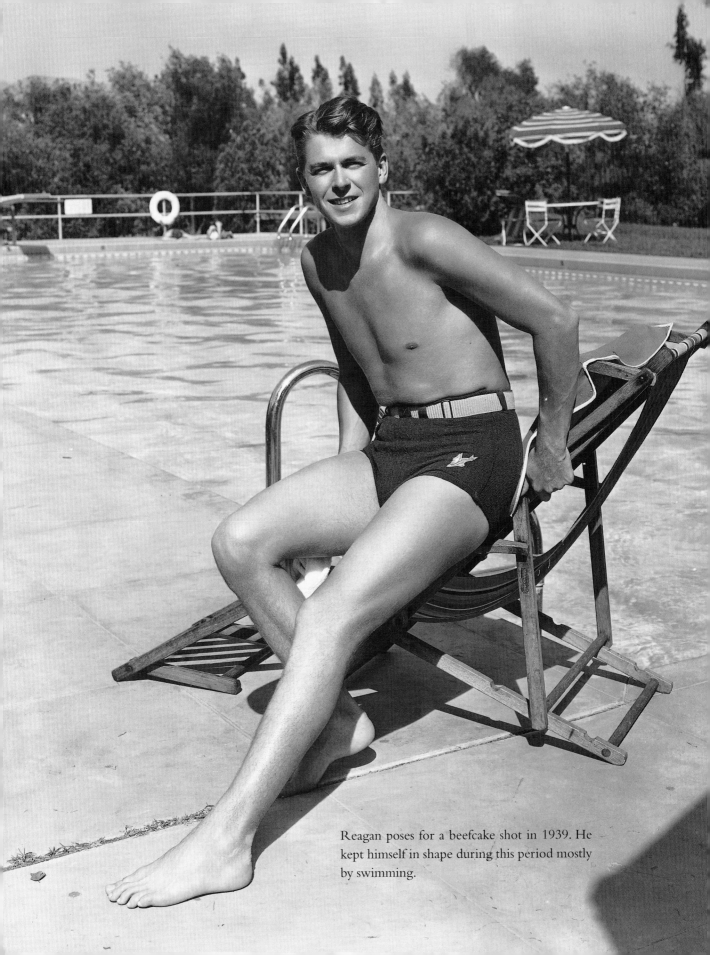

Reagan poses for a beefcake shot in 1939. He kept himself in shape during this period mostly by swimming.

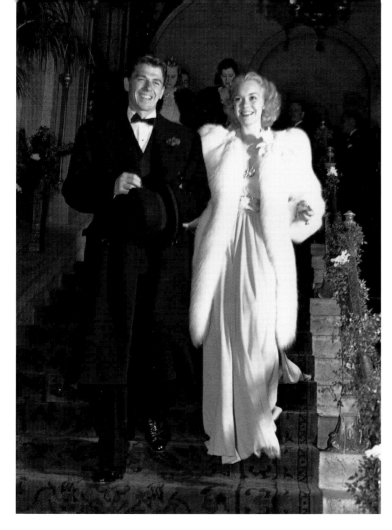

Ronald Reagan and Jane Wyman are the epitome of Hollywood glamour as they leave the 1938 Academy Awards ceremonies at the Biltmore Hotel in Los Angeles on February 23, 1939. When they initially worked together, Jane had been suspicious of Reagan's apparent equanimity. "I couldn't help wondering if some of his easy good nature could be an 'act.' It didn't seem possible that a man could have so even a disposition consistently." She decided he was genuine when he asked her out to dinner. "His manner was as kind, as friendly when he spoke to a waiter as it was when he spoke to a friend. . . . It was not an act. It was the real Ronnie." She began to fall in love.

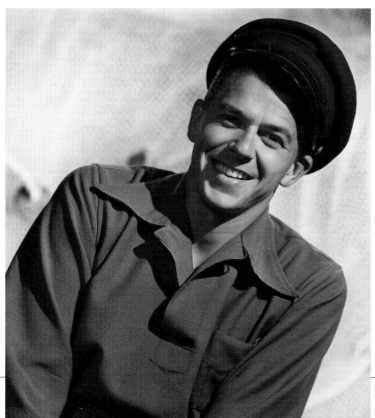

A jaunty study of Reagan from the late 1930s. Around this time he began to wear one of the first pairs of contact lenses available in the United States. "They were big, rigid, and fit over your eyes like a pair of football helmets," he recalled. "Each lens had a little bubble over your cornea that you had to keep filled with a saline solution, and every couple of hours, the solution would turn gray and you'd find yourself blinded. . . . They were difficult to wear, but vanity prevailed. . . ."

On June 21, 1939, Jane Wyman joined Reagan, Rose-mary Lane, and Tom MacAvity for a game at the Sunset Bowling Center in Hollywood. Jane and her "Ronnie" had dated fairly steadily, and by now she was hopelessly in love. Reagan seemed more casual in his feelings; he described Jane to a reporter as "a good scout" and "loads of fun to be with."

By late September 1939, Jane was pressuring him to marry her. He resisted. On October 4 she was rushed to the hospital with what the studio described as a "stomach disorder." Two days later, Reagan gave her an engagement ring. In 1989, Nancy Reagan revealed that Wyman had in fact "said she would kill herself if he didn't marry her," then sent him "a suicide note and swallowed a whole lot of pills and got herself taken to the hospital. As soon as he got the note, he rushed down there, while they were pumping her out, and said, 'Of course I'll marry you!' You know how softhearted he is. She knew which of his buttons to push."

Jane beams up at her fiancé as fellow actors Joy Hodges and Arleen Whelan admire her engagement ring—a fifty-two-carat amethyst—during a personal appearance stop in Pittsburgh on December 2. The group was part of "Hollywood Stars of 1940 on Parade," a national variety-show tour organized by the gossip maven Louella Parsons. Playing to packed houses in movie theaters from San Francisco to Washington, D.C., Reagan appeared in skits and was, according to *Variety,* "very personable, deft, and obviously at home on stage. [He] is in and out of the act throughout, talking with [Parsons], kidding with the girls, and doing brief comedy sketches with Jane Wyman and Susan Hayward."

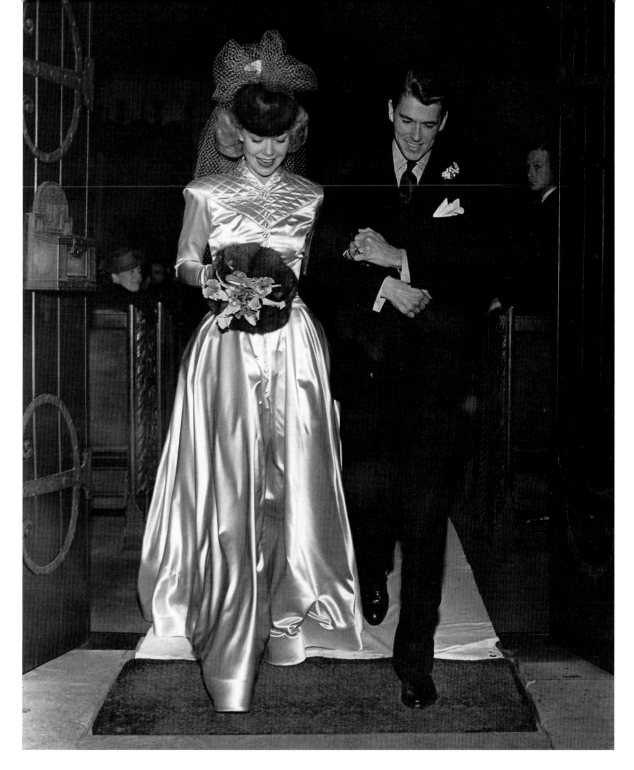

January 26, 1940: Mr. and Mrs. Ronald Reagan leave Wee Kirk o' the Heather chapel at Forest Lawn Memorial Park in Glendale after exchanging their wedding vows. The reception was held at Louella Parsons's Beverly Hills home. (Parsons was a fellow native of Dixon, Illinois, and had taken Reagan under her wing.) The newlyweds spent a week in Palm Springs, where rain dashed their hopes to play golf and Reagan's plan to teach Jane to swim.

Upon their return to Los Angeles, the Reagans set up housekeeping in Jane's three-bedroom apartment at 1326 Londonderry View, near the Sunset Strip, three blocks from the groom's old bachelor pad.

Murder in the Air, the fourth and last of Reagan's Brass Bancroft movies, featured what the studio dubbed "the most deadly weapon ever known to man": the Inertia Projector, a "death-ray machine" (which Reagan unveiled in this scene) capable of immobilizing internal combustion engines. Bancroft uses the Projector to down a plane carrying his nemeses. Jokes popped up about "Ronald Ray-gun," and years later cynics would wonder if the Inertia Projector hadn't inspired President Reagan's enthusiasm for the "Star Wars" Strategic Defense Initiative antimissile system. In any event, the Brass Bancroft series struck a chord with young American audiences, and by mid-1940 the only actor at Warner Bros. who received more fan mail than Ronald Reagan was the *real* Errol Flynn.

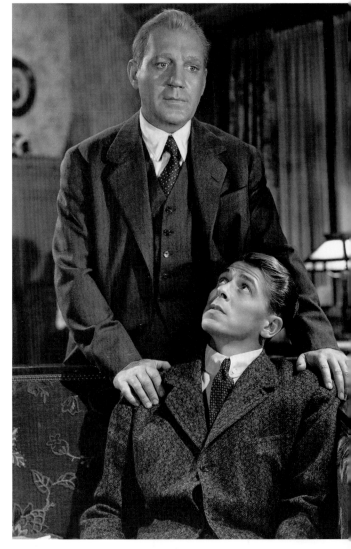

Pat O'Brien and Reagan in a scene from *Knute Rockne—All American,* the first of his films to utilize Reagan's football prowess. While a sports announcer, "Dutch" had often spoken of Rockne, the legendary Notre Dame University football coach, and his star player, the doomed George Gipp. He had urged the studio to film Rockne's story with Pat O'Brien in the title role and himself as Gipp. He started to write a spec screenplay for the picture, then read in the trade papers that the studio had bought the rights to Rockne's story from his widow. They cast O'Brien immediately but told Reagan that he didn't look like a football player and instead tested ten other actors for the Gipp role. None of them, apparently, looked the part either, so when Reagan showed the producer, Hal Wallis, photographs of himself in uniform from his college days, he got the part he had coveted.

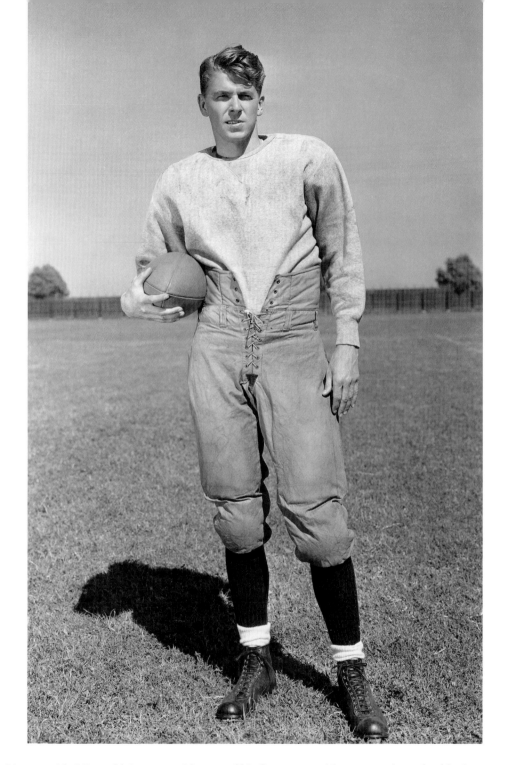

George Gipp provided Ronald Reagan with one of his few memorable screen roles—deathbed scene and all—and he handled it well. As Gipp succumbs to pneumonia, he tells his coach, "Someday when things are tough, maybe you can ask the boys to go out there and win just once for the Gipper." At film's end, with the most important game of the season slipping away from them, Rockne rallies the team with the cry "Win one for the Gipper!"

For the first time, critics described Reagan's performance as more than just "competent" or "natural."

In early October of 1940, Reagan joined a *Knute Rockne* publicity junket to South Bend, Indiana, the home of Notre Dame. The junket's entourage, which also included Bob Hope, Rudy Vallee, Jane Wyman, and Reagan's parents, Nelle and Jack, took the city by storm. All four of South Bend's movie houses premiered the film simultaneously; a welcoming banquet at the university, at which Reagan gave a touching speech about George Gipp, was telecast nationwide over radio; and Kate Smith's popular radio show, broadcast from John Adams High School in South Bend that week, featured readings from the film's script. After the broadcast, Reagan posed with, left to right, Donald Crisp, Mr. and Mrs. Pat O'Brien, Gale Page, and Kate Smith.

The Reagans' joy is apparent later that month as they clown around after announcing they expect their first child in January.

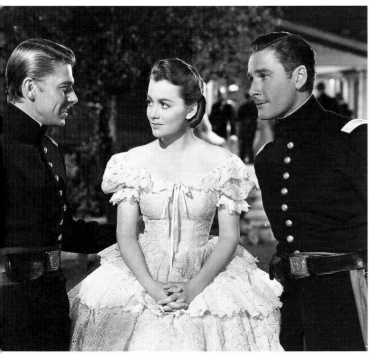

Reagan with Olivia de Havilland and Errol Flynn in a scene from *Santa Fe Trail*, his sixth and last release of 1940. Although the script was a muddle of questionable abolition-era history and took place mostly in Kansas, Reagan's casting as General George Armstrong Custer in this big-budget vehicle indicated the studio's new respect for him. In fact, he'd been told the role was his immediately after a well-received preview of *Knute Rockne*. "At the studio the next day, I thought people were suddenly more friendly to me," he recalled. "Then I went to the wardrobe department and witnessed a scene I will never forget." As he waited to be fitted, he noticed a rack of Custer uniforms with another actor's name on them. A wardrobe man entered, threw the costumes "like rags" into a corner, and replaced them with "blue and gold-braided uniforms marked 'Custer' with my name on them. I looked at those uniforms piled up on the floor and said to myself, 'That can happen to me someday.'"

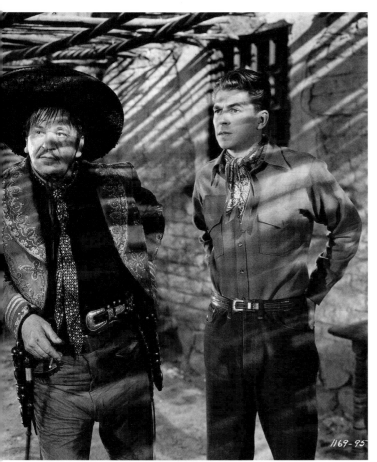

The first request by another studio to "borrow" Ronald Reagan for a film came in January 1941 from MGM, which cast him as the romantic second lead in *The Bad Man*, a bad movie about a lovable Mexican bandit played by Wallace Beery, shown here. The cast boasted another grizzled veteran, Lionel Barrymore, who played Reagan's wheelchair-bound uncle. While Reagan thought working with the great Barrymore made him a better actor, it also proved dangerous. "He was confined to his wheelchair at the time and he could whip that thing around on a dime. It's hard to smile in a scene when your foot has been run over and your shin is bleeding from a hubcap blow."

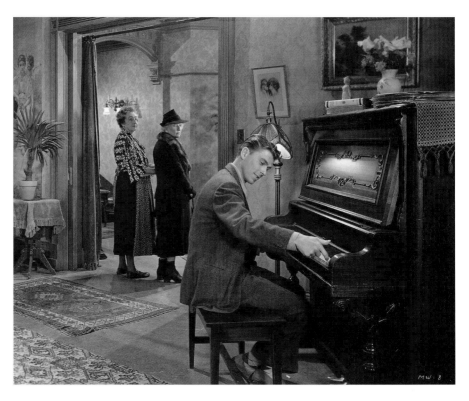

Reagan tickles the ivories in a scene from *Million Dollar Baby* with Helen Westley and May Robson. He played a concert pianist and worked for two weeks in the Warners musical department to learn keyboard technique. "A lot of acting is imitation anyway," he said, "and I became pretty good, as long as the piano remained silent. For a while there I almost convinced myself I could play."

In his memoirs, Reagan recalled that during his Hollywood career, "I usually played a jet-propelled newspaperman who solved more crimes than a polygraph machine. My one unvarying line, which I always snapped into a telephone, was 'Give me the city desk. I've got a story that will crack this town wide open!'" In fact, he played a reporter in only two films, *Swing Your Lady* in 1938 and this one, *Nine Lives Are Not Enough*. He received some of his best reviews for his performance in this film, released in October 1941. *Variety's* critic wrote that he was "not only a brash reporter to end all screen reporters, he's also hilariously scatterbrained and devilishly resourceful."

FP.108.A3

A dashing portrait from *International Squadron,* Reagan's fourth 1941 picture, re-
leased three weeks before America's entry into World War II after the Japanese attack
on Pearl Harbor. He played a cocky Yank in Britain's Royal Air Force who must
learn the necessity of teamwork before he can truly prove his valor. This and several
similar pictures that ensued helped create a public image of Ronald Reagan as a
wartime hero. Reagan was in fact an officer in the Cavalry Reserve, and he had re-
ceived his first induction notice for active duty in February. Jack Warner wrote to
the army claiming that Reagan's absence would hurt several films about to go into
production, and Reagan was granted the first of several "professional hardship"
deferrals.

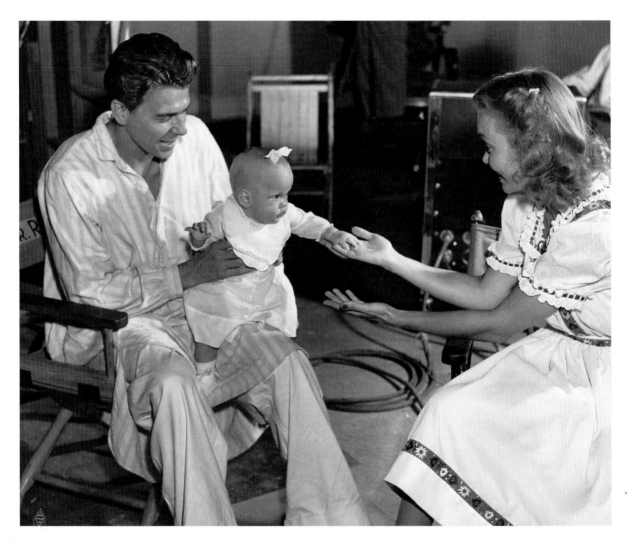

Eight-month-old Maureen Elizabeth Reagan returns to her mother's arms after a hug from her father on the set of *King's Row*, his most important film to date, in August 1941. The baby was born on January 4. "I wanted a boy," Jane said shortly after. So did Reagan, who had printed up mock military call-up notices for "Ronald Reagan Jr." as birth announcements. He sent them out anyway with the notation "This is the announcement we were going to send . . . but it's hardly appropriate for Maureen Elizabeth Reagan, is it?"

"Where's the rest of me?" Upon its release in February 1942, *King's Row* proved not only Reagan's most prestigious film, but his most controversial as well. Based on a novel that delved into the dark underbelly of small-town life and concerned incest, infidelity, insanity, and sadism, the project was nearly censored to death. Reagan played a young man whose legs are amputated by a sadistic doctor angry that he has romanced the doctor's daughter. As he prepared to shoot the scene, Reagan found the experience of looking down to see nothing below his hips (his legs were hidden inside a hollowed-out section of a mattress) "a shock," his most emotional moment as an actor. He whispered to the director, "No rehearsals—just shoot it," and did the scene in one take. "I realized I had passed one of the biggest milestones of my career. . . . *King's Row* is the finest picture I ever appeared in, and it elevated me to the degree of stardom I had dreamed of when I had arrived in Hollywood four years earlier."

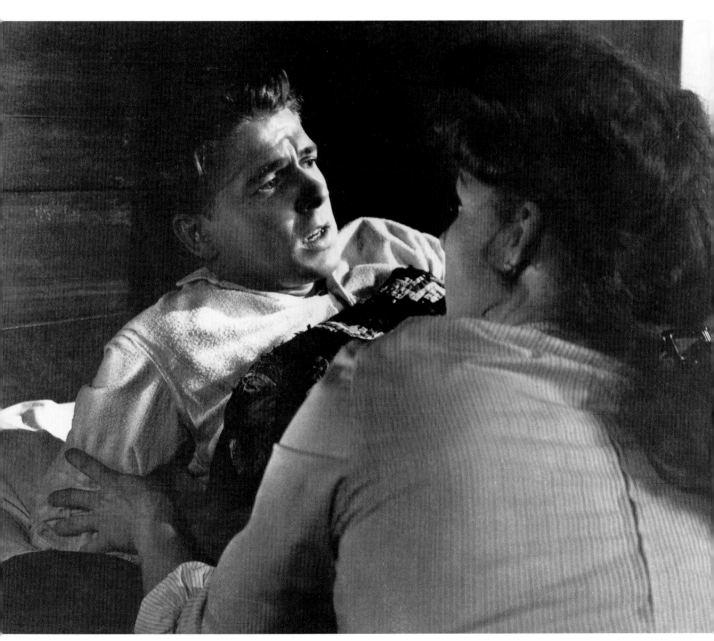

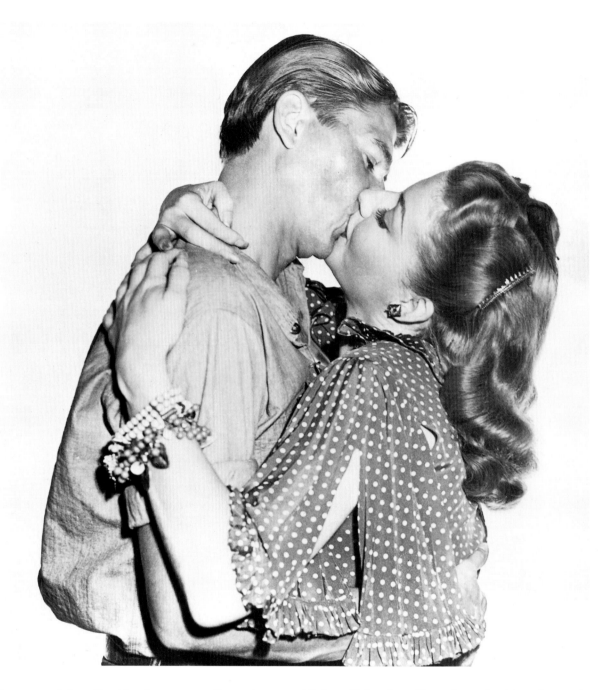

Reagan and Ann Sheridan in an unusually passionate publicity still for their film *Juke Girl*. Although its title makes it sound like a teen soda-shop picture, the story in fact concerned the plight of itinerant crop pickers in the humid heat of Florida. It was filmed in the winter cold of central California, where the actors had to smoke in order to disguise their vaporized breaths in the near-freezing night air. In one scene, thugs hired by a packing plant owner attempt to break the resolve of an independent farmer by smashing truckloads of tomato crates. Reagan was forced to wallow in the same squashed tomatoes for three nights while the scenes were shot. "With all the misconceptions about pampered stars," he later said, "none is so far afield as the belief that physical discomfort isn't tolerated."

In September 1941 Reagan joined Louella Parsons for a star-studded homecoming junket to Dixon for the world premiere of *International Squadron*. WELCOME HOME DUTCH banners waved, and chants of "We love Dutch!" rang out as Reagan spoke at length of his hometown memories. "I want all of you to know that I did not sleep last night, thinking of my trip back to Dixon, where I could meet my old friends. I counted the seventy-seven persons whom I have been credited with pulling out of the Rock River at Lowell Park many times during the night." As Parsons moved forward to cut off Reagan's remarks, comedian Jerry Colonna whispered to her, "This fellow must be running for Congress!"

There followed a parade down the town's main street in which Nelle and her son sat in an open car and basked in the cheers of crowds lining the roadway. (Jack had passed away four months earlier.)

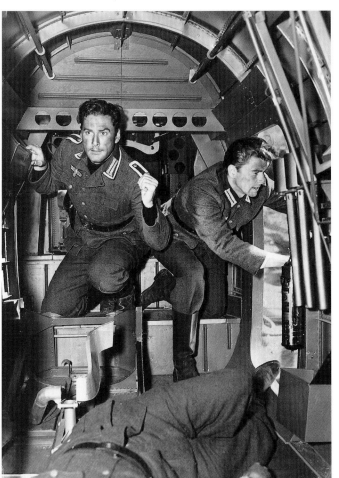

"The Errol Flynn of the B pictures" teamed up again with the real thing for *Desperate Journey*, released September 1942. Reagan again played a Yank in the RAF in this cartoonish story of valiant Allies and nincompoop Nazis. Flynn made an unsuccessful attempt to wrest away from Reagan the best scene in the picture, in which his character pretends to give a Nazi Major secret information, then knocks him out with a punch and eats his breakfast. "Errol was a strange person," Reagan recalled, "terribly unsure of himself and needlessly so. He was a beautiful piece of machinery, and yet convinced he lacked ability as an actor . . . he was conscious every minute of scenes favoring other actors. . . ."

Jane Wyman salutes 2nd Lieutenant Reagan, Army Air Force Personnel Officer, in the fall of 1942. America had been at war with Germany, Italy, and Japan since Japan's attack on Pearl Harbor on December 7, 1941, but Reagan had continued to receive deferrals until April 1942. His poor eyesight kept him from active duty, and he was assigned as a recruiter for army film units in Hollywood. "We would turn out training films and documentaries," he said, "and conduct a training school for combat camera units. All of the newsreel material in the theaters of bombings and strafings was the product of these units."

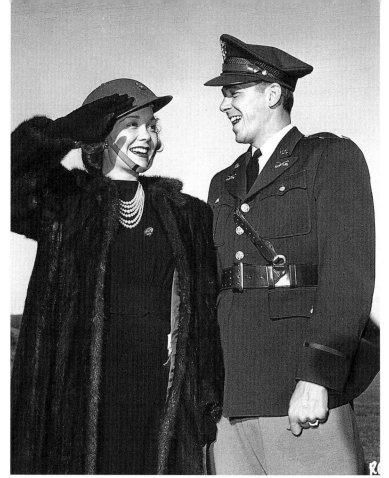

September 1943: Nelle visits her son at "Fort Roach," the headquarters of the production unit, so called because it was housed in the old Hal Roach Studios in Culver City. In addition to recruiting talent from all the Hollywood studios, Reagan appeared in several short propaganda films produced by the unit. "A great many people harbor a feeling that the personnel of the motion picture unit were somehow draft dodgers avoiding danger," Reagan said, a tad defensively. "[But] there was a special job the army wanted done, and it was after men who could do the job." Apparently, Reagan did his job to the army's satisfaction: He was promoted to first lieutenant, and ultimately captain, during his three and a half years of service.

Jane Wyman's salary came in handy during this period, since Reagan's studio paycheck was suspended while he served, and his army pay amounted to just $250 a month.

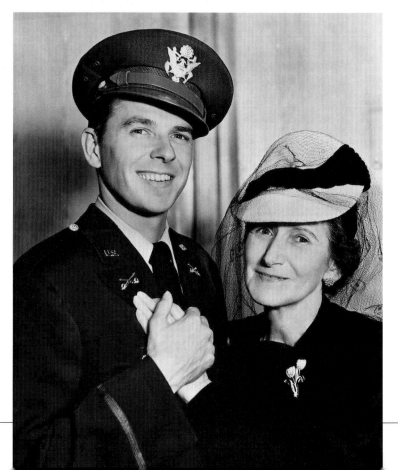

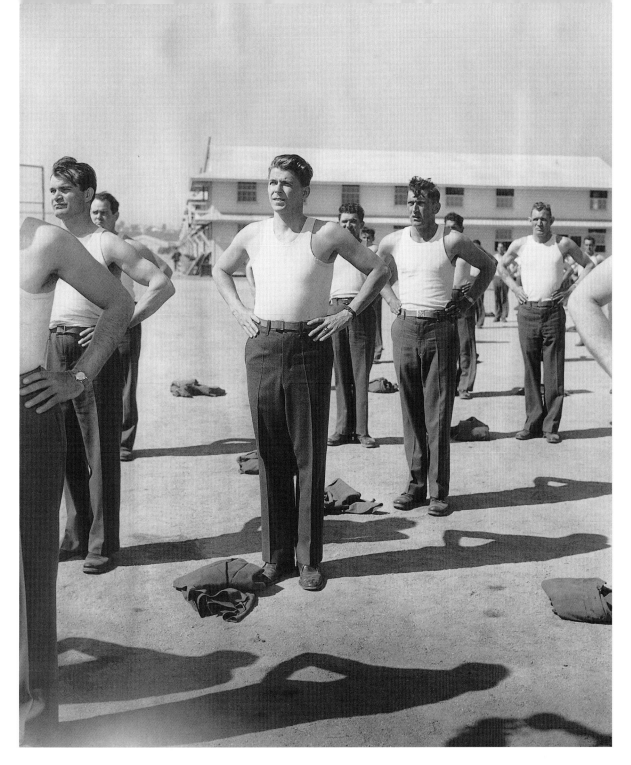

Early in 1943, Reagan was granted leave to appear in the film version of Irving Berlin's rousingly patriotic Broadway musical, *This Is the Army*, which had raised ten million dollars for war relief. Reagan played Johnny Jones, the author of the show the servicemen perform in the movie; he's pictured here doing calisthenics in a scene. During the first week of filming, Reagan was introduced to the legendary Berlin no fewer than five times. "Each time he was glad to see me," Reagan recalled. After he had viewed some of Reagan's early rushes, Berlin told him he had to work on his voice a bit, but "it's very possible you could have a career in show business."

Modern Screen

OCTOBER

15¢

CAPT. RONALD REAGAN

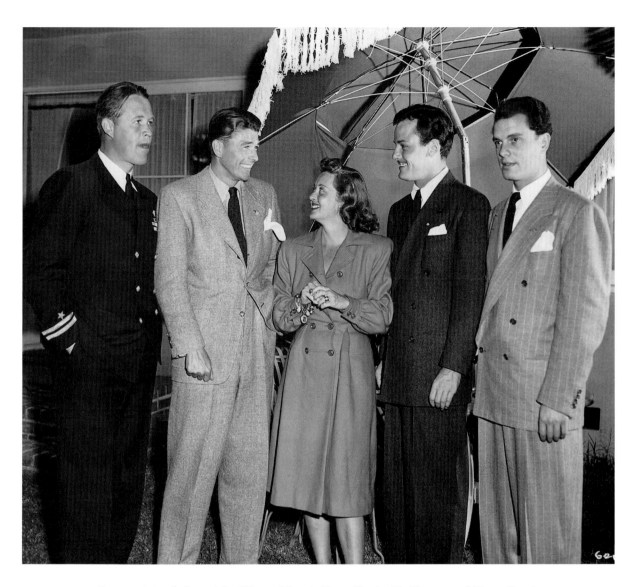

Reagan joins, left to right, Wayne Morris, Bette Davis, Gig Young, and Harry Lewis as they prepare to welcome home returning servicemen at a ceremony on the Warner Bros. lot in the fall of 1945.

OPPOSITE The October 1944 issue of *Modern Screen* features a dashing portrait of Captain Ronald Reagan. The war would be over in eleven months.

The Reagans at home in December 1945. After the birth of Maureen, the family had built an eight-room house on a plot of land with a breathtaking view above the Sunset Strip. The Reagans weren't part of the A-list Hollywood party scene; most of their socializing was done at home during small dinner gatherings with friends. By now Ronald Reagan had a reputation for verbosity. On any given occasion he was sure to offer lengthy discourse on the hot political topic of the day. His command of facts (and often minutiae) surprised many, and so did his verbatim recitation of passages from recent speeches delivered in Congress. Some found Reagan refreshingly erudite, others thought him insufferably boring. Among the latter, apparently, was his wife. At one dinner party she leaned over to a guest while Reagan pontificated and said, "If I have to listen to him spout off one more time, I'll either kill him or kill myself."

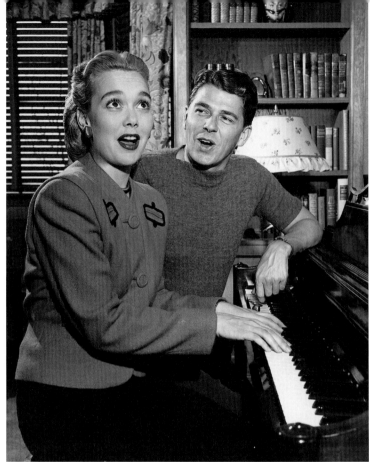

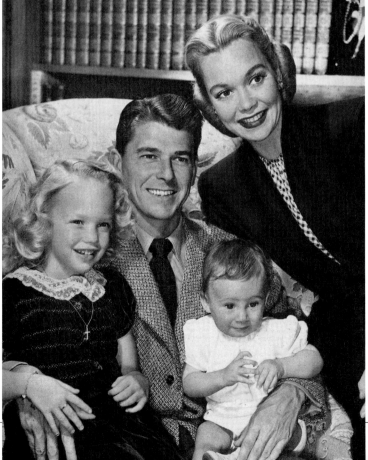

A Reagan family portrait taken in the spring of 1946. Five-year-old Maureen had pestered her parents for a baby brother, but with Jane's career ratcheting into high gear, she didn't feel she could take time off for a pregnancy. So on March 18, 1945, the Reagans adopted an infant boy whom they named Michael Edward. "Michael was only twelve hours old when Ronnie and I got him," Jane recalled. "As far as we're concerned, we're blood. . . . He's my baby boy."

Autumn 1946: A prop man cools Reagan off during the filming of his first commercial movie in four years, *Stallion Road*. Warner Bros. had welcomed the thirty-five-year-old back in August with a million-dollar contract that brought him a $3,500 weekly paycheck. Visually arresting but overly melodramatic, *Stallion Road* was Reagan's first real Western, despite his love of horses and the outdoors. "Jack Warner preferred me in gray flannel suits," he said. By now Reagan was a partner in a horse farm in Northridge, California, and he rode one of his own horses, Baby, in the film.

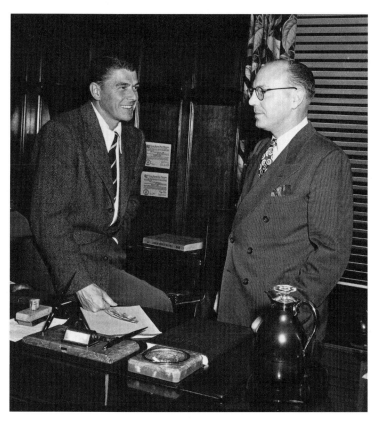

Jack Dales, Executive Secretary of the Screen Actors Guild, congratulates Reagan on his appointment as the union's interim president in March of 1947. Reagan had been elected 3rd Vice President of SAG the prior September, amid a series of violent strikes by the Conference of Studio Unions, which SAG did not support. The CSU was accused of being "communist-dominated," and when an anonymous phone caller threatened to throw acid in Reagan's face unless he supported the CSU's objectives, he began to carry a concealed handgun. "These were eye-opening years for me," Reagan said. "Now I knew from firsthand experience how Communists used lies, deceit, violence, or any other tactic that suited them to advance the cause of Soviet expansion."

SAG president Reagan joins, left to right, 3rd Vice President George Murphy, 1st Vice President Gene Kelly, and 2nd Vice President William Holden at a meeting of the SAG Executive Committee later in 1947. Reagan was elected president of the union by the full SAG membership in November. Many in Hollywood had been impressed with his handling of aspects of the CSU problem. "Reagan was a one-man battalion," said Sterling Hayden.

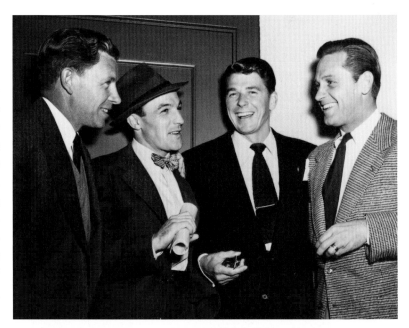

The Reagans join Dinah Shore and her husband, George Montgomery, at the Academy Awards ceremonies at the Shrine Auditorium in Los Angeles, March 13, 1947. Jane was nominated for her performance in *The Yearling* but did not win; Dinah sang the year's Best Song, "On the Atchison, Topeka, and the Sante Fe," and Reagan shared Master of Ceremonies duties with Jack Benny.

Three months later, on June 17, Reagan nearly died from a bout with viral pneumonia that kept him hospitalized for several weeks. He left the hospital seventeen pounds lighter, severely weakened, and faced with a sad task: the cremation of the premature baby girl Jane had given birth to on June 26. The Reagans had named the baby Christine, but she succumbed to cardiac arrest nine hours after her delivery.

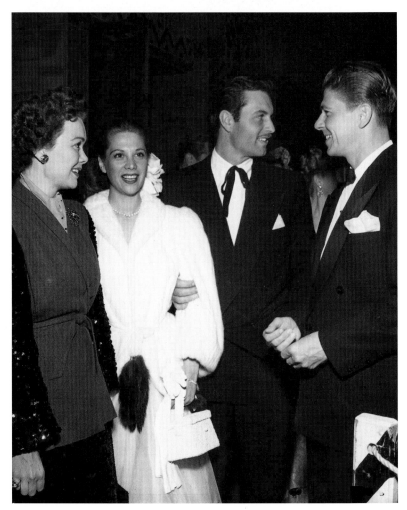

683-582

Back in a gray flannel suit for *That Hagen Girl*, Reagan poses with his costar, the former child sensation Shirley Temple, now nineteen. He hated the film, a rather outlandish soap opera in which he falls in love with a girl who is not only half his age but is rumored to be his illegitimate daughter. Those whispers aren't true, but audiences were no more eager than Reagan was to see him as Rebecca of Sunnybrook Farm's cradle-robber. At a sneak preview in the fall of 1947, he recalled, "Came the moment on the screen when I said to Shirley, 'I love you,' and the entire audience cried, 'Oh no!' I sat huddled in the darkness until I was sure the lobby would be empty." The line was edited out of the film, leaving the ending unclear. "You are left to guess as to whether we are married, just traveling together—or did I adopt her?"

On September 19, 1947, Reagan returned to his alma mater for Eureka's annual Pumpkin Festival. He crowned the festival queen, rode horseback in the homecoming parade, and visited his old frat house, where current TKE brothers took out a paddle and made him relive his initiation hazing.

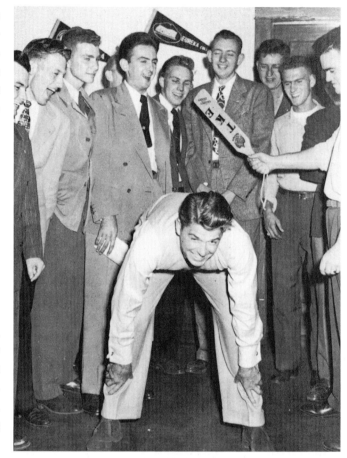

In Washington, D.C., on October 22, Reagan, wearing a winsome bow tie, listens to testimony before the House Un-American Activities Committee about communists in the movie industry. As president of the Screen Actors Guild, Reagan was scheduled to testify the following day.

Robert Montgomery, George Murphy, and Reagan wave to the crowd outside the Capitol Building in Washington, D.C., on October 23, after testifying. Although a liberal Democrat his entire life to this point, Reagan had been distressed by the attempts of communists and their sympathizers to foment union trouble in Hollywood, and he and Jane had been FBI informers for several years. But he was equally disturbed by the committee's attempts to stigmatize every liberal cause as communist-influenced and a threat to the country. He refused to "name names," a practice that destroyed lives and careers, sometimes of innocent people, and told the committee, "As a citizen I would not like to see any political party outlawed on the basis of its political ideology. . . . However, if it is proven that an organization is an agent of . . . a foreign power . . . then that is another matter."

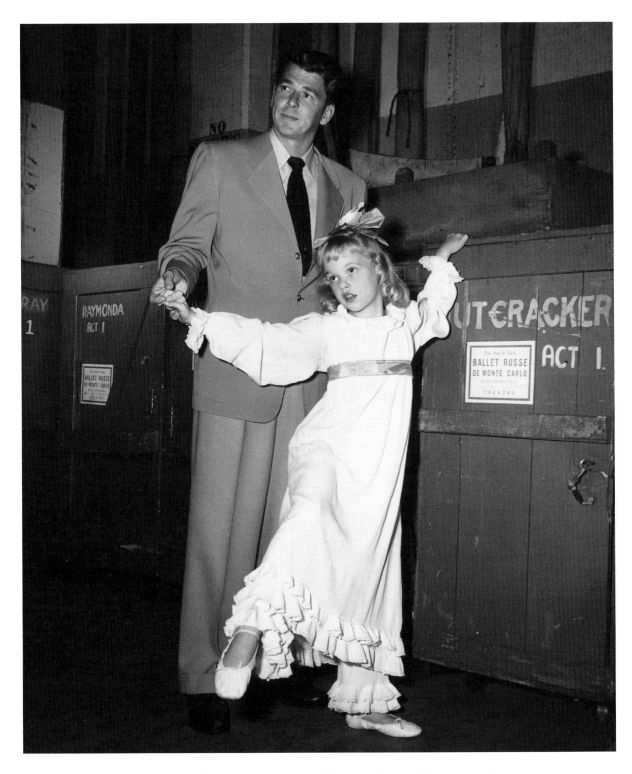

Reagan helps Maureen, nearly seven, with her stretches as she prepares for an appearance as one of the children in the Ballet Russe de Monte Carlo production of *The Nutcracker* in Los Angeles, Christmas 1947.

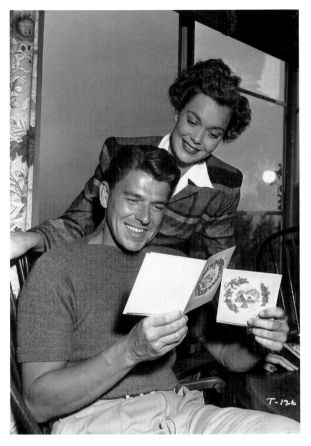

The Reagans appear happy as they read holiday cards during this at-home photo opportunity, but in fact their marriage was falling apart. Her career had burgeoned while his languished; her demanding role as a deaf mute in *Johnny Belinda* left her little time for home life; and there were rumors that she'd had an affair with her *Belinda* costar Lew Ayres. The presidency of the Screen Actors Guild monopolized most of *his* time, and Wyman found his increasingly conservative political views offputting. After several separations, she filed for divorce in June of 1948. "My husband and I have engaged in continual arguments on his political views," she told the court. "Finally there was nothing in common between us. . . . Despite my lack of interest in his political activities, he insisted I attend meetings with him. . . . But my own ideas were never considered important."

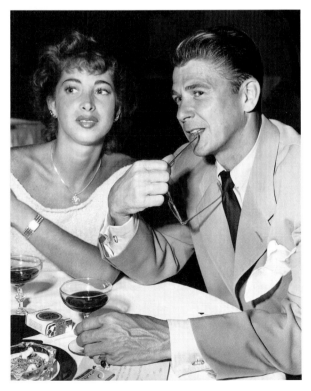

On July 30, two weeks after the divorce was final, newly "eligible bachelor" Ronald Reagan squires starlet Betty Bligh to dinner at Ciro's in Hollywood. The date was atypical; Reagan in fact was devastated by the finality of the divorce decree. "I suppose there had been warning signs," he said. "If only I hadn't been so busy, but small-town boys grow up thinking that only other people get divorced. The plain truth was that such a thing was so far from being imagined by me that I had no resources to call upon."

His movie career offered little solace. He had no films in release during all of 1948, and his 1949 pictures were either slight concoctions or dramatic misfires. *John Loves Mary,* a romantic comedy costarring Patricia Neal (shown here with a trouser-challenged Reagan), fell into the former category. Enjoyable enough, it remains notable principally as Neal's film debut. She found him "sad, because he did not want a divorce."

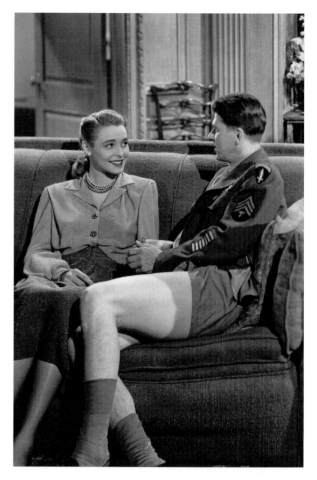

The year's misfire was *Night Unto Night,* a romantic drama with newcomer Viveca Lindfors filmed in January 1947 but unreleased until June 1949 (always a bad sign). The plot concerned an epileptic biochemist who rents a secluded beach house from a beautiful young widow who is haunted by the voice of her late husband. They fall in love. He tries to persuade her that the dead do not return, and she saves him from committing suicide during a hurricane. "If you think that this was a hard story to bring to life on the screen," Reagan wrote in his memoirs, "you are right." In *her* memoirs, Lindfors remembered Reagan as a "bland and smooth and seemingly pleasant" man who once confided to her that in his view sex was "best in the afternoon after coming out of the shower."

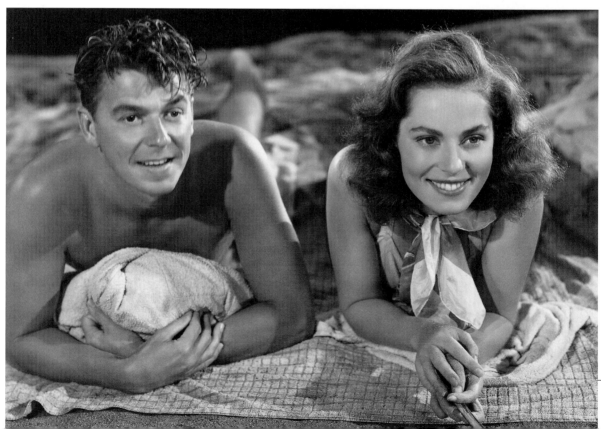

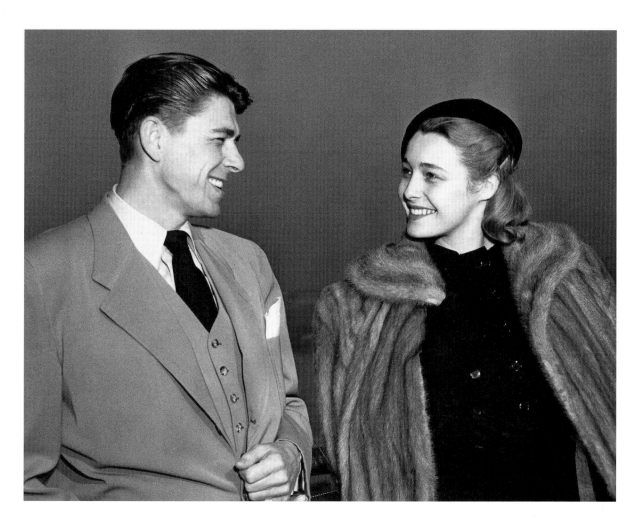

Reagan and Patricia Neal return from England aboard the *Queen Mary* in April 1949 after filming *The Hasty Heart,* a well-received melodrama about five convalescent soldiers in Burma cared for by a kindly nurse. Reagan had hated England's cold damp (he called the country "this dismal wilderness" in a letter to Jack Warner) and found that he missed both America and female companionship ("*Lay*—there's a word I no longer experience or understand"). Gossip linked him romantically with Pat Neal, but nothing ever developed between them despite Reagan's attempt once to kiss her. "Oh, Ronnie, no!" she had exclaimed.

"I missed not having someone to love," he said in 1989.

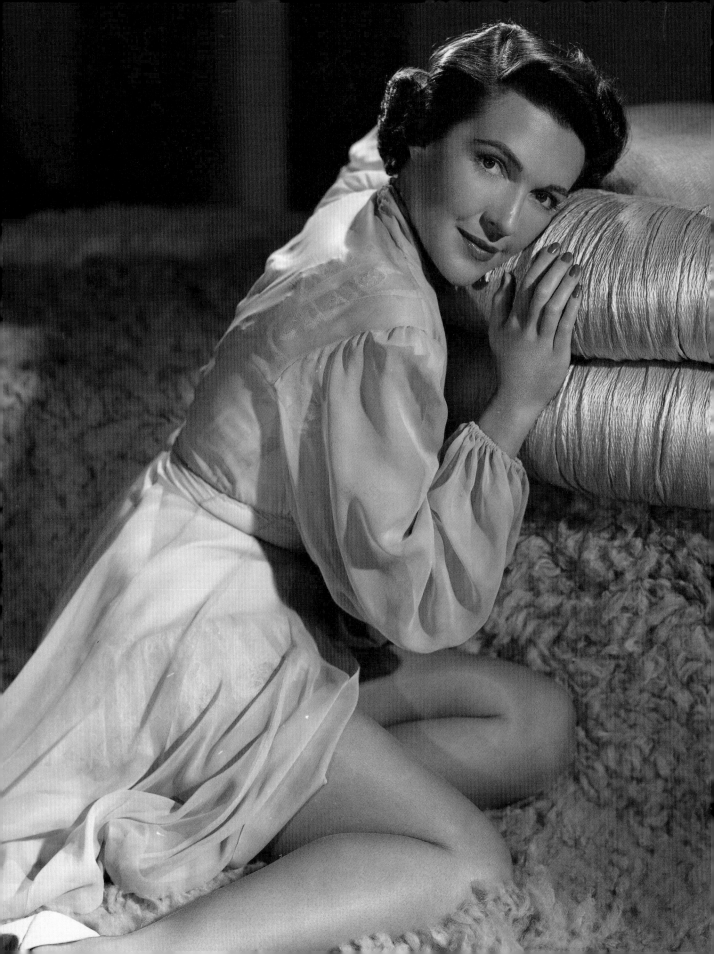

OPPOSITE "And then along came Nancy and saved my soul." The twenty-eight-year-old daughter of an actress and a prominent Chicago neurosurgeon, Nancy Davis had signed an MGM contract in the spring of 1949. Neither a great actress nor a great beauty, she was used sparingly by the studio—which didn't bother her much, since her professed overriding ambition was "to have a successful marriage."

Nancy had dated Spencer Tracy and Clark Gable while working on Broadway in the late forties; she's shown here at New York's Stork Club with Gable and Adolph Menjou. She met Ronald Reagan at a party early in September 1949, and two months later went to dinner with him to discuss her concern that she was being confused with another actress with the same name, a member of the Communist Party. She hoped Reagan, as president of SAG, could help prevent discrimination against her in the industry for this reason.

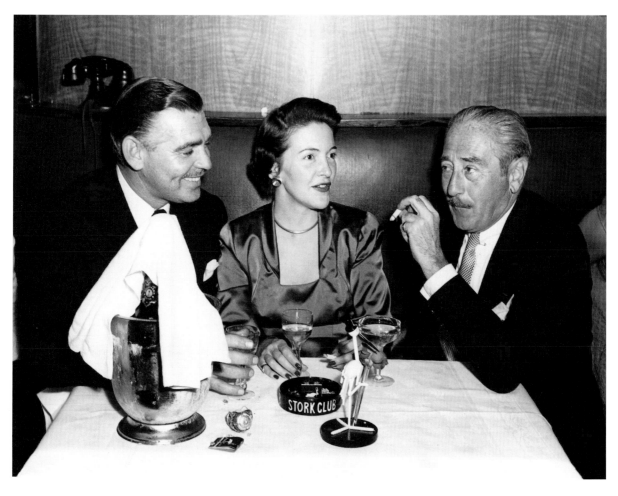

During a charity baseball game in September 1949, Reagan broke his right thigh in three places when Eddie Bracken Jr. tripped him as he slid into first base. The injury put him in the hospital for seven weeks and brought him leg pain for years afterward. It also cost him two films (and $150,000) and kept him from his duties as SAG president.

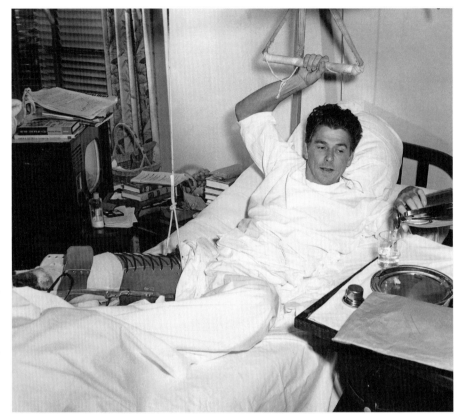

Nancy in a publicity still for the 1950 film *East Side, West Side.* For that first dinner date on November 15, Reagan—hobbling on two canes—took her to a restaurant on the Sunset Strip. There they fell into deep conversation about their backgrounds and lives, and Reagan didn't want the evening to end. He suggested they catch Sophie Tucker's early show at Ciro's; they wound up seeing both of them—and returned home at three A.M. He asked her to dinner the following night. "After that," he recalled, "we dated occasionally, sometimes with our good friends Bill and Ardis Holden, but both of us continued to date other people, and now and then our paths would cross while we were out with someone else."

Ah, the indignities to which actors are subjected: Reagan and Diana Lynn with Bonzo in a campy publicity still for *Bedtime for Bonzo*. This film, released in April 1951, concerned a college professor who attempts to raise a chimpanzee as his child to prove a theory. Leaden except for the delightful antics of its title actor, this film would prompt innumerable jokes at the expense of politician Reagan.

"Naturally, [Bonzo's] trainer was on the set," Reagan recalled, "and the normal procedure called for the director, Fred de Cordova, to tell the trainer what he wanted from Bonzo. But time after time Freddie, like the rest of us, was so captivated that he'd forget.... He'd say, 'No, Bonzo, in this scene you should ...,' then he'd hit his head and cry, 'What the hell am I doing?'"

I'M SENDING CHESTERFIELDS to all my friends. That's the merriest Christmas any smoker can have — Chesterfield mildness plus no unpleasant after-taste *Ronald Reagan*

see RONALD REAGAN starring in "HONG KONG" a Pine-Thomas Paramount Production Color by Technicolor

CHESTERFIELD *Buy the beautiful "Christmas-card" carton*

A Reagan advertisement published in *Life* magazine in December 1951. He had done a similar pitch for Chesterfield in 1948; such ads brought Reagan and the studio extra money while promoting his latest film.

Reagan addresses the SAG Board of Directors on January 10, 1952. Nancy sits in the second row, gazing fondly at the man who will soon be her husband.

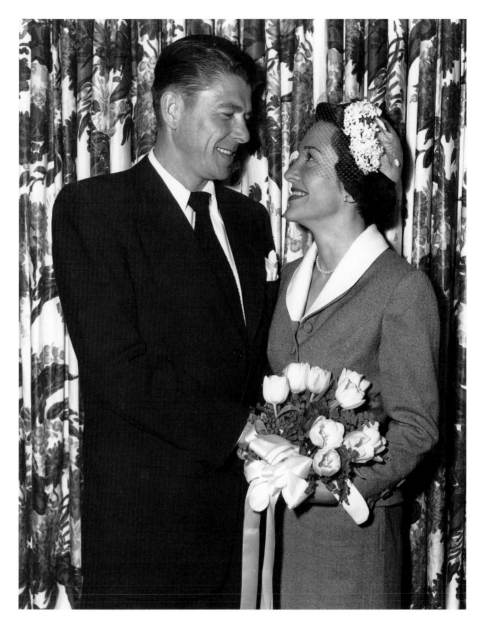

Ronald Reagan, forty-one, and his bride, thirty, cut the wedding cake at the home of Bill and Ardis Holden after their marriage at the Little Brown Church in the San Fernando Valley on March 4, 1952. The couple spent their wedding night at the Mission Inn in Riverside, California, and then drove on to Phoenix, where Reagan met his in-laws for the first time. It had taken him nearly two and a half years after meeting Nancy to propose to her, a period during which he tired of dating a succession of other women, including Doris Day, Rhonda Fleming, and Piper Laurie. "When I woke up one morning with a young lady whose name I couldn't recall, I knew that was it." At dinner one evening in December of 1951, he looked across the table at Nancy and said to her simply, "Let's get married." Unlike Jane Wyman, Nancy agreed with most of her husband's politics, and she was perfectly happy to be simply Mrs. Ronald Reagan, especially after MGM failed to pick up her contract. "Sometimes I think my life really began when I met Nancy," Reagan said. "It is almost impossible for me to express fully how deeply I love [her]."

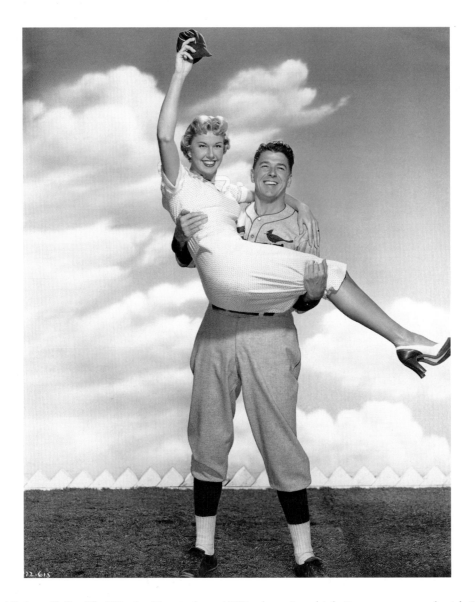

A publicity still for *The Winning Team,* a June 1952 release in which Reagan costarred with Doris Day. He played the legendary St. Louis Cardinals pitcher Grover Cleveland Alexander. It proved one of his better films, and a personal favorite, but it was his last picture for Warner Bros. Threatened by the growing popularity of television, the Hollywood studios had declined to extend the contracts of most of their high-salaried veteran players around this time. Reagan received no parting gift or reception, or even a good-bye handshake from Jack Warner.

OPPOSITE "She shakes the student body like it's never been shook before!" Reagan with Virginia Mayo in *She's Working Her Way Through College,* a "limp and vulgar" (according to Leslie Halliwell) musical remake of the 1942 Henry Fonda movie *The Male Animal.* Although the picture was filmed at Warners before *The Winning Team,* it was released a month after that film. Reagan played a college professor whose world is turned upside down by a burlesque queen who enrolls in his writing class.

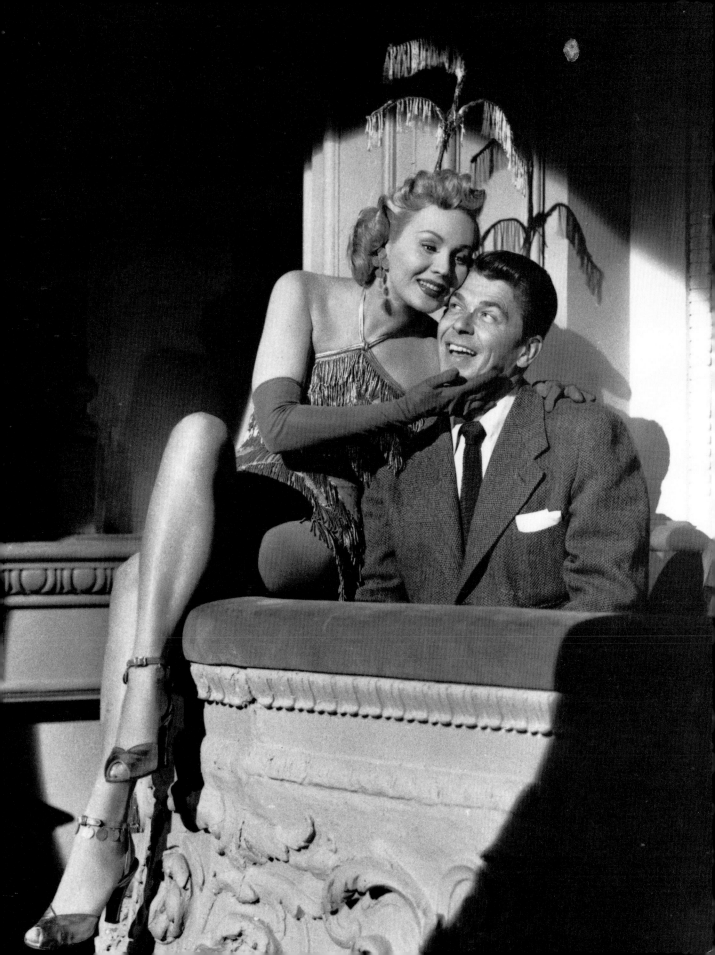

Nancy's parents, Loyal and Edith Davis, flank her and baby Patricia Ann as Reagan and his mother look on during Patti's christening early in 1953. The child was born October 22, 1952. Now that Nancy was a mother, Reagan began a lifelong habit of calling her "Mommy" in addition to his usual term of endearment, "honey."

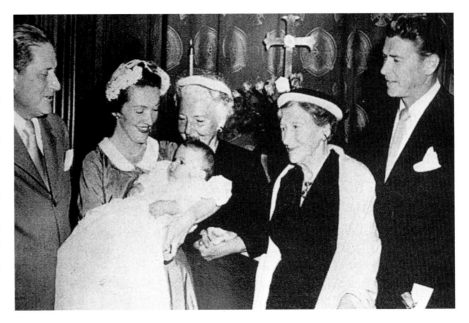

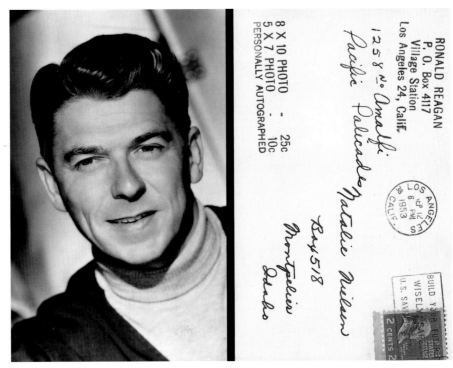

The Reagans sorely missed his $3,500-a-week studio salary. "They were pretty lean and sometimes difficult times," he admitted. He made only two films in 1952 (*Tropic Zone* for Paramount and *Law and Order* for Universal), both so mediocre *The New York Times* reviewed neither.

The Reagans' financial situation got so bad by mid-1953 ("We were broke," Nancy has admitted) that he began mailing this postcard to fans who had written him over the years. It offered autographed photos of himself—eight-by-tens could be purchased for twenty-five cents apiece, five-by-sevens for ten cents. Whether the Reagans made much money from this entrepreneurial venture remains unrecorded.

To further supplement his income, Reagan did another ad, this one for Van Heusen Shirts, in 1953.

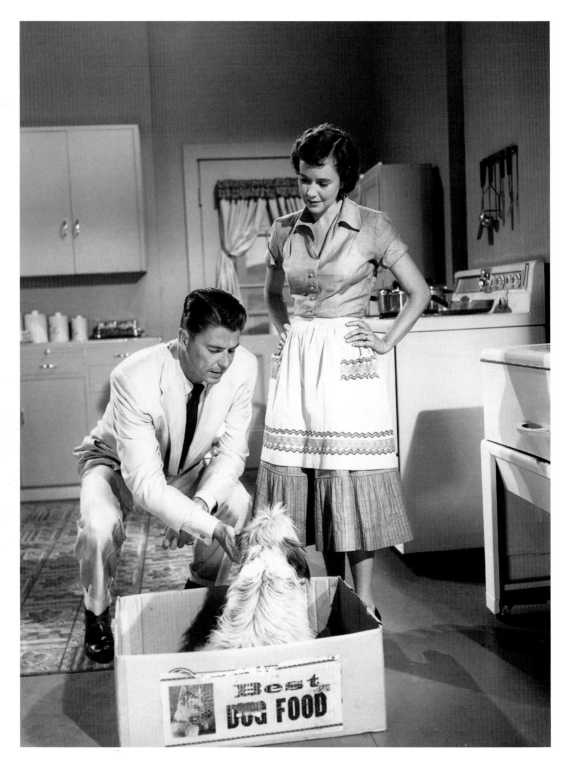

His money woes pushed Reagan in the direction many former movie stars had turned: into television. He made seven appearances on anthology drama series in 1953; one of these was in the *Ford Theater* episode "And Suddenly You Knew." He is shown here in a scene with Teresa Wright.

The Reagans' financial situation continued to be dire in early 1954. To bring in some money, Reagan accepted an unlikely engagement in February as an emcee and performer in a comedy revue at the Last Frontier Hotel in Las Vegas. (Here he's shown during a beer-garden skit with the slapstick Honey Brothers.) He hadn't wanted to do it, but the $30,000 paycheck for the two-week gig changed his mind. He found the whole experience an embarrassment, especially when local reviewers wondered in print whether Las Vegas would now "suffer a retreating Army of fading Hollywood stars." He was invited to return, but he and Nancy "were glad to go home. Never again will I sell myself so short."

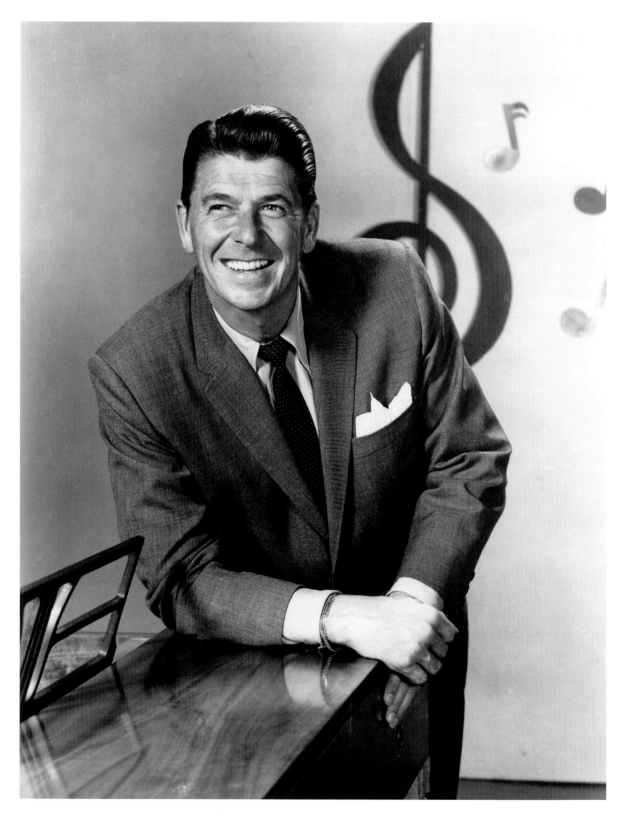

Reagan as the host of *General Electric Theater*, aired Sunday nights at nine-thirty on CBS.

TV Host, Citizen Politician

Arguably, Ronald Reagan owes not only his movie career to the lightbulb, but his presidency as well. Of course, there would not have been any movies for him to star in without Thomas Alva Edison's invention. And neither would there likely have been a General Electric Corporation, which provided Reagan with a job as its corporate spokesman—a job he called "a postgraduate course in political science."

Six weeks a year he toured the country for the billion-dollar company, visiting its 161 factories in twenty-five states, sometimes delivering fifteen speeches a day. Over eight years, the appearances evolved from generic pep talks into desiderata of Reagan's increasingly conservative worldview—fervently anticommunist, fiercely anti–big government, and always delivered with a folksy populist touch. If Reagan the politician had been weaned at the Screen Actors Guild, he came of age on the stump for General Electric.

The GE trips, he said, were "murderously difficult." He spent eighteen-hour days signing autographs until his fingers blistered. He shook hands until he got a bone bruise. He walked forty-six miles of assembly line—twice—and had to cut his laces to get his shoes off when he finished.

What better preparation could a man have for a political campaign? "And I enjoyed every whizzing minute of it."

Reagan watches as a scene is filmed for an episode of *General Electric Theater* in 1954. General Electric had signed him to host the half-hour weekly anthology series, and in 1954 alone he also acted in four of the episodes, once with Nancy. He was paid $125,000 a year for his hosting duties, plus additional salary for each episode in which he acted. He earned still more for his personal appearances around the country as a goodwill ambassador for the company.

Nancy visits Ronnie and his costars Robert Horton and Steve Forrest on the set of MGM's *Prisoner of War* early in 1954. She was one of the few female visitors allowed on the set of the all-male picture, intended as a searing true-to-life indictment of communist torture and brainwashing of Korean War prisoners. The film excited neither critics nor moviegoers, which upset Reagan. "The picture should have done better. Every torture scene and incident was based on actual happenings. . . . Unfortunately, production and release were both rushed."

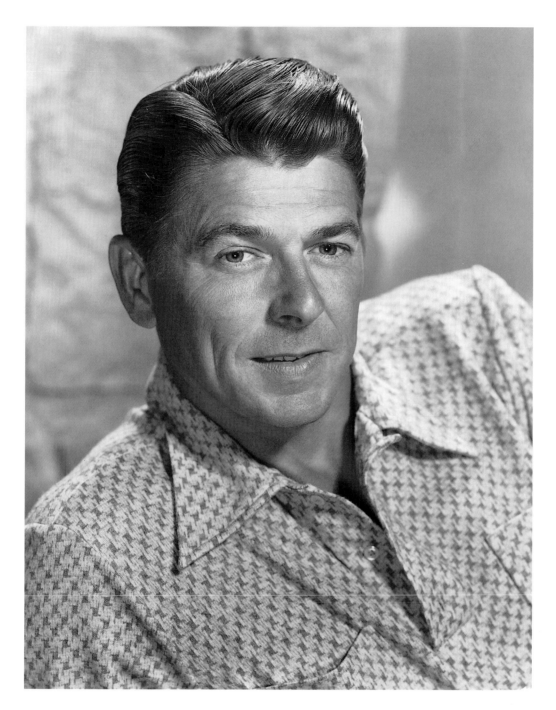

A portrait of Reagan from this period. He was now forty-three, and his advancing years wore well on him. Reagan now earned more than his $175,000 annual salary at Warner Bros. The windfall allowed him and Nancy to buy a 350-acre ranch in the Santa Monica Mountains north of Los Angeles "that we loved." They also built an all-electric "dream home overlooking the Pacific Ocean that GE stuffed with every imaginable electric gadget," Reagan said. Among them were newfangled dimmer switches and a circle of twelve recessed colored lights above the dining-room table.

Cattle Queen of Montana, Reagan's other 1954 film, teamed him with Barbara Stanwyck in a Western notable chiefly for its magnificent Glacier National Park scenery, shot in Technicolor. Stanwyck played a character named Sierra Nevada Jones in what seems now an audition for her 1960s television series *The Big Valley*. Reagan immensely enjoyed the filming. "Somehow working outdoors amid beautiful scenery and much of the time on horseback never has seemed like work to me," Reagan said. "It's like getting paid to play cowboy and Indian."

A suitably lurid poster for Ronald Reagan's last big-screen Western, a hokey 1955 RKO tale of gamblers, gold diggers, and gunslingers in a California mining town.

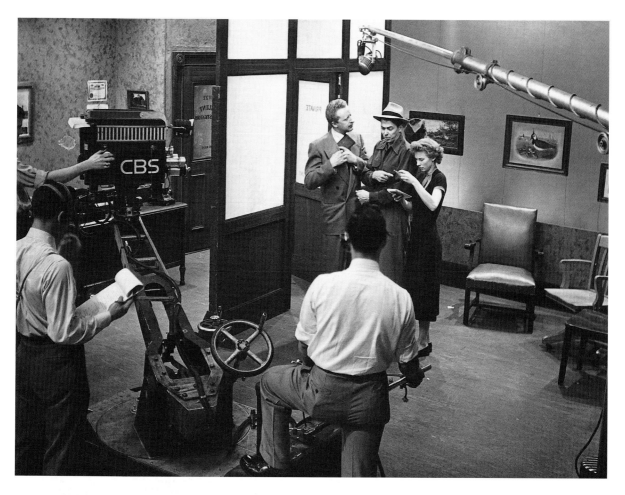

Camera and microphone boom in place, Reagan performs a scene with David White and Cloris Leachman from "Let It Rain," a *General Electric Theater* drama aired on December 18, 1955.

To kick off his third season as host of *General Electric Theater* on September 30, 1956, Reagan starred in "The Professor's Punch," a story in which, the press release accompanying this photo tells us, he "shatters with a bang! (and a broken window!) the stereotyped opinion that all school teachers are timid, repressed individuals."

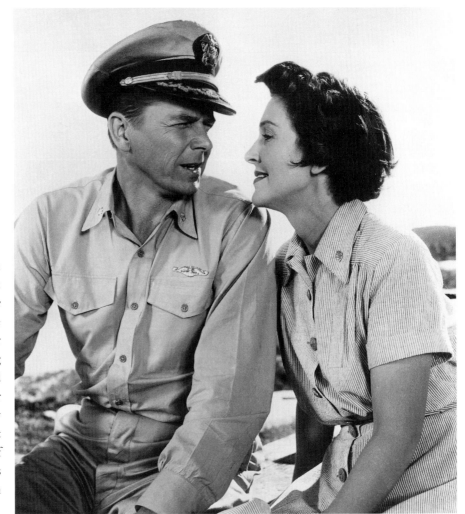

Reagan made no films in 1956 and only one in 1957—*Hellcats of the Navy*, in which he costarred with Nancy for the first time on the big screen. The picture, called by his official biographer Edmund Morris "a turkey so multi-feathered it practically squawked off the screen," would be his last feature film for seven years.

Ronald Reagan Recommends, one of two promotional albums Reagan did with General Electric, was released in 1959 and featured eight Academy Award–winning songs and four others performed by the General Electric Transcription Orchestra. The back of the album cover also featured an advertisement for GE electric ranges—"there's a model for every pocketbook."

Reagan speaks to a meeting of General Electric executives in the late fifties. Since 1954 he had toured 130 GE factories and met more than 200,000 employees. His speeches, delivered to Lions, Kiwanis members, Rotarians, and chambers of commerce as well as GE employees, usually roused his audiences, and his weekly visits via television into the homes of millions of viewers brought him more popularity than he had ever enjoyed as a movie actor. He had become, as *TV Guide* put it, "a living TV symbol as vividly distinct in viewers' minds as the flowing script of the sponsor's initials on its products."

Wealthy and influential men in California had begun to think of Reagan as a possible Republican candidate for senator or governor. Still nominally a Democrat, Reagan now found the GOP more closely attuned to his evolving worldview.

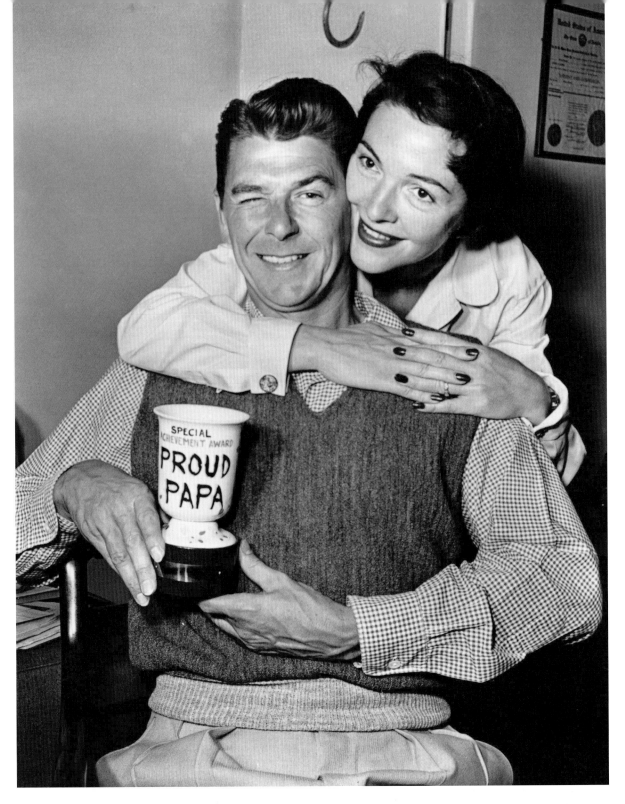

In his *General Electric Theater* dressing room, Nancy presents Ron with a special commemorative cup shortly after the birth of their second child, Ronald Prescott Reagan. The eight-pound, eight-ounce baby was delivered by Cesarean section on May 21, 1958.

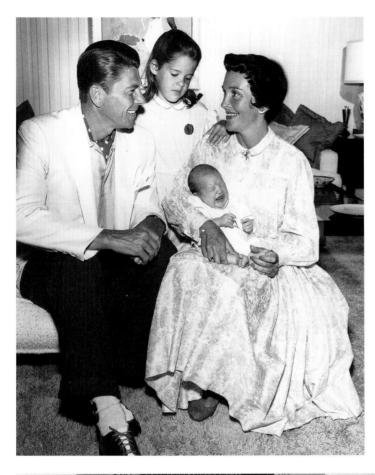

Six-year-old Patti gazes down at her new brother as the Reagan family poses for an at-home portrait in June.

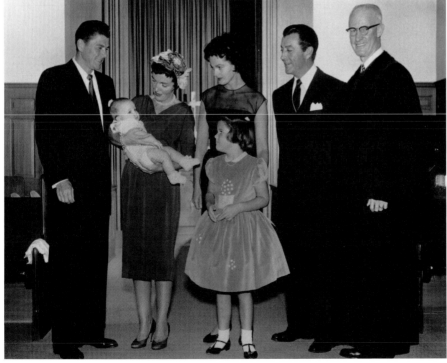

Godparents Robert Taylor and his wife, Ursula, look on with Dr. H. Warren Allen and the Reagan family at the baby's christening in September.

Nancy admires a plaque awarded to Reagan by SAG on November 21, 1960, at the union's annual membership meeting at the Beverly Hilton Hotel. The presentation was made in honor of Reagan's service to the Guild during his seven (sometimes nonconsecutive) terms as its president. Nine months earlier, Reagan, then president, led a six-week strike by the union aimed at achieving a more favorable contract with motion picture producers. The strike was settled when the union sold the producers all television rights to theatrical films made between 1948 and January 31, 1960, in exchange for $2.65 million that was used to set up the Guild's first pension and welfare plan. While a large group within the union felt the settlement was a "sell-out," Reagan considered it the crowning achievement of his SAG career and left the Guild for good on June 6.

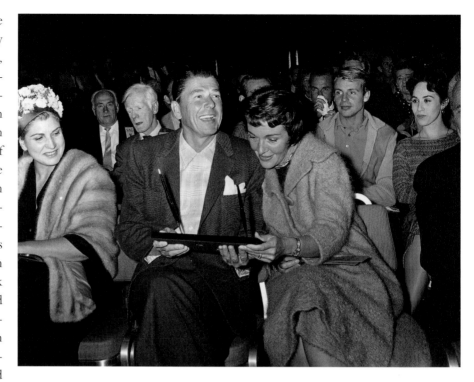

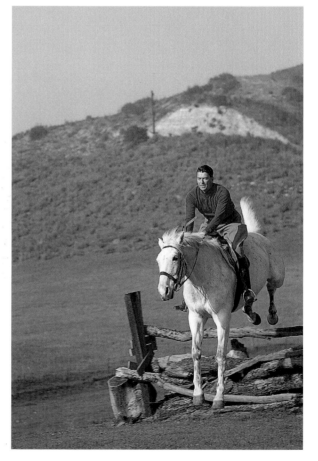

Reagan takes his horse over a hurdle at the Malibu Ranch. "To my mind," Reagan wrote in his memoirs, "nothing compares with the kinship between man and animal you find on the back of a horse. I'm not sure what it is, but there you are, in charge of an animal with more muscles in its neck than you have in your whole body. From the moment the horse takes its first step, every muscle in your own body begins to respond to it. . . . There's no better place for me to think than on a horse."

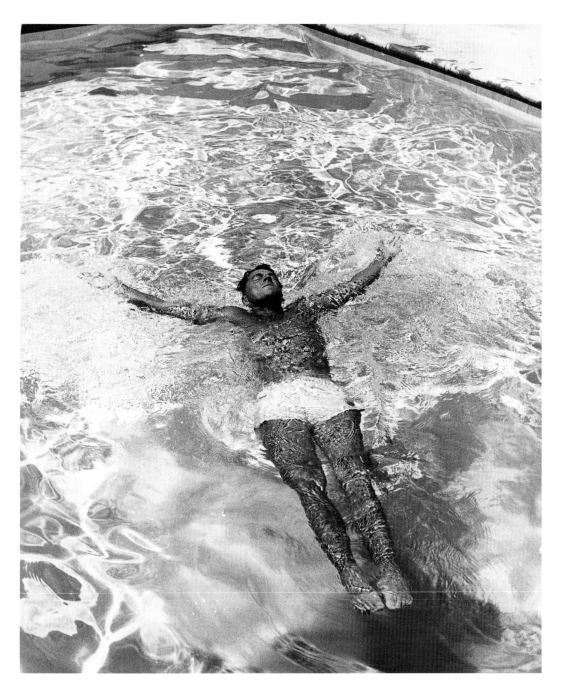

Reagan floats in the pool of his Beverly Hills home in the spring of 1962. He had a lot of time to think after *General Electric Theater* was canceled and he found himself unemployed as both a television host and a corporate spokesman. Money was no longer a major concern—by now the Reagans were very wealthy—but his free time, the death of his mother in July, and the fact that he was now in his early fifties gave Reagan pause to reassess his life. His conservatism and anticommunism were now all-encompassing. He had supported Vice President Richard Nixon in the 1960 election and, in a letter to the candidate, compared his opponent, John F. Kennedy, to Karl Marx. His rich California friends—principally auto dealer Holmes Tuttle—urged him to run for office, but he refused. "The whole idea of entering politics was alien to my thinking."

Reagan relaxes with his son Ronald, nicknamed Skipper, at Coronado Beach, California, in the summer of 1962. That fall, for the first time, Reagan registered as a Republican and made a twenty-eight-minute televised address to Californians in which he laid out his conservative philosophy and urged them to vote for Richard Nixon in his race for governor against the incumbent, Pat Brown. Nixon lost, and vowed that he had held his "last press conference." But Ronald Reagan's political star was on the ascent.

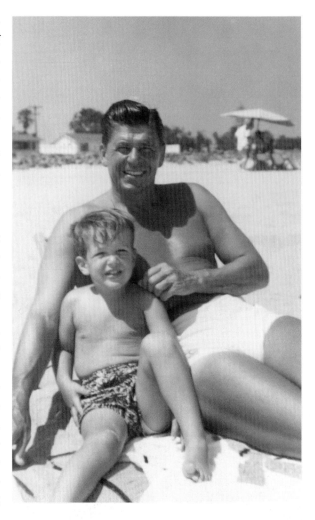

Reagan hoped to return to acting full-time now, but there were no movie offers. He made only two television appearances in 1963 and 1964, on *Wagon Train* and *Kraft Suspense Theater*. He began work on his memoirs in 1963, then finally found a meaty role early in 1964: the brutal crime boss in a film of Ernest Hemingway's short story "The Killers." (Here he's shown with costar Angie Dickinson.) Originally intended for television, the movie, as directed by Don Siegel, proved too violent for the home screen and was released instead to theaters. It would be Ronald Reagan's last film—and the only one in which he played a villain. Critics commended his performance, but a scene in which he smacks his mistress, played by Dickinson, hard across the mouth brought gasps from audiences used to seeing Reagan as the good guy.

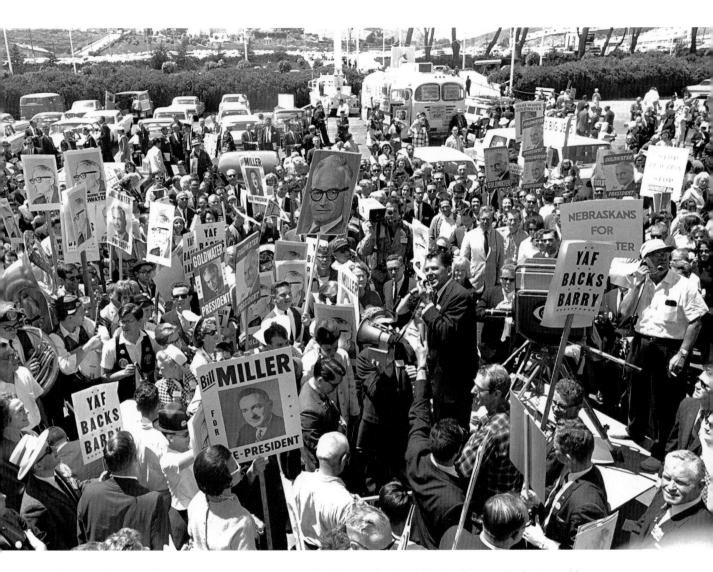

On July 15, 1964, Reagan leads an impromptu "Goldwater for President" rally outside the Republican convention at San Francisco's Cow Palace. Goldwater campaigned against Lyndon Johnson's big government programs, sounding very much like Ronald Reagan. A week before the election, Reagan delivered a nationally televised pro-Goldwater address that distilled everything Reagan had said on the GE circuit for eight years. "We approach a point of no-return, when government becomes so huge and entrenched that we fear the consequences of upheaval and just go along with it. . . . You and I have a rendezvous with destiny. We will preserve for our children this, the last best hope of man on earth, or we will sentence them to take the last step into a thousand years of darkness."

"The Speech," as it reverentially became known among conservatives, instantly turned Reagan into a national political leader. Goldwater lost resoundingly, but *Time* magazine called Reagan's speech one of the high points of the election, and the pressure on him to run for office increased dramatically—especially since George Murphy, the man who had played Reagan's father in *This Is the Army*, had just been elected a U.S. Senator from California.

As a CBS-TV commentator for the Pasadena Tournament of Roses Parade in January 1965, Reagan poses behind Rose Queen Dawn Baker (holding the dark roses) and the runners-up. Later in the year he began a one-season stint as replacement host of a syndicated anthology series, *Death Valley Days,* in which he occasionally acted and did commercials for the sponsor, Borax, sometimes with his daughter Patti. His brother, Neil, an advertising executive who handled the show's sponsor, arranged for him to get the job. It proved his last show business employment.

January 4, 1966: With Nancy at his side, Reagan, one month shy of his fifty-fifth birthday, announces his first candidacy for public office—the governorship of California. He knew it would be a tough race. He would have to win the Republican primary against former San Francisco Mayor George Christopher, and then face Pat Brown, a Democratic incumbent in a state in which Democrats outnumbered Republicans three to two.

As expected, both Christopher and Brown ridiculed Reagan as inexperienced and unfit for such high office. Not only was he merely an actor, they implied, but a mediocre one at that. Reagan attempted to turn the criticism to his advantage: "I am an ordinary citizen with a deep-seated belief that much of what troubles us has been brought about by politicians; and it's high time that more ordinary citizens brought the fresh air of commonsense thinking to bear on these problems."

Reagan had a strong feeling things were going his way on March 10, when, after a press conference across the hall from Pat Brown's offices in Sacramento, a group of the governor's secretaries greeted him and asked for his autograph.

Reagan won the primary in June with 64 percent of the vote and became the Republican nominee for governor of America's second-largest state. "Once I got on the campaign trail, I discovered, a little to my surprise, that I liked campaigning." The enthusiasm of his audiences helped; voters were receptive not only to his citizen-politician persona but also to his conservative politics. California had been roiled for several years by student unrest, race riots, tax increases, burgeoning crime, and exploding welfare rolls. Many white, middle-class residents longed for the halcyon days of the forties and fifties, when the Golden State seemed to offer both unlimited possibilities and unfettered paradise.

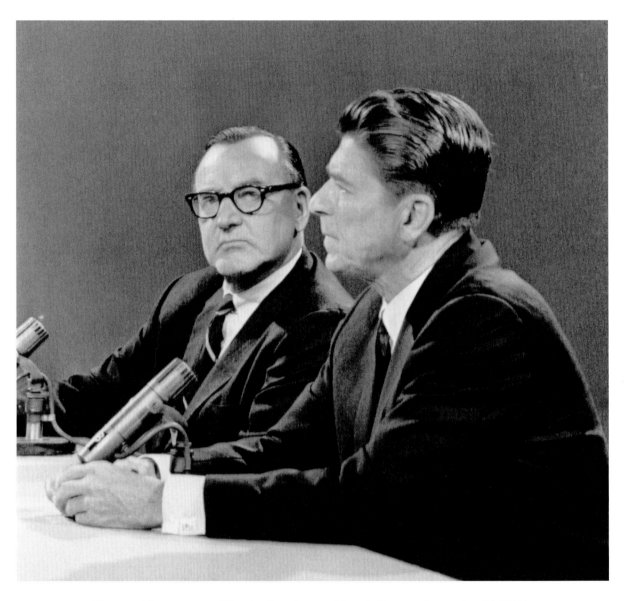

The candidates square off for the first time on *Meet the Press* on September 11. While Reagan lambasted Brown primarily on the issues, the governor attempted to portray Reagan as incompetent and none-too-bright. The image failed to stick as Reagan acquitted himself well in this debate and in "town meeting" exchanges with voters.

Brown then made a tactical error. He ran a television commercial in which he and a group of African-American children watch an old Reagan movie on TV. After a few moments, the governor turned to the children and said, "You know, I'm running against an actor. It was an actor who shot Lincoln."

"When he did that," Reagan recalled, "I knew he knew he was in trouble."

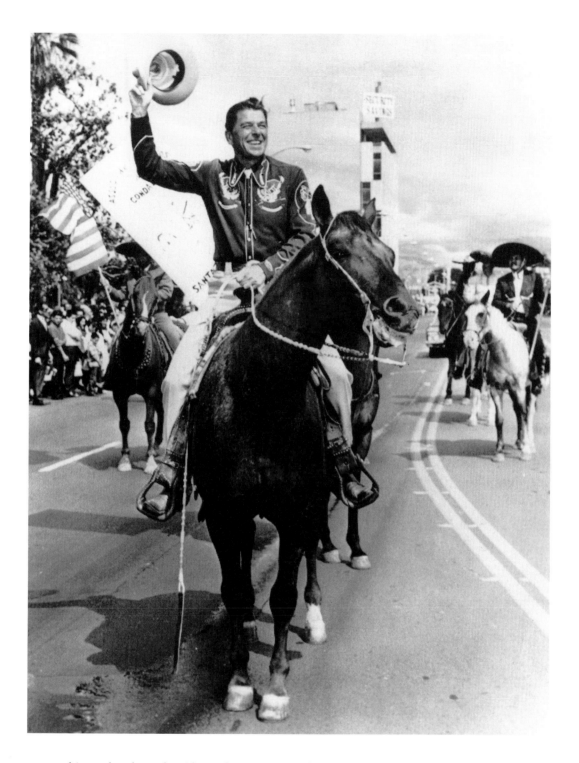

Reagan waves his cowboy hat as he rides in the Mexican Independence Day parade in San Jose on September 19. The Reagan-Brown contest excited much interest and put Reagan on the covers of most of the national newsmagazines. "If Reagan's road show is a hit," *Look* magazine predicted, "the GOP may shift further toward conservatism, and the beglamored man moving into the governor's mansion in Sacramento might well try next for the White House."

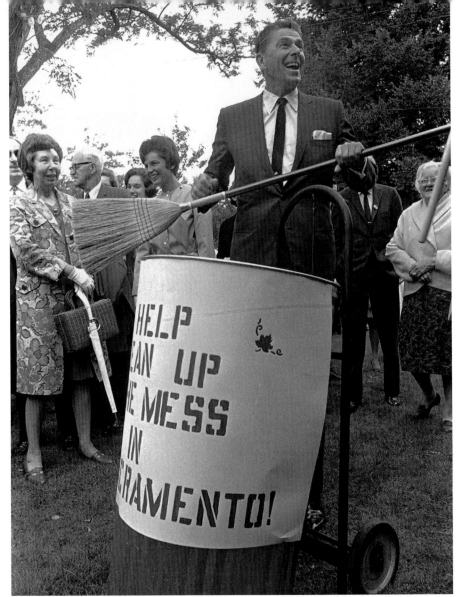

During a campaign stop in St. Helene on September 30, Reagan promises to make a clean sweep of things if elected.

The sleeve of a 33⅓-rpm acetate recording that Reagan sent to hundreds of thousands of voters just before Election Day offering his "commonsense answers to California's problems." His opponent had labeled Reagan's platform—lower taxes, stricter law enforcement, less government regulation, and less welfare—"right-wing extremism." But Reagan sensed that much of his support was coming from middle-of-the-road voters who "were growing resentful of bureaucrats whose first mission in life seemed to be protecting their own jobs by keeping expensive programs alive long after their usefulness had expired."

A RECORD FROM RONALD REAGAN TO ALL CALIFORNIANS

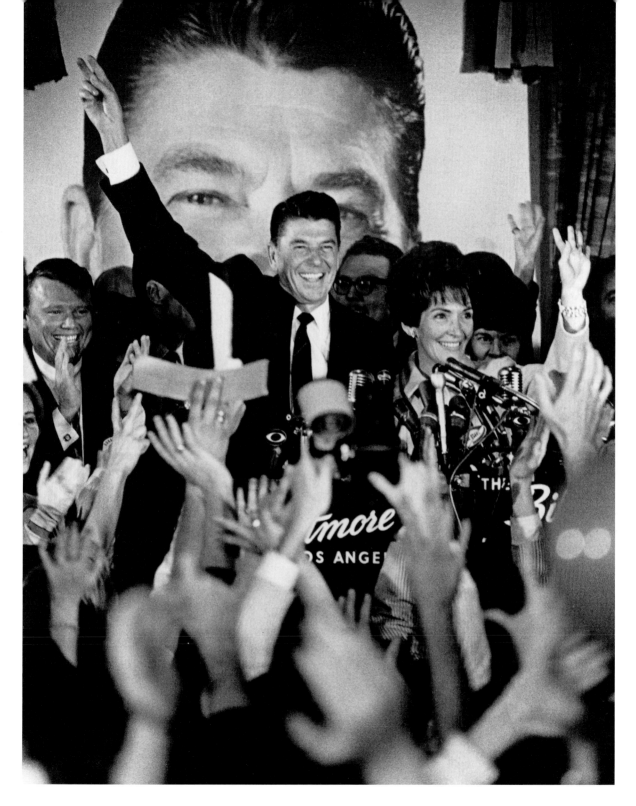

On Election Day, Reagan beat Brown by more than one million votes to become the governor-elect of one of the most complex states in the union. Here he and Nancy acknowledge the cheers of supporters at a victory rally in the Biltmore Hotel in Los Angeles.

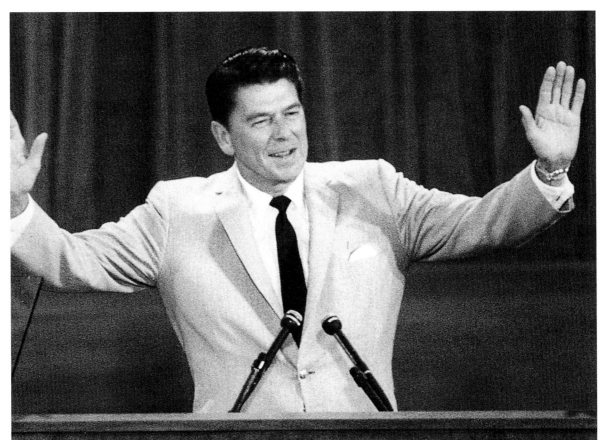

REPUBLICAN

California Governor, Presidential Candidate

He had been the most noncontroversial of actors, a genial second-stringer who didn't play a villain until his fifty-third—and last—film. "No, no, no," his erstwhile studio boss, Jack Warner, said when he heard that Reagan had announced his candidacy for governor of California. "Jimmy Stewart for governor. Ronald Reagan for best friend."

Within weeks of his swearing-in, Reagan became both a hero and a villain as he faced budget catastrophe. His funding cuts seemed righteous to many, coldhearted to many others. His staunch conservatism made him a rising star on the national Republican stage, and his last-minute run for the Presidential nomination in 1968 created genuine excitement at the convention.

Opinions of Reagan polarized further in California even as his popularity burgeoned among conservatives nationally. He made a full-press run for President in 1976, but his timing was off—death for a politician as much as for an actor. Four years later, however, he regained it nicely, helped by national "malaise" and international terrorism. He was rested and well rehearsed. The script was polished. The critics were panning his rival. Most of the audience wanted a new leading man.

OPPOSITE California governor and last-minute presidential candidate Ronald Reagan acknowledges the cheers of delegates at the 1968 Republican National Convention.

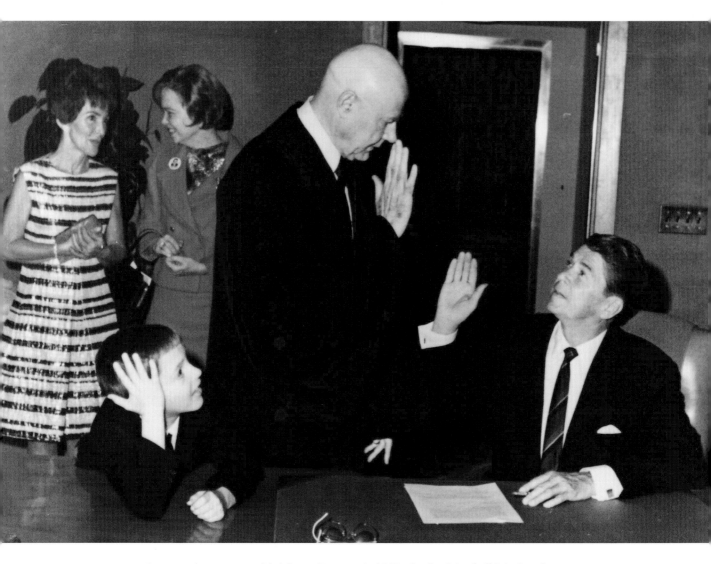

At two minutes past midnight on January 1, 1967, Justice Marshall McComb swears in Ronald Reagan as the thirty-third governor of California in a private ceremony. He had decided on the unusual timing, Reagan said, in order to prevent Governor Brown from making any last-minute judicial appointments. Nancy, wearing a summery plastic dress, chats with Maureen Reagan, now twenty-five, while eight-year-old "Skipper" seems delighted by the whole thing.

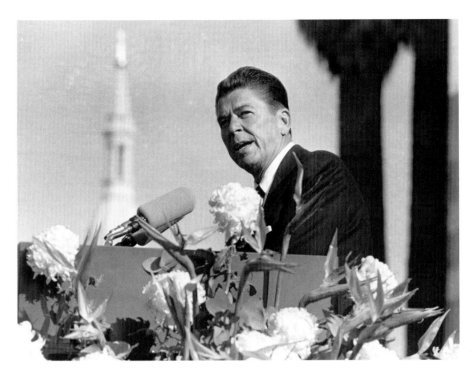

Governor Reagan delivers his inaugural address from the steps of the state capitol in Sacramento on January 5. His daughter Patti, away at boarding school, did not attend. She had wept when she heard that her father had been elected. "The Vietnam War was going on," she explained. "The one place I wanted to be . . . was on the streets of Haight-Ashbury, braiding flowers into my hair. . . . And now my father was governor of California. . . . I just didn't think it was a good image for me, you know?"

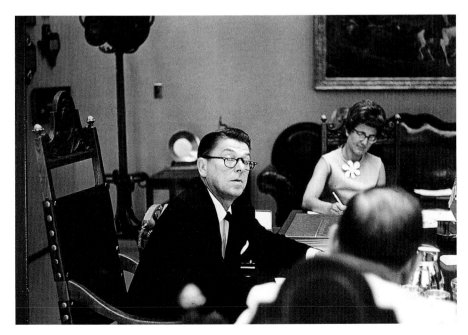

At his first meeting with his staff, Reagan asked, "What do we do now?" He had discovered that there was a $350 million deficit in the state budget, and decided upon an across-the-board 10 percent cut in all government spending, including the budget for the state's highly regarded higher-education system. He announced that he would seek tuition from students for the first time.

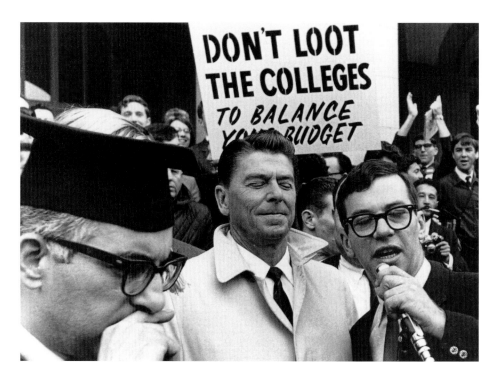

ABOVE On February 11 thousands of teachers and students marched on the capitol to protest, and here Reagan reacts as hecklers interrupt him while he speaks to the crowd.

BELOW Reagan attempts to flip a jelly bean into his mouth—and fails—during a governors' conference in Washington, D.C., on March 17 as Michigan Governor George Romney cheers him on. The beans were presented to Reagan by an admirer after word got out that the governor kept a jar of the candy on his desk at all times.

Shortly after they moved into the nearly one-hundred-year-old governor's mansion in Sacramento, the Reagans realized the building, although a beautiful Queen Anne Victorian, was "a fire trap." They decided to live elsewhere, and on April 1 Reagan helped movers haul the family's belongings into an elegant Tudor home in an exclusive Sacramento suburb. Wealthy friends of the Reagans purchased the property and leased it back to the state.

The Reagans then sold their ranch in Northridge because, Nancy said, as governor her husband "had to take a large cut in income. We simply could not afford the luxury of a ranch." The selling price of $2 million, however, allowed them to purchase over six hundred acres in the Santa Ynez Mountains near Santa Barbara two years later. They named the new spread Rancho del Cielo—Ranch in the Sky.

Buffalo Bills quarterback Jack Kemp discusses football with Reagan in the governor's office on July 3. Reagan had hired Kemp as a special assistant in February, but he was set to return in a week to the Bills training camp for the start of his eleventh season with the NFL club.

The Reagans relax by the pool at their Sacramento home. As First Lady of California, Nancy Reagan got her first taste of bad press when the writer Joan Didion profiled her in June of 1968 for *The Saturday Evening Post*. Expecting a puff piece from that weekly beacon of conservatism, Nancy was shocked to read Didion's description of her as a "put-on" and her smile as "a study in frozen insincerity." Didion went on to conclude that Nancy had the "beginning actress's habit of investing even the most casual lines with a good deal more dramatic expression than is ordinarily called for on a Tuesday morning on Forty-fifth Street in Sacramento."

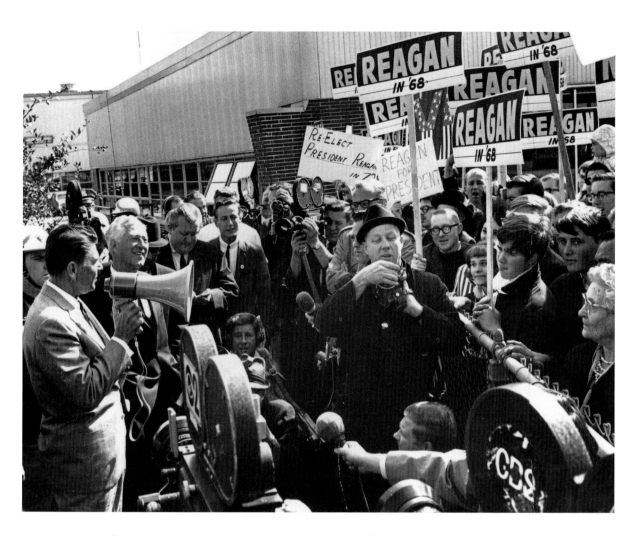

As the governor of a pivotal Electoral College state, Reagan was widely mentioned as a potential candidate for President in 1968. On a visit to Wisconsin on September 30 for a Republican fund-raiser, supporters mobbed him and urged him to make the run. Many conservatives considered Reagan a hero when he refused to raise taxes to cover the deficit, and felt his draconian budget cuts were long overdue.

Others felt that Reagan's cut were injudicious at best, reckless at worst. "It was a disaster," the author Gary Wills felt. "He cut equally into bare subsistence programs, efficiently run ones, and padded ones . . . it punished [both] the needed and the unnecessary." Reagan was picketed and heckled as often as he was cheered. Here protesters from a farm workers' union greet him harshly as he inspects a farm labor housing project near Fresno, California, on March 13, 1968.

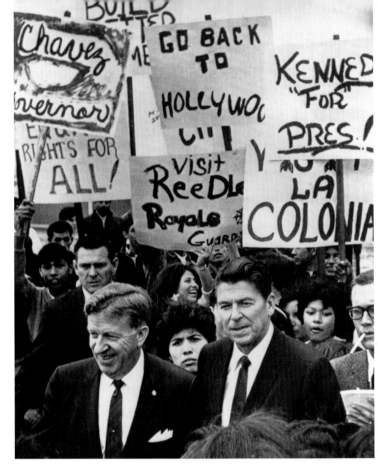

Reagan speaks to reporters in the capitol garage in Sacramento on July 10 after a firebomb attempt on his home. In just over a year in office, Reagan had become the most controversial governor in California's history, inspiring both passionate loyalty and fierce anger.

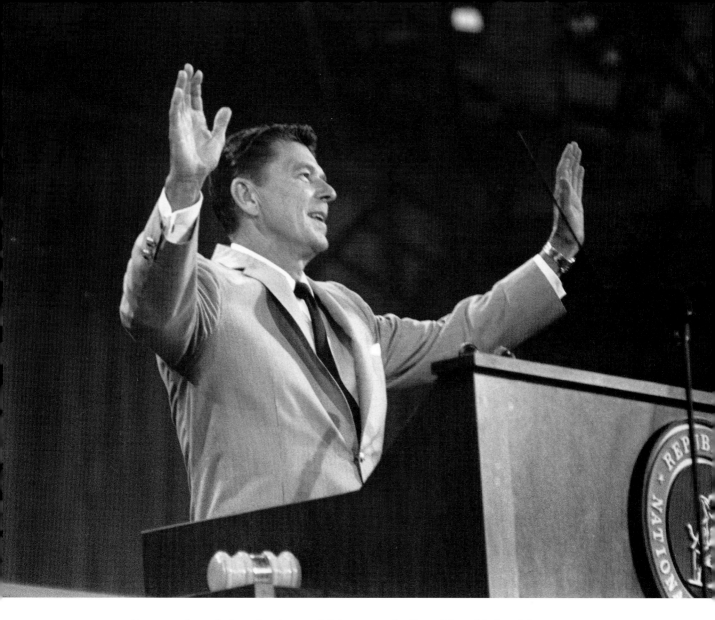

Reagan acknowledges the cheers of delegates at the Republican National Convention in Miami on August 8. As the national election approached, many of Reagan's advisers had urged him to run for President. They felt that after two high-profile defeats, front-runner Richard Nixon had the aura of a loser. They also considered Nixon's main rivals, Governors Nelson Rockefeller of New York and George Romney of Michigan, too liberal. Reagan was skeptical. "Feels kinda premature, fellows," he demurred. "I just don't think I'm ready."

Still, enough support for his candidacy arose at the convention that he allowed his name to be placed in nomination at the last minute. He received a sizable bloc of votes on the first ballot, but trailed both Nixon (who had a large plurality) and Rockefeller. In his address to the convention he asked for Nixon's nomination by acclamation. The delegates cheered him wildly, and it was clear that Ronald Reagan now had a national stage. Nixon was elected President in November over Vice President Hubert Humphrey.

Reagan inspects a home damaged by water and mud in Carpinteria, California, on January 28, 1969. He and his aides were on an all-day flying tour of storm-damaged areas of the state.

A prolonged period of student unrest in California, directed against both the Vietnam War and Reagan's budget cuts, deeply angered Reagan. He spoke his mind, often with sarcasm. One demonstrator, he said, "had a haircut like Tarzan, walked like Jane, and smelled like Cheetah." His response to a student strike at Berkeley in February 1969 was swift and brutal: He sent in county and state police, whose presence precipitated a riot that killed one student. Then he deployed the National Guard, who kept the demonstrators (including several professors) at bay with bayonets for seventeen days.

In this photograph, Reagan waves a finger at a group of University of California professors during a meeting about the National Guard troops at Berkeley on May 21, 1969. The military presence defused the situation, and many credited Reagan for his bold stand. Others likened his actions to Gestapo tactics. Reactions to Ronald Reagan would grow ever more polarized as his political ambitions grew.

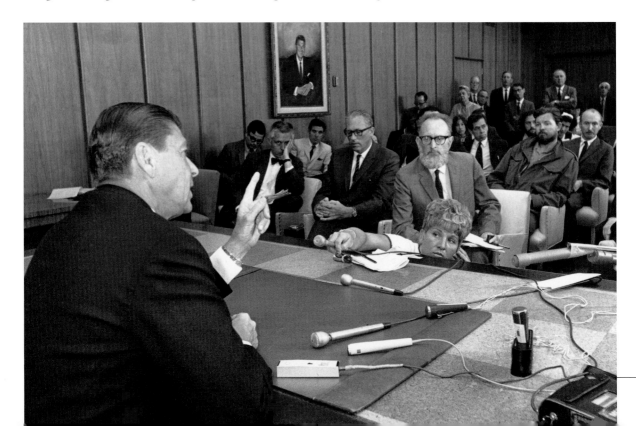

Reagan's displeasure is clear on April 3, 1970, as Irving Hall, a graduate student at the University of California at Riverside, accuses the governor of "expressing a philosophy which has no relevance to power politics in California." Reagan was running for reelection against Jesse Unruh, the speaker of the California assembly. Reagan's refusal to debate led Unruh to camp out in front of Reagan's house (he wasn't home) and follow him to the airport, again without result. Reagan won reelection, but with only 52 percent of the vote, a much-reduced margin.

After his swearing-in on January 5, 1971—at which protesters threw an orange at him—Reagan poses in Sacramento's Municipal Auditorium with Nancy and inaugural gala participants—and old friends—Frank Sinatra, Vicki Carr, Dean Martin, and John Wayne.

Reagan watches grimly as a victim is removed from the rubble of a Veterans Administration hospital in Sylmar following a 6.6 earthquake on February 9. To Reagan's left are Los Angeles County Sheriff Pete Pitchess and Rep. Barry Goldwater Jr. Fifty-one people were killed in the Southern California quake, and property damage exceeded $1 billion.

Reagan reviews notes for an upcoming speech in his home office on November 15, 1971.

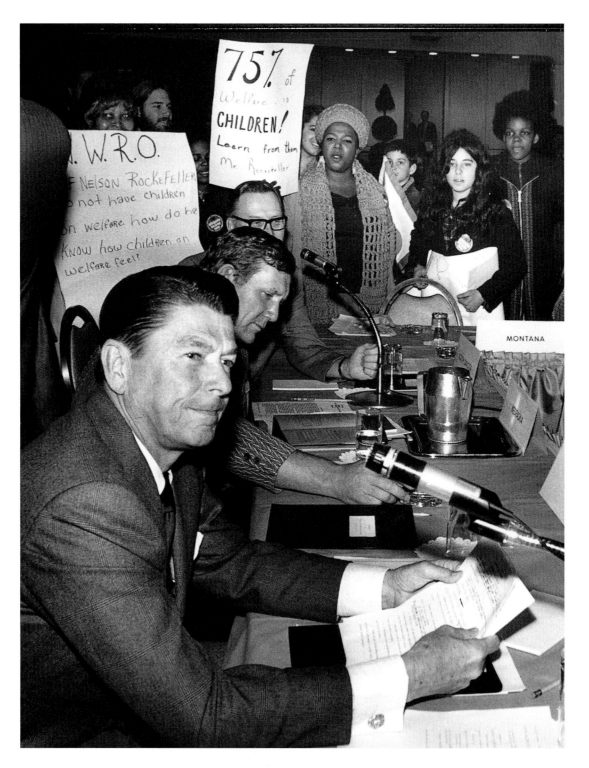

More protests—these against cuts in welfare—at a governors' conference in 1972. Reagan summed up his feelings about welfare thus: "I fear that with the best of intentions, with only a desire to help those less fortunate, we are making a god of government. A Samaritan crossed over the road and helped the beaten pilgrim himself—he did not report the case to the nearest welfare agency."

Governor Reagan rears back to throw out the first ball of game three of the 1972 World Series at Oakland on October 18. Athletics owner Charles O. Finley is at far right. The California team went on to defeat the Cincinnati Reds, four games to three, to win the world championship.

Ronald Reagan left office as governor of California on January 2, 1975, far less popular than he had been when he took on the job. Reagan's tenure had been tumultuous and controversial. The voters elected as his successor Jerry Brown, the ultraliberal son of the man Reagan had ousted from office in 1966. But his tax and budget cuts and his staunch stands against campus unrest had made him a hero to conservatives nationally.

As Reagan toured the country over the next two years giving speeches to conservative groups, it became clear to him that many in his party wanted him to run for President in 1976. He was said to consider himself the heir apparent to Nixon, who had been reelected in 1972. But history intervened when Nixon resigned the presidency rather than face certain impeachment and conviction for Watergate crimes. His replacement, Gerald Ford, was eligible to run for election in his own right as an incumbent in 1976. Still, there were rumblings among conservatives that Ford was too moderate and that Reagan should run against him. Reagan kept his own counsel, but continued to travel the country collecting political IOUs just in case.

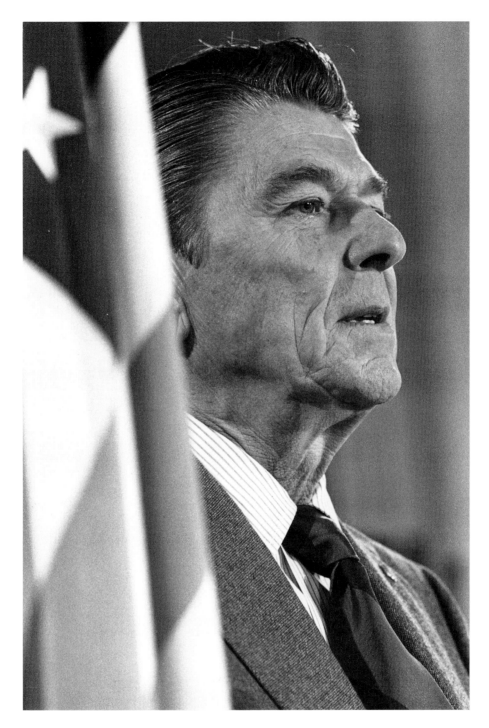

November 20, 1975: Ronald Reagan announces his intention to challenge President Ford for the 1976 Republican nomination. Although generally regarded as a decent man, Gerald Ford had not been a successful President. His pardon of Richard Nixon had been unpopular, and the country's economic "stagflation" further hurt his standing with the voters. By the end of 1975 he seemed a poor prospect for reelection, and Reagan, now nearly sixty-five, decided to take a huge risk and challenge an incumbent President of his own party. "Otherwise," he told his family, "I'd feel like the guy who always sat on the bench and never got into the game."

A Secret Service agent keeps a wary lookout as Reagan gives a speech in New Hampshire, site of the first presidential primary of 1976.

LEFT In the January snows of the Granite State, Reagan urges a young skier to ask her parents to vote for him. His campaign themes reflected his conservative views and touted his record in "turning California around." He did not directly attack Ford, believing, as he did, in the "eleventh commandment": "Thou shalt not speak ill of another Republican."

BELOW Nancy gives her husband what will become known as the "Nancy Reagan gaze" as he concedes defeat in the New Hampshire primary. Although the results were close in New Hampshire, Reagan lost the next four primaries as well. With his campaign nearly broke and polls showing him ten points behind Ford in the next state, North Carolina, all of Reagan's aides, including Nancy, urged him to quit. Instead he launched a strong attack against Ford's foreign policy. "Under [Secretary of State Henry] Kissinger and Ford," he said, "this nation has become number two in military power in a world where it's dangerous—if not fatal—to be second best."

Reagan then took the North Carolina vote by ten percentage points and went on to win the next five primaries, including Texas and Indiana.

Reagan also won the California primary on June 8, and told the press, "I believe that there is a very great possibility—if not probability—that I could go to the convention with enough delegates in advance to win on the first ballot." When he arrived in Kansas City for the convention, his supporters gave him a tumultuous welcome, and in an attempt to give his campaign extra impetus, Reagan announced that he had chosen moderate Pennsylvania Senator Richard Schweiker as his running mate. The move wasn't enough to put him over the top in the delegate count, and he lost the nomination to Ford in a close finish. Here, he and Schweiker meet the press after the final tallies were announced.

Still, Ronald Reagan had come very close to toppling an incumbent President, and Ford acknowledged his opponent's political clout by offering him the vice presidency. Reagan declined. "I just wasn't interested in being Vice President," he later said.

After Ford delivered his acceptance speech the next day, he invited Reagan to address the delegates, and his appearance caused a sensation. Afterward Reagan posed for a "unity photograph" with Ford, but his endorsement wasn't enough to propel the Gerald Ford–Bob Dole ticket to victory. The Democratic nominee, Georgia Governor Jimmy Carter, won election as the thirty-ninth President on November 2.

Nancy considered her husband's campaign for President in 1976 "a glorious defeat," and as Reagan chopped wood at Rancho del Cielo early in 1977, few doubted that he would be the front-runner for the Republican nomination in 1980. He spent the bulk of the next three years traveling the country, making speeches, writing newspaper columns, collecting more political IOUs—and planning the campaign that would likely be his last chance to realize his dream: "I wanted to be President."

New York City, November 13, 1979: Maureen, Nancy, and Patti join Reagan after his announcement that he will seek the Republican presidential nomination to oppose President Carter in 1980. Carter's popularity had waned in the wake of runaway inflation and the taking of fifty-two American hostages by religious fundamentalists in Iran. America seemed caught in what Carter termed a "malaise." In this atmosphere, Barry Goldwater's brand of conservatism—a call for lower taxes, less government, and more military power to fight communism and extremists abroad—had gained in popularity. Moreover, these policies seemed less harsh and threatening to many when espoused by the genial Reagan. He and his supporters felt that surely his time had come, and they pointed to the recent passage of Proposition 13 in California, which dramatically cut back the state's property taxes. "There was a rebellion out there," Reagan said, "and it was growing like wildfire."

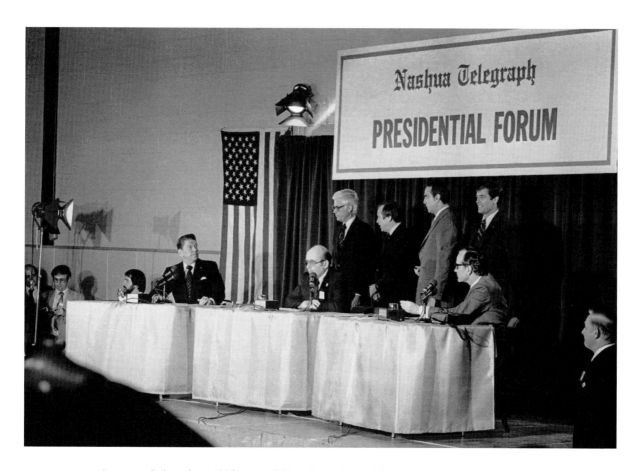

It seemed that the wildfire would be doused quickly when Reagan lost the Iowa caucuses to former CIA Director George Bush, who called Reagan's fiscal theories "voodoo economics." But a debate on February 23, 1980, sponsored by the Nashua *Telegraph,* turned the tide for Reagan. He and Bush had agreed that the debate would be just between them, but the other candidates objected and argued that the *Telegraph*'s sponsorship amounted to an illegal contribution to the Reagan and Bush campaigns. Bush refused to split the costs, so Reagan agreed to pay the entire bill.

Shortly before the debate, Reagan changed his mind—he wanted the other candidates included to prevent the perception that Bush was his main rival. When Bob Dole, Howard Baker, Phillip Crane, and John Anderson showed up, Bush objected. Reagan sat down and tried to explain why he considered it unfair to exclude the other candidates, but the editor of the *Telegraph,* John Breen, told the sound man, "Turn Mr. Reagan's microphone off!"

Reagan turned to him angrily and said, "I'm *paying* for this microphone!" The force and seeming righteousness of his argument gained him many more admirers across the country. He won the primary with 51 percent of the vote to Bush's 27 percent, and went on to triumph in twenty-eight of the next thirty-two contests. After three attempts over twelve years, Ronald Reagan was about to be nominated for President of the United States.

On July 16, the Reagans acknowledge the cheers of delegates after Reagan's nomination in Detroit.

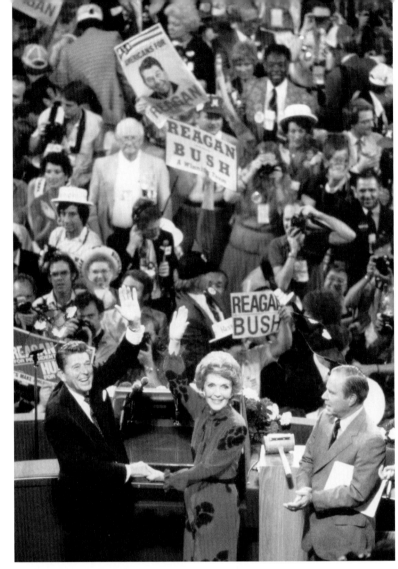

The next day, Reagan delivered an acceptance speech in which he promised to cut taxes, reduce the federal bureaucracy, strengthen America's defenses, and restore the values of family, hard work, and patriotism that had made America great. At the end of the address he said, "I've been a little afraid to suggest what I'm going to suggest, what I'm going to say. I'm more afraid not to. Can we begin our crusade together in a moment of silent prayer?" The entire convention rose, bowed their heads, and remained silent for a minute until Reagan concluded his speech with a rousing, "God bless America!"

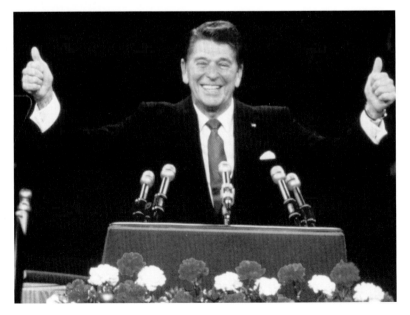

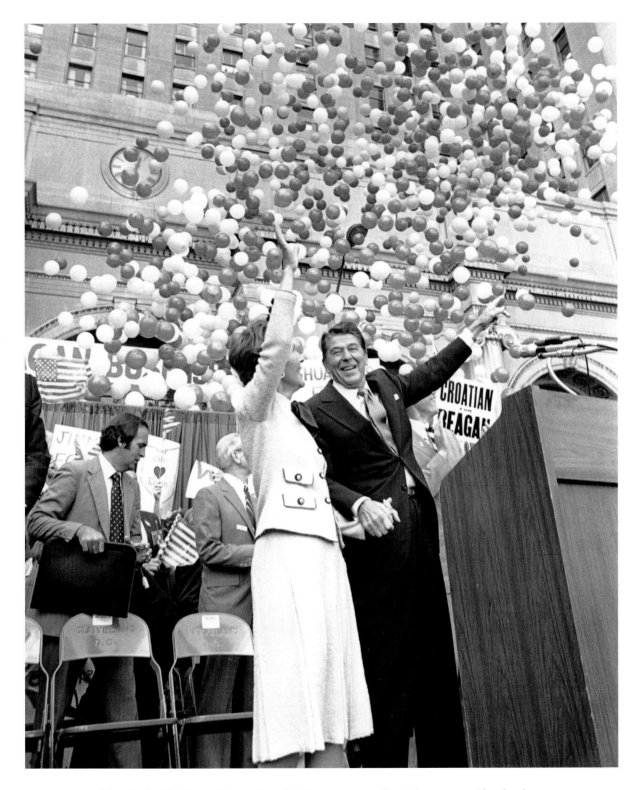

Hundreds of balloons descend on the Reagans at a rally in downtown Cleveland on September 10. Reagan had just given a speech criticizing the Carter administration's energy policy.

An exhausted Nancy sleeps on the Reagan campaign plane in October. She zealously defended her husband against each and every attack. She insisted on appearing in a television ad in which she responded to Carter's campaign charges, and told reporters, "Carter is waging a vicious and cruel campaign. I'm offended when he tries to portray my husband as a warmonger, as a man who would throw the elderly out on the street and cut off their Social Security. . . . I deeply, deeply resent it. . . ."

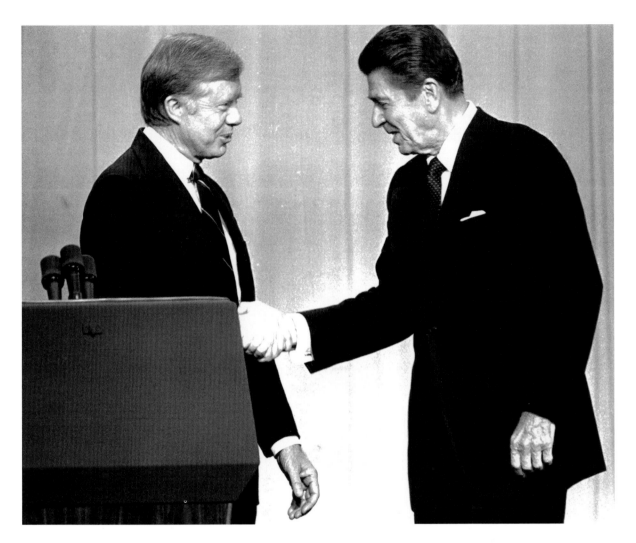

The candidates shake hands before their October 28 debate in Cleveland. Most Americans had never seen Ronald Reagan up close for any length of time as a politician, and the Carter campaign had been successful in painting him as barely competent to be President, hard-hearted and dangerously bellicose. In this debate he was able to alleviate all three concerns. He not only seemed warm and genial, he held his own on debate points. When Carter accused him of opposing Medicare, Reagan said, "There you go again, Mr. President." It became a catchphrase that neatly diminished most of Carter's accusations against him.

Reagan's most effective moment in the debate came when he asked Americans, "Are you better off today than you were four years ago?" The answer for most of them was no. What had been a close race suddenly shifted in Reagan's favor.

On the eve of the election, Reagan makes his final appeal for votes at a rally in Cincinnati, Ohio. Polls showed him with a four-percentage point lead over Carter, within the margin of error for most surveys.

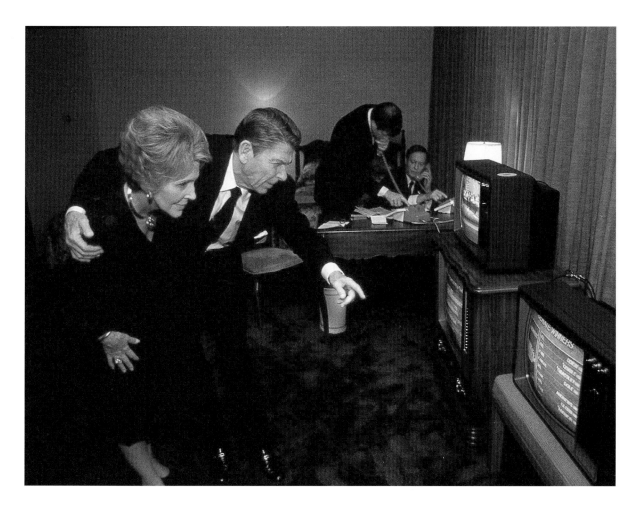

On November 4, at the Century Plaza Hotel in Los Angeles, the Reagans joyously watch the election returns on television. Reagan knew he'd won the presidency earlier, when President Carter called to concede and congratulate him, even though the West Coast polls wouldn't close for two hours. Nancy had called her husband out of the shower to take the call. "Standing in the bathroom with a towel wrapped around me, my hair dripping with water, I had just learned I was going to be the fortieth President of the United States."

Later Nancy burbled to reporters, "We never thought it would be as big as this!" Reagan won 55 percent of the popular vote and a huge Electoral College majority of 489 to 49.

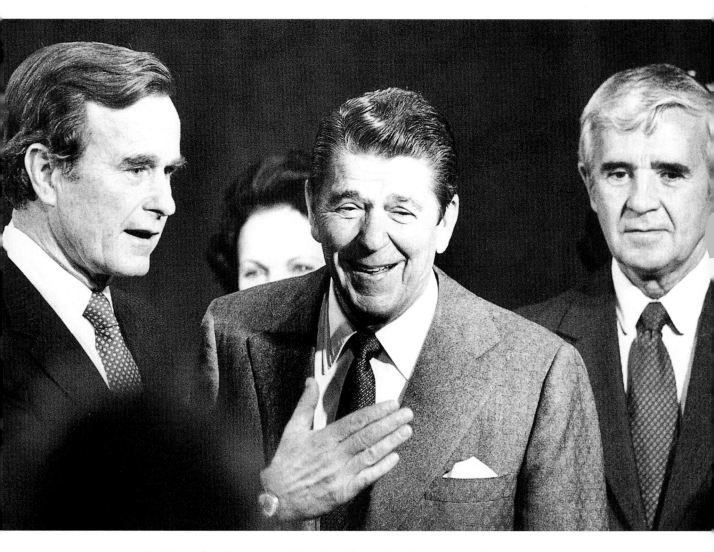

President–elect Reagan and Vice President–elect Bush beam after a press confer-
ence at which they announced the members of their transition team. Among them
were Anne Armstrong (partially hidden behind Reagan) and Paul Laxalt, right.

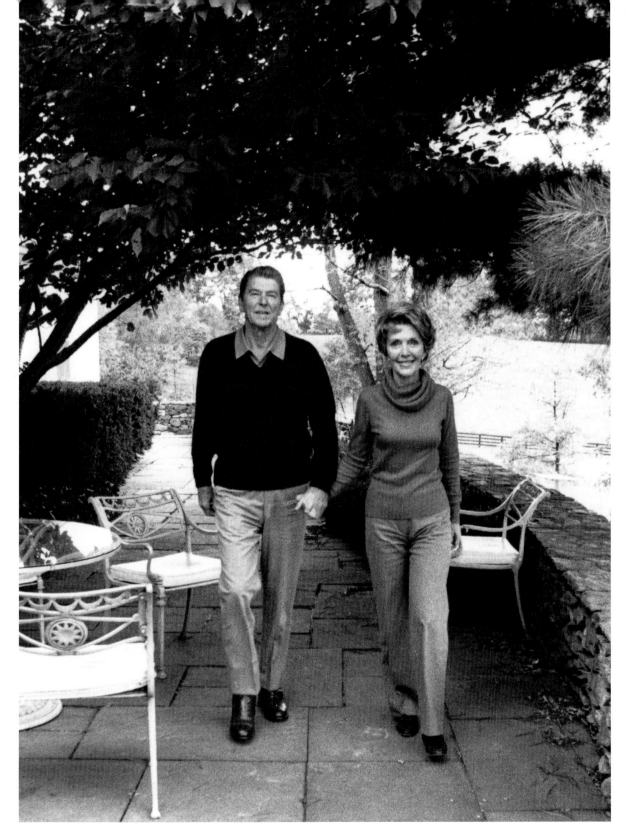

The President-elect and the future First Lady prepare for their new lives at a rented home in Virginia, December 1980.

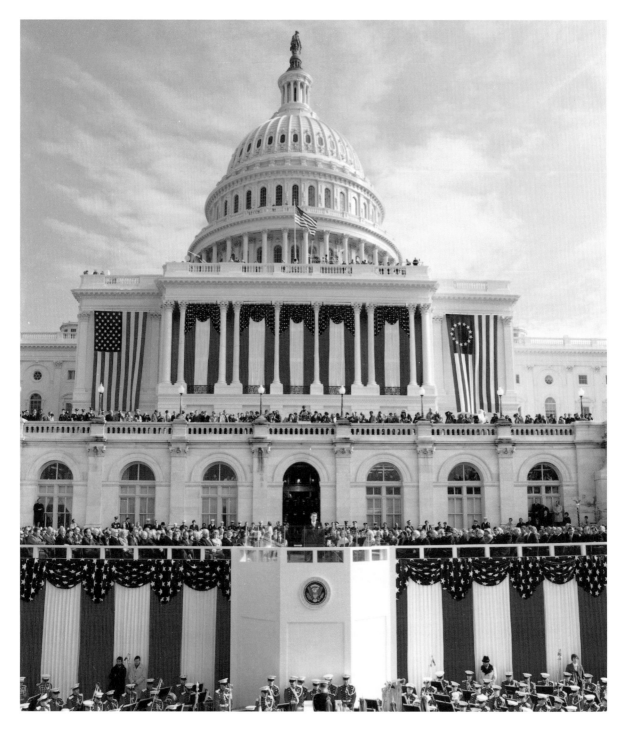

Ronald Wilson Reagan, just sworn in as the fortieth President of the United States, delivers his inaugural address on January 20, 1981.

Mr. President

By any standard, his life was now the apotheosis of the American Dream. He had risen from small-town poverty to success on such a scale—and in so many different endeavors—that it defied credulity. As his son Michael watched him dress in white tie and tails for the ten inaugural balls scheduled for the evening of his inauguration, Ronald Reagan danced a little jig and delightedly, almost disbelievingly, cried, *"I'm the President of the United States!"*

The real world came back into focus with the *pop pop pop* of bullets, but just like in the movies, the hero was only wounded. He returned weaker of body but stronger of spirit, more eager than ever to cut taxes, government payrolls, welfare subsidies, and budgets of all stripes. As he had in California, he polarized America as had no President since Abraham Lincoln.

A fiscal theory took his name—Reaganomics. At first it seemed to be a failure as the economy soured further and his popularity plummeted. Then, as had happened so often before in Ronald Reagan's life, his fortunes turned around. The economy picked up, workers went back to work, and he told his countrymen, "It's morning again in America." Now most of them were eager for an encore.

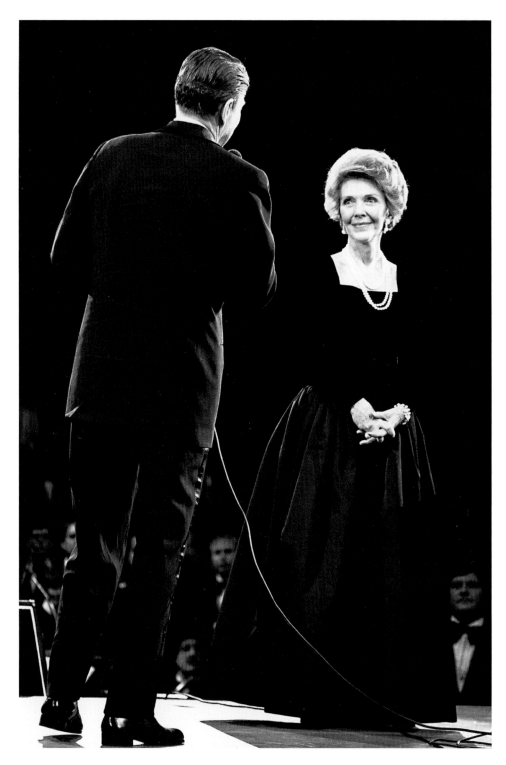

President-elect Reagan pays tribute to his First Lady at the pre-inaugural gala at the Capitol Centre in Maryland on January 19. "You look very pretty tonight," he told her, then turned to the audience. "I think she looks gorgeous, as a matter of fact." The two-and-a-half-hour gala, produced and hosted by Frank Sinatra, raised over half of the $10 million cost of Reagan's inaugural—the most expensive in history.

Before the gala, Reagan and Nancy—still in her housecoat—had celebrated her father, Loyal Davis's, birthday at Blair House, the vice presidential residence.

ABOVE Ronald Reagan recites the oath of office after Chief Justice Warren Burger on the west steps of the Capitol Building. Looking on, left to right, are Vice President and Mrs. George Bush, Ron Reagan and his wife, Doria, Nancy Reagan, Senator Mark Hatfield, former President and Mrs. Jimmy Carter, and former Vice President and Mrs. Walter Mondale.

In his inaugural address, Reagan summed up the credo he had espoused since his days as a General Electric spokesman and that had brought him from former movie star to the most powerful position in the world: "Government is not the solution to our problem," he said. "Government is the problem."

BELOW On the inaugural parade reviewing stand, the new President goes out of his way to greet an old friend sitting beyond the inner circle. Included among the dozens of bands in the parade were the Dixon High School Marching Dukes.

Moments after the inaugural parade concluded, Reagan went straight to the Oval Office to try out his new desk and sign a few documents as his press secretary, James Brady, checked some notes.

Earlier, at the traditional inaugural luncheon in the Capitol Building, Reagan had announced that Iran had released the fifty-two American hostages it had held for over a year. Although the negotiations had been conducted by the Carter administration, many saw Reagan's announcement as symbolic of the new hope and optimism his presidency promised.

RIGHT At his first cabinet meeting the following morning, Reagan breaks up after he's presented with a laminated blowup of his Van Heusen shirt advertisement of 1953.

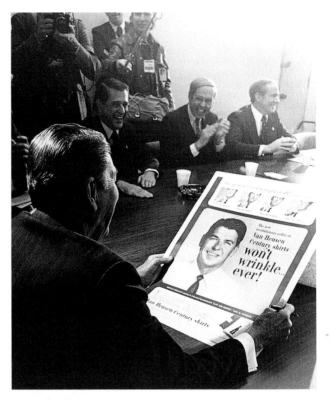

BELOW On February 5, Reagan made a televised address to the nation about the state of America's economy. Using a dollar bill and some small coins to illustrate the impact of inflation, he told the country that "we're in the worst economic mess since the Great Depression." He wanted, he said, to begin to solve the problems just as he had in California: by lowering taxes, reducing wasteful government spending, and cutting the budget. But, he added, "our spending cuts will not be at the expense of the truly needy."

ABOVE The day after his televised address, the President cuts in on Frank Sinatra—who had danced with Nancy quite long enough, thank you—at a gala White House soiree to celebrate Reagan's seventieth birthday. In her book *Nancy Reagan*, Kitty Kelly intimated that Nancy and Frank later conducted an affair inside the White House. The only evidence she offered for the assertion was that Sinatra and the First Lady occasionally enjoyed private luncheons together.

LEFT At Rancho del Cielo on February 14, "Ronnie" gives "Mommy" a Valentine's Day box of chocolates. "My parents," their daughter Patti has said, "have about as close a relationship as I've ever seen anyone have. They really sort of complete each other."

The President welcomes British Prime Minister Margaret Thatcher during a ceremony on the south lawn of the White House on February 26. An equally conservative leader, Thatcher forged an unusually close political and personal relationship with the Reagans.

At a reception to honor Thatcher that evening, their old friend Bob Hope cracks up the first couple with one of his patented dry quips.

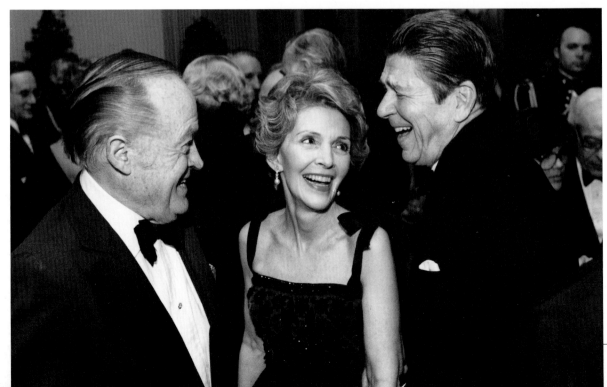

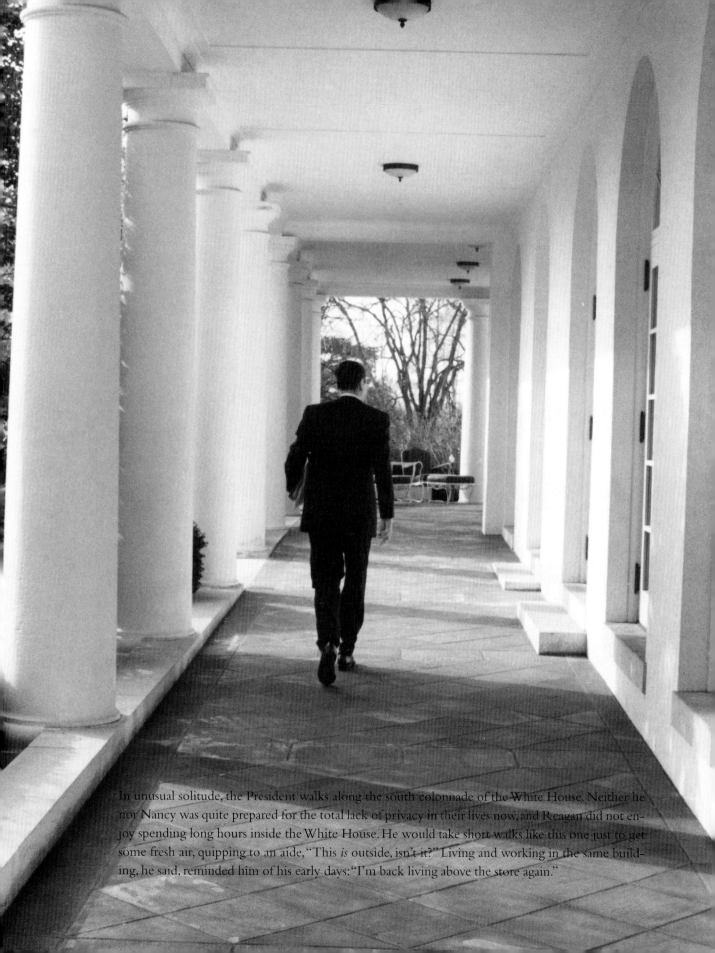

In unusual solitude, the President walks along the south colonnade of the White House. Neither he nor Nancy was quite prepared for the total lack of privacy in their lives now, and Reagan did not enjoy spending long hours inside the White House. He would take short walks like this one just to get some fresh air, quipping to an aide, "This *is* outside, isn't it?" Living and working in the same building, he said, reminded him of his early days: "I'm back living above the store again."

On March 15, Nancy Reagan gives her son a congratulatory hug after his debut as a dancer with the Joffrey Ballet, as the President beams. Ron's interest in ballet prompted a reporter to ask Reagan whether his son was homosexual. "He's all man, we made sure of that," the President replied. Reagan had been supportive of Ron's interest in dance; he asked his friend Gene Kelly for advice on where Ron should go to school, and paid his living expenses while he studied on scholarship.

After this performance, one of the President's aides told Ron that his father had asked, "I wonder if he knows how proud I am of him?" Ron replied, "It would have been nice to hear it from him."

Four days later Nancy again congratulates a performer, this time Elizabeth Taylor after a performance of *The Little Foxes* in Washington, D.C. The President reaches out a hand to the playwright, Lillian Hellmann, who is flanked by other cast members Maureen Stapleton and Austin Pendleton.

Later Reagan recalled that the following week he and Nancy attended a benefit at Ford's Theater in D.C., and when he saw the flag-draped box in which President Lincoln had been sitting when he was shot, the thought of his own safety had crossed his mind. "Even with all the protection in the world, I'd thought, it was probably impossible to guarantee completely the safety of the President."

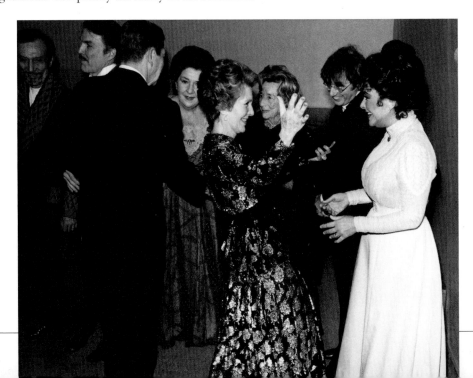

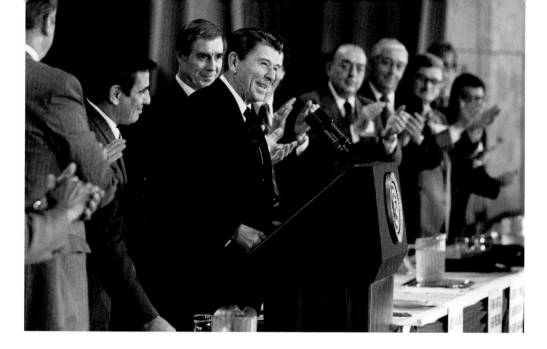

On the afternoon of March 30, President Reagan, who recalled that he was wearing a brand-new blue suit that day, delivered a ten-minute speech at the Washington Hilton Hotel to the Building Trades Council of the AFL-CIO. His call for support of his budget cuts "was not riotously received" by the traditionally Democratic union, "but at least they gave me polite applause."

Outside the hotel, the presidential motorcade awaited, along with a small crowd of onlookers and reporters. It was 2:25. As Reagan walked toward his limousine, he waved in response to cheers from the crowd. Behind him walked Secret Service Agent Jerry Parr, wearing a raincoat, and press secretary James Brady. Ahead of Reagan were one of his aides, Michael Deaver, an unidentified D.C. policeman, D.C. policeman Thomas Delahanty, and Secret Service Agent Timothy McCarthy.

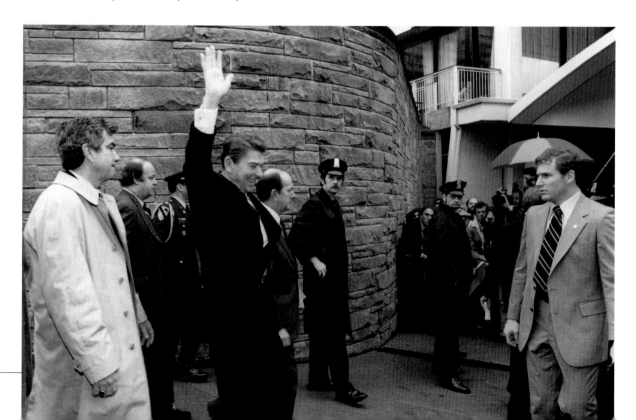

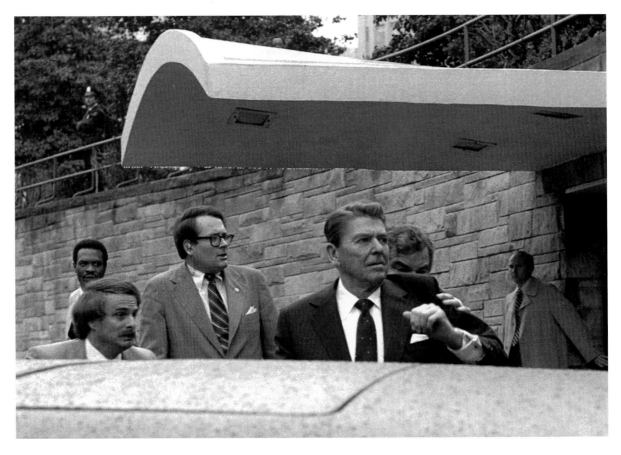

As the President approached the open door of the car, he heard "what sounded like two or three firecrackers over to my left—just a small fluttering sound, *pop pop pop*. I turned and said, 'What the hell's that?'" *That* was John Hinckley firing six scattershot bullets at him. Agent Parr grabbed Reagan around the waist and pushed him violently into the car, shouting to the driver to "haul ass" out of there and back to the White House. Behind them, James Brady, Officer Delahanty, and Agent McCarthy lay seriously wounded.

Reagan's face hit the top of the armrest across the back of the limousine, and Parr tumbled in on top of him. "When he landed," Reagan recalled, "I felt a pain in my upper back that was unbelievable. It was the most excruciating pain I had ever felt."

"Jerry," Reagan moaned, "get off, I think you've broken one of my ribs." When both men got up and into their seats, Parr saw blood bubbling out of the President's mouth and ordered the driver to go to George Washington University Hospital. Reagan said that he was having so much trouble breathing, he thought the rib must have punctured a lung.

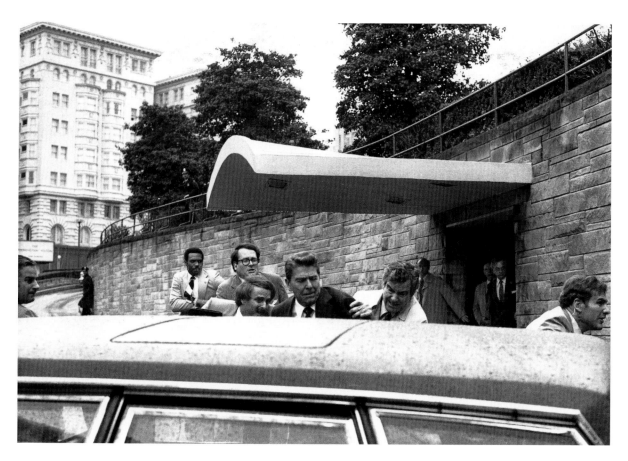

In the three and a half minutes it took the car to reach the hospital, Reagan had grown ashen and weak, but he insisted on walking on his own into the hospital. Just beyond its doors, he collapsed. What no one realized—including his doctors at first—was that one of Hinckley's "Devastator" bullets, designed to explode on impact for maximum killing efficiency, had hit the limousine, and a fragment of it, thin and bladelike, had ricocheted into Reagan's chest, missing his aorta by a fraction of an inch.

Over the next two hours Reagan underwent open-chest surgery to remove the fragment, which had lodged in one of his lungs and collapsed it. "It took me forty minutes to get through that chest," his doctor recalled. "I've never in my life seen a chest like that on a man his age."

Reagan's official biographer, Edmund Morris, has written, "We had no idea how close the President actually came to dying that afternoon. The fact that he lost 3,500 cubic centimeters of blood—well over half his total supply—was suppressed for a long time."

Nancy and the President smile broadly in his hospital room on April 3. The photograph was meant to reassure the world that Reagan was on his way to recovery, as were the examples of his humor during the ordeal. "Please tell me you're Republicans," he said to the doctors just before his surgery. "Does Nancy know about us?" he asked a nurse holding his hand. And, after the surgery, unable to speak because of tubes in his nose and down his throat, he scribbled, *I'd like to do this scene again—starting at the hotel.*

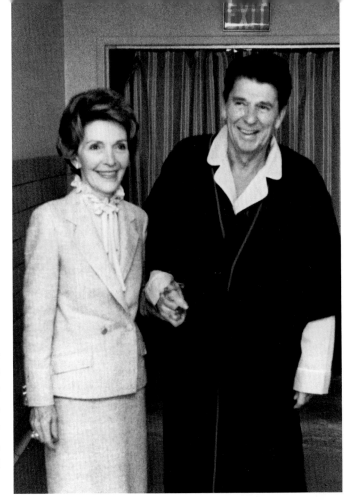

Wan and drawn, the recovering President is cheered by a huge get-well card from the White House staff on April 8. He received a similar card from the citizens of Dixon, Illinois. Reagan had developed a fever and coughed up blood again on the fourth, but he responded to antibiotics, and his general good health helped him make a swift recovery.

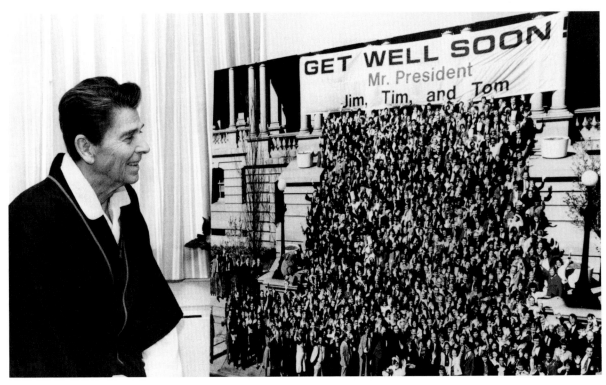

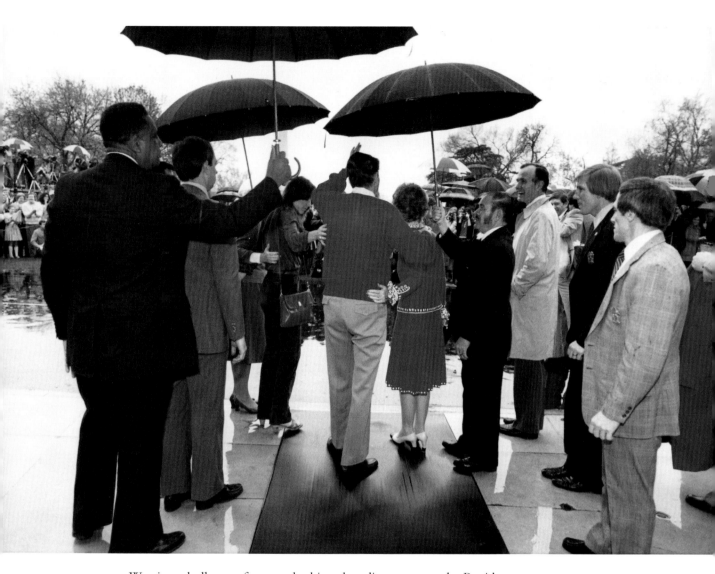

Wearing a bulletproof vest under his red cardigan sweater, the President waves to a crowd of White House staffers and their families as he returns home on April 11. Nancy and Vice President Bush look on. Devastated at having nearly lost her beloved Ronnie, Nancy told the Secret Service that he must never be put in a position where such a thing could happen again. No longer would the President wade into crowds to shake hands in unsecured areas, or even stop to answer reporters' impromptu questions. As ABC White House correspondent Sam Donaldson recalled, "It began to close down the presidency even more from the standpoint of the access to the average citizen."

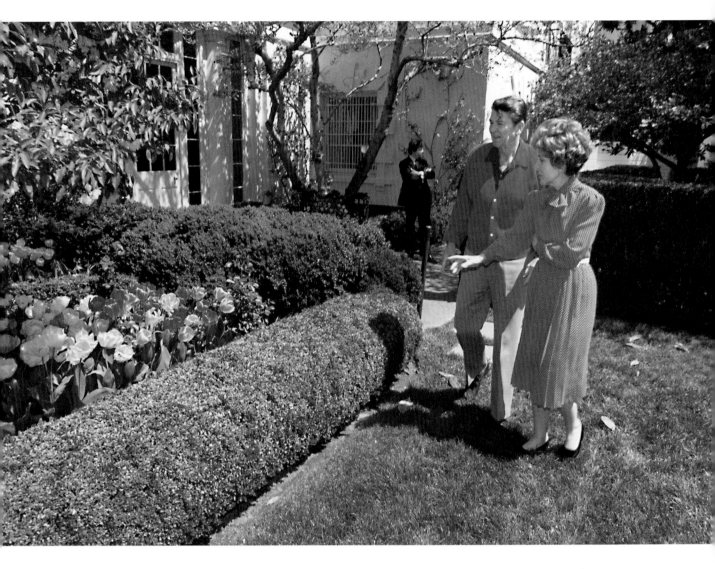

Five days later, Nancy takes her husband on a walk around the White House grounds to see the first of the spring tulips. Reagan's injuries slowed him considerably at first; he took afternoon naps for several months and needed to carry a Respirex, a small device into which he had to blow as hard as possible to help reinflate his lung. Those close to Reagan noticed that even after he had made a full recovery, he was a changed man. His son Ron noted, "He was never really the same after that. . . . There was a certain bounce that was taken out of his step."

His near-death experience, Reagan said, also affected him spiritually. The day after this photo was taken, he asked New York's Terence Cardinal Cooke to pay him a visit, and told the cardinal, "I have decided that whatever time I have left is left for Him."

On April 28, Reagan arrives on Capitol Hill to give a scheduled address to a joint session of Congress outlining his economic recovery program for America and is greeted as a returning hero by both Republicans and Democrats. Later Reagan said, "That was such a great reception, it was almost worth getting shot." Then he delivered the speech, and the response was far less enthusiastic, at least from the Democratic side of the aisle. Reagan proposed huge cuts in Medicare payments, child nutrition programs, public service jobs, mental-health subsidies, college education benefits, and unemployment compensation, among others. He also proposed to lower taxes.

His critics were appalled. Despite what he had said during his televised speech in February, the truly needy would indeed be affected, they argued, and they pointed to Reagan's request for increased defense spending as an example of the worst kind of government waste. They believed that a tax cut would help only America's wealthiest individuals and that Reagan had proved himself a Robin Hood in reverse: taking from the poor and giving to the rich. Reagan and his supporters countered that the money freed up by the tax cuts would create a "trickle-down" effect that would benefit everyone, and that America's defenses needed to be stronger than ever. The battle lines were drawn.

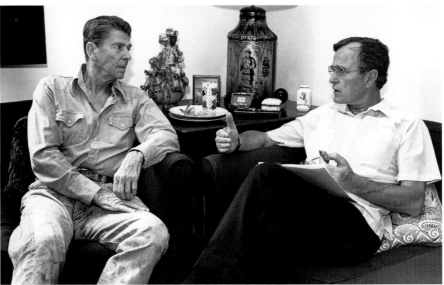

TOP The President shakes hands with a cadet at the West Point Academy graduation ceremonies on May 27.

BOTTOM After chopping wood and clearing brush at Rancho del Cielo, Reagan confers with Vice President Bush, who was visiting with his wife, Barbara. One of the first questions Reagan had asked his doctors after the shooting was whether he would be able to horseback-ride again. They assured him he would, and cleared him to do so on this visit "if I took it easy." The ranch, Reagan wrote in his memoirs, provided "a sanctuary like no other" for him and Nancy. "[We] could put on our boots and old clothes, recharge our batteries, and be reminded of where we had come from."

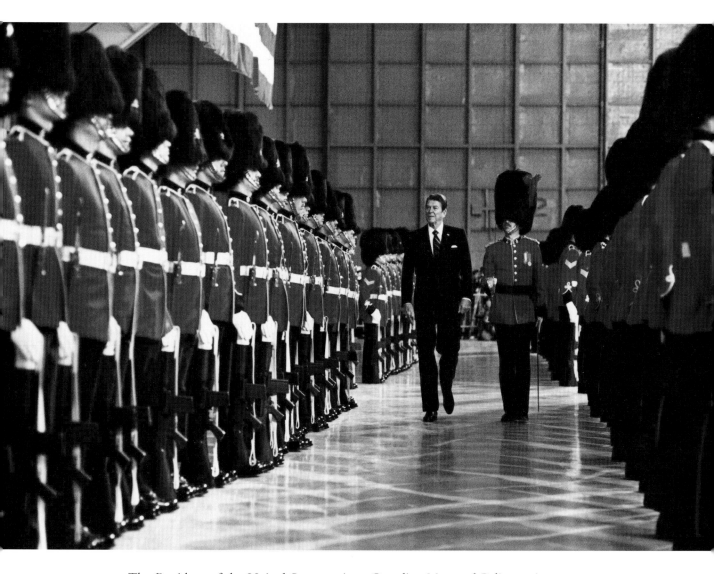

The President of the United States reviews Canadian Mounted Police regiments upon his arrival in Ottawa on July 17 for the first "Group of Seven" world economic conference in July. He met with the leaders of Great Britain, France, Italy, Germany, Canada, and Japan to discuss strategies for reviving the global economy. France's Francois Mitterand, a man of rapier intellect and deep erudition, at first wondered at Reagan's apparent intellectual vacuity when he spent most of his speaking time telling stories about his Hollywood days. But later he told German leader Helmut Schmidt, "This is a man without ideas and without culture. A sort of liberal, for sure, but beneath the surface you find someone who isn't stupid, who has great good sense and profoundly good intentions. What he does not perceive with his intelligence, he feels by nature."

The trip to Canada left the still-weakened President "exhausted nearly to the point of incoherence," his longtime observer Lou Cannon said. But less than a week after his return, Reagan had reverted to his ebullient self, showing reporters a doodle he had drawn at his desk on July 29.

A mixture of determination and sadness etched into his face, Reagan waits to read his prepared remarks concerning the air traffic controllers' strike on August 3. He terminated the employment of any controllers who did not agree to return to work immediately. "I'm not very good at firing people," he later wrote. "Maybe it goes back to the fact that as a child I can remember my father being out of work. . . . But as a former union president myself, I couldn't go along with the controllers violating not only the law, but their own pledges not to strike. I also don't believe government employees have the right to strike, because the strike is against their fellow citizens, not some moneyed employer."

Egyptian President Anwar Sadat presents Mrs. Reagan with a gift from the people of his country during his state visit to Washington on August 3. During the meeting that followed between the two Presidents, Reagan told Sadat that he planned to send American warships over the line that Libyan strongman Colonel Muammar al-Quaddafi had sought to create in international waters off his country's coastline in the Gulf of Sidra. "Magnificent!" Sadat exclaimed.

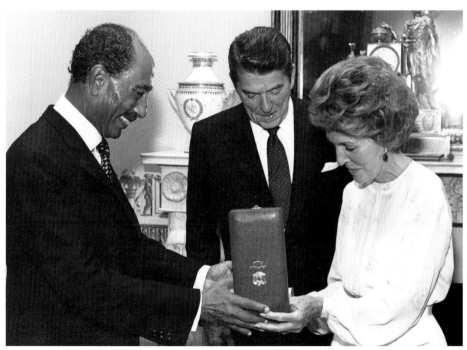

The next day, the President greets one of the family dogs, Victory, after arriving at Rancho del Cielo's landing pad at the start of a nearly month-long vacation in California.

The President chats with American servicemen at a barbecue at the ranch on August 12. Exactly one week later, Reagan was awakened by his chief of staff, Edwin Meese, at 4:32 in the morning and informed that two American F-14 fighter planes had been engaged by two Libyan SU-22s in the skies above the Libyan coast and that the SU-22s had been downed by heat-seeking Sidewinder missiles.

Reagan asked if there had been any American fatalities, and when he was told there hadn't been, he went back to sleep. The incident, although a victory for the American military, redounded to Reagan's detriment when reporters discovered that Meese had learned of the battle at 11:05 the night before but had decided to let the President sleep. Reagan became the butt of jokes; wits called him Ron Van Winkle, and Art Buchwald entitled a book of observations about his presidency *While Reagan Slept* (a play on the title of John F. Kennedy's book on the events leading up to World War II, *Why England Slept*).

Johnny Carson joked, "There are only two reasons you wake up Ronald Reagan. One is World War III. The other is if *Hellcats of the Navy* is on the late show."

On August 13, at the fog-shrouded ranch, Reagan kicks up his heels with joy after signing, with twenty-four different pens, the largest tax-reduction and spending-control bills in American history. Congress had enacted most of the plan that had come to be known as Reaganomics, despite dire warnings of a ballooning federal deficit and the possibility of recession. The President never wavered in his belief that his economic policies would bring Americans unparalleled prosperity *eventually*, and that whatever hardships the country might have to endure initially would be worth it.

President and Mrs. Reagan pay tribute to Anwar Sadat at the White House on October 8 after receiving the news that the Egyptian leader had been assassinated in Cairo. "Our sense of loss was personal," Reagan recalled. "Anwar was a warm human being who didn't hold back from personalizing things. He had a wonderful smile and remarkable courage. He was one of a kind, and it's a damn shame we lost him." Two days later, Reagan spoke eloquently about Sadat's legacy at a ceremony to see off former Presidents Nixon, Ford, and Carter as America's representatives to Sadat's funeral. "To those who rejoice in the death of Anwar Sadat, to those who seek to set class against class, nation against nation, people against people, those who would choose violence over brotherhood and who prefer war over peace, let us stand in defiance. . . . For the memory of this good and brave man will vanquish you."

ABOVE Nancy joins the President at the end of the day in the sitting area of their boudoir. She had set about redecorating the White House as soon as she moved in, at an eventual cost of nearly $1 million to the taxpayers. Distressed by the chipped and unmatched official china, she ordered 220 new place settings with 24-carat-gold embellishments at a cost of $1,000 a setting. She also ordered $100,000 worth of personal china, designed to her specifications, and called the pattern "Nancy Reagan."

Unfortunately from a public-relations standpoint, the press got wind of the $1,000-a-setting china order on the same day that the President cut funding for school lunch programs and declared that ketchup would be counted as a vegetable in the government school menu guidelines.

LEFT The First Couple spent the Christmas 1981 holidays at the lavish Palm Springs estate of *TV Guide* publisher Walter Annenberg. The visit did little to quiet the growing chorus of criticism of the Reagans as the Louis XVI and Marie Antoinette of America, even from such conservative stalwarts as the Manchester, New Hampshire, *Union-Leader.* The *Washington Monthly* asked Nancy in an editorial, "Can't you just *pretend* you care about something in life besides handbags and hors d'oeuvres?"

Prior to a White House conference on physical fitness on January 2, 1982, the President shows George Allen how well he has recovered from his gunshot wound.

In the Oval Office on February 6, Reagan blows out the candles on his seventy-first birthday cake. "When I go in for a physical," Reagan quipped, "they no longer ask how old I am. They just carbon-date me."

At Rancho del Cielo in March, Ron and Nancy do morning stretching exercises in anticipation of a day of work around the ranch . . .

. . . then Nancy hitches a ride with the President on the lawnmower.

Later he takes the jeep and clears away some dead tree limbs.

Once the work is completed, the First Couple share a romantic sunset on the dock of a lake on their property.

Rawhide (the President's Secret Service code name) visits the cockpit of Air Force One on the flight back to Washington on March 16. Reagan had refused to fly for twenty-five years following frightening experiences in his first two airplane rides in the 1930s.

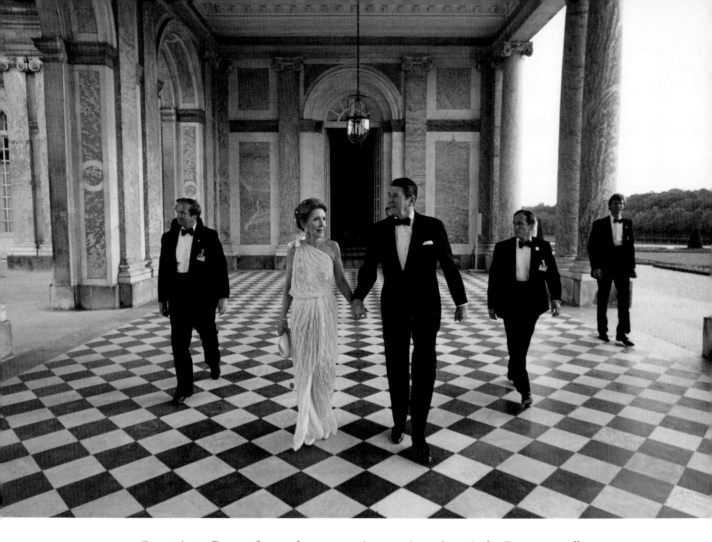

On a trip to Europe for another economic summit on June 6, the Reagans stroll through a courtyard at the palace at Versailles, Louis XIV's lavish eighteenth-century retreat and now a French national museum.

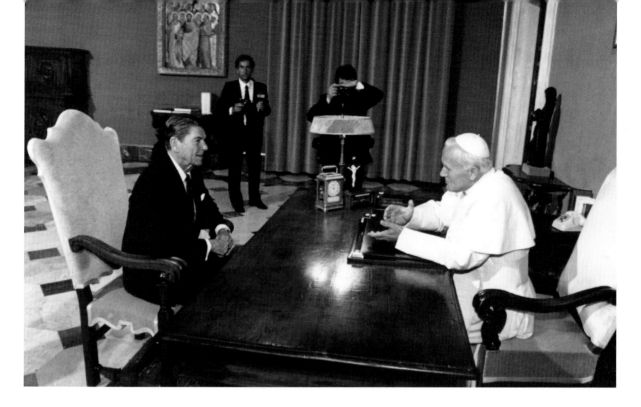

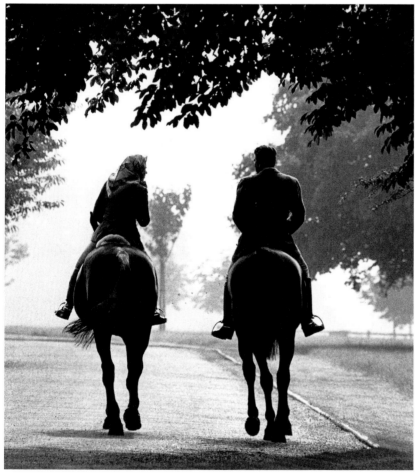

The President and Pope John Paul II meet at the Vatican on June 7. They discussed Lech Walesa's Solidarity movement in the Pope's native Poland, a defiance of the country's communist government that the Pope supported and Reagan called "the first fraying of the Iron Curtain." Later in the year Reagan imposed sanctions against Poland and the Soviet Union, and by 1989 Walesa had been elected President of a democratic Poland.

Reagan and Britain's Queen Elizabeth II enjoy an early-morning horseback ride through the grounds of Windsor Castle on June 8. The Reagans were guests of the Queen during their three-day visit to England.

Under a statue of Elizabeth I and a painting of Elizabeth II, Reagan addresses the British Parliament in the Palace of Westminster on June 8, delivering "one of the most important speeches I gave as President," which became known as the "Reagan Doctrine" on the Soviet Union. "I wanted to do some things differently," he later recalled, "like speaking the truth about them for a change." He spoke bluntly of the "decay of the Soviet experiment," lambasted Soviet promotion of "violence and subversion" in many countries, and voiced his administration's determination to "foster the infrastructure of democracy."

This last objective evolved into what Reagan admitted was a "controversial" policy of lending American support to anticommunists "wherever we found them"—including Nicaragua.

Back in the States on July 4, the Reagans chat with space shuttle *Enterprise* astronauts at Edwards Air Force Base. Later he would tell participants in the Young Astronauts Program that through space exploration mankind embarks "on the boldest, most noble adventure of all. . . . Dip your hand in that limitless sea; you're touching the mystery of God's universe."

The President holds a press conference on July 28, 1982. Most of the questions concerned the poor state of the American economy, still mired in recession. Unemployment was high, the economy had shrunk instead of grown, and the needy were falling out of a social safety net weakened by Reagan's budget cuts. The President placed the blame on Carter policies and Federal Reserve Chairman Paul Volker's insistence on high interest rates to keep inflation in check. He asked the American people to be patient until his own policies began to take effect, but more and more of them had begun to see Reagan as heartless, concerned more with helping the rich than the poor. His popularity began to plummet.

TOP Waning popularity polls or not, visitors who had lined up to take the White House tour were delighted when the President came over to shake their hands on August 17.

BOTTOM Reagan does a few bicep curls during a visit to the U.S. Secret Service gym on September 8. Although he often joked about his age ("I can remember when a hot story broke and the reporters would run in yelling, 'Stop the chisels!'"), the President missed few opportunities to show off his level of fitness, remarkable for a man in his seventies.

The Washington Monument looms as a symbol of freedom as President Reagan gives West German Chancellor Helmut Kohl a warm welcome to America on November 15. Kohl supported Reagan's determination to end Soviet oppression around the world, and nowhere more so than in Kohl's own region, where the Soviets controlled East Germany and an impenetrable wall separated East and West Berlin. During his visit to Europe in June, Reagan had briefly seen the gray, pocked, graffiti-strewn, gun-tower-topped cement barrier between the East Germans and freedom. "It's as ugly as the idea behind it," he had said.

Two days after Christmas, Patti Davis joins her parents in Phoenix, Arizona, for a visit to Nancy's mother, Edith, "a remarkable, warm, and loving woman," Reagan recalled. "Nancy worshiped her, and I worshiped her too."

During a White House press briefing on Friday, February 4, Nancy surprised her husband with a birthday cake. The First Couple celebrated his seventy-second privately that Sunday, February 6.

At the White House Governors Dinner on February 27, the President chats with Governor and Mrs. Bill Clinton of Arkansas. Reagan had learned earlier in the month that his popularity rating stood at a dismal thirty-five—the lowest such midterm figure for any President in forty years—principally because the economy had continued to flounder. Still, convinced the country would turn around, Reagan determined to "stay the course."

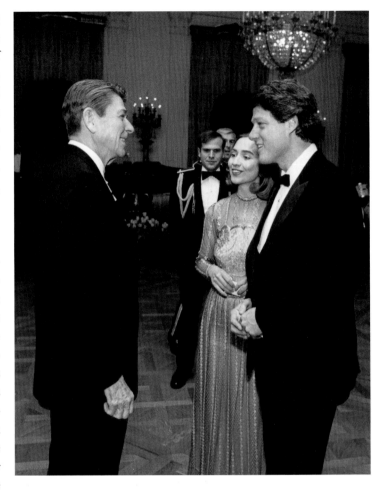

On March 8, Reagan spoke before the annual convention of the National Association of Evangelicals in Orlando, Florida. In his comments he reiterated his opposition to abortion and his support for a constitutional amendment to restore prayer in public schools. But the speech became famous for his description of the Soviet Union as an "evil empire" and his defense of America's nuclear missile buildup to keep them at bay. Addressing himself to nuclear freeze proponents (who included his daughter Patti), Reagan said, "I urge you to beware the temptation . . . to ignore the facts of history and the aggressive impulses of an evil empire . . . and thereby remove yourself from the struggle between right and wrong, good and evil."

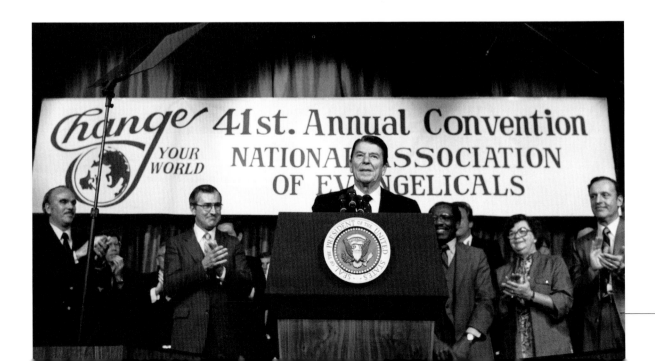

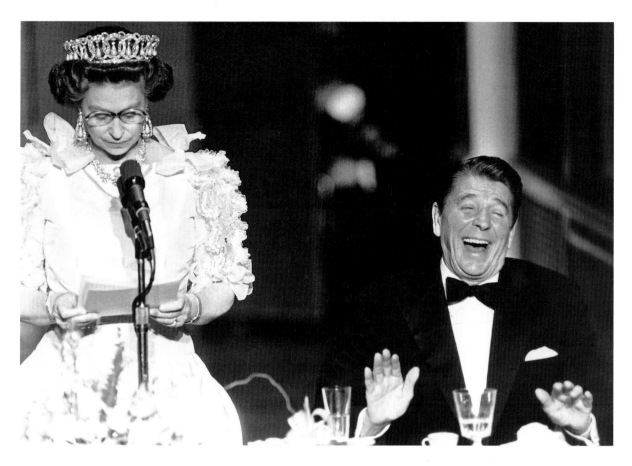

Queen Elizabeth's joke about the drenching California rains breaks up the President at a reception in the Queen's honor in San Francisco on March 10. The next day, the Reagans welcomed the Queen to the "nearly flooded" Rancho del Cielo, where they visited for the afternoon. "Thank God they're not going to stay the night," Nancy told her friend Betsy Bloomingdale. Nancy was concerned, Betsy said, because the house "really is a little ranch house with a guest bedroom about as big as a minute and a bathroom you can hardly turn around in."

At the presidential retreat at Camp David on March 19, the Reagans enjoy Nancy's appearance on the television sitcom *Diff'rent Strokes*. She made the appearance to promote her "Just Say No" antidrug program.

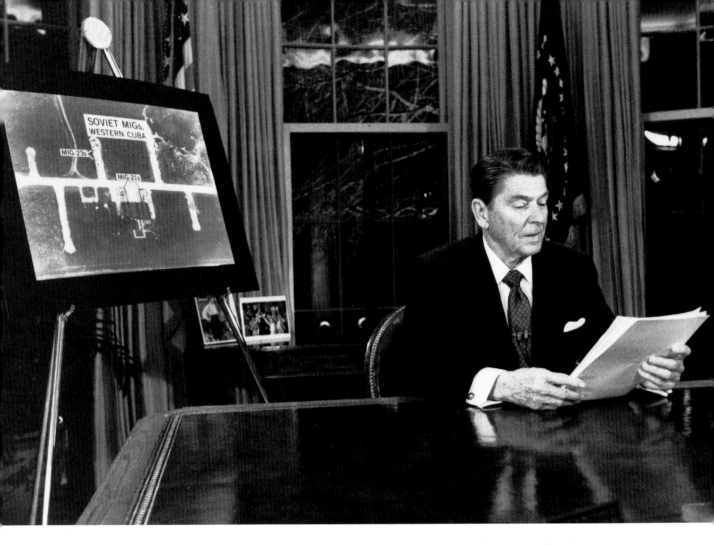

The President addresses the nation on March 23, outlining the threats posed by So-viet military buildups in several parts of the globe. Toward the conclusion of his pres-entation, Reagan startled the world by announcing "an effort which holds the promise of changing the course of human history"—the Strategic Defense Initia-tive, a system of satellites designed to "intercept and destroy [with laser beams] strate-gic ballistic missiles before they reach our own soil or that of our allies."

The press quickly dubbed the technologically and financially awe-inspiring concept "Star Wars." Reagan's critics called it laughably impracticable—indeed, sci-entifically impossible—and wondered whether its inspiration hadn't been the Iner-tia Projector in Reagan's film *Murder in the Air*. The Soviets termed it "insane" and a direct threat to their national security—if the system were in place, they would be defenseless against nuclear attack by the United States.

Whether or not Reagan truly believed the SDI system could ever be imple-mented, its threat had the result he intended: The balance of power between the So-viet Union and the United States shifted permanently in America's favor.

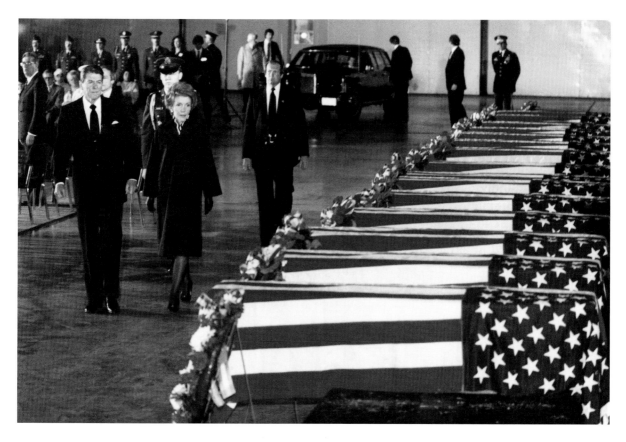

On April 18, a van bomb exploded outside the U.S. embassy in Beirut, killing sixty-three people, among them seventeen Americans. "Lord," Ronald Reagan wrote in his diary, "forgive me for the hatred I feel for the humans who can do such a cruel and cowardly deed." Five days later, he and Nancy reviewed the mournful row of flag-draped coffins at Andrews Air Force Base.

Reagan indicates difficulty hearing a reporter's question on the White House lawn on July 19. Reagan wore a hearing aid, a result of the damage to his left ear on the set of *Code of the Secret Service* in 1939, and frequently had to ask people to repeat themselves. Many suspected, however, that he used the deafness excuse to avoid answering some reporters' questions.

The Reagans enjoy a canoe ride on the lake during their summer vacation at Rancho del Cielo, August 17. Earlier in the year they had celebrated their thirty-first wedding anniversary.

September 9: The Reagans at a memorial service for the sixty-one Americans killed when the Soviets shot down Korean Airlines Flight 007 on September 1. For almost a week, Moscow had refused to reveal what had happened to the commercial flight carrying 269 passengers; then they admitted shooting it down and claimed it had been on an espionage mission for the United States.

This wasn't true, and the Soviet action outraged Reagan. He spoke to the American people from the Oval Office: "[This] was an act of barbarism born of a society which wantonly disregards individual rights, the value of human life, and seeks constantly to expand and dominate other nations."

Reagan speaks to Vice President Bush from Augusta, Georgia, in the early-morning hours of October 22 to inform him that the United States will invade the small Caribbean country of Grenada, a British Commonwealth nation, to restore it to democracy and rescue six hundred American students on the island. Six neighboring countries had requested the U.S. action after a bloody coup d'état by Cuban-backed commandos had toppled Grenada's government.

The next day, at 2:27 in the morning, Reagan was informed that a suicide bomber had driven two thousand tons of explosives through a series of barriers and crashed through the doors of the U.S. Marine Headquarters at Beirut International Airport. The explosion ripped the four-story concrete building to shreds and killed 241 sleeping soldiers, sent by the President to keep peace in Lebanon. The tragedy devastated Reagan, shown here being driven to the airport for the flight back to Washington. "My, how it still hurts to have lost those young men," he later wrote. "Sending our boys to that place is the most anguishing regret of my years as President."

Back in the Oval Office on October 27, Reagan prepares his remarks for a televised address to the nation in which he explained the need for the Grenada invasion and the continued American presence in Beirut. Lebanon's energy resources, he argued, made that country "key to the political and economic life of the west. . . . If that key should fall into the hands of a power . . . hostile to the free world, there would be a direct threat to the United States and to our allies."

Despite widespread condemnation of the Grenada plans (even from staunch Reagan ally Margaret Thatcher) and the loss of nineteen American servicemen, the invasion on October 24 proved a success. A democratic government was restored on the island, and the Americans were brought home safely.

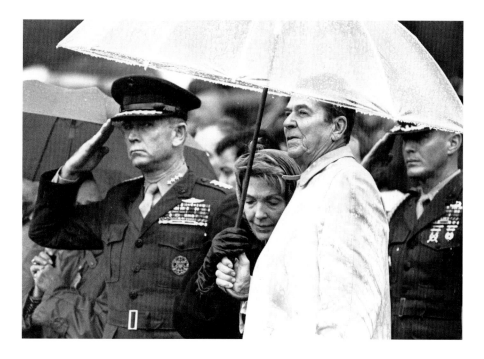

ABOVE On November 5 the Reagans joined Marine Commandant P. X. Kelley, left, at a memorial service at Camp Lejeune, North Carolina, to honor those who died in Beirut and Grenada.

BELOW In South Korea on November 13, the President joins American soldiers in the chow line at Camp Liberty Bell in the demilitarized zone. Reagan refused to remove U.S. troops from the country, arguing that their presence was necessary to help prevent the communist North Koreans from taking over.

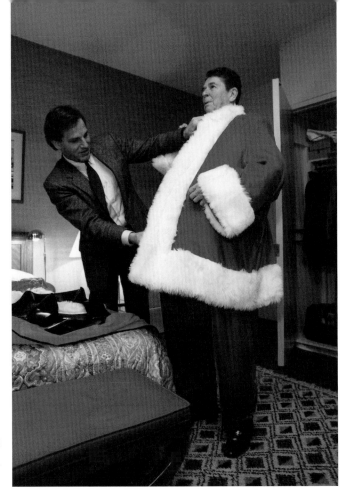

On December 24, an aide helps the President into a Santa Claus suit in preparation for a Christmas Eve party in the White House . . .

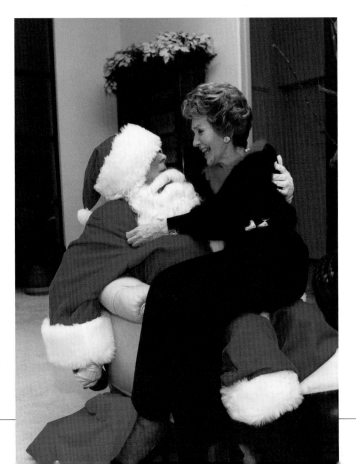

. . . and later, little Nancy Davis tells Santa all she wants for Christmas.

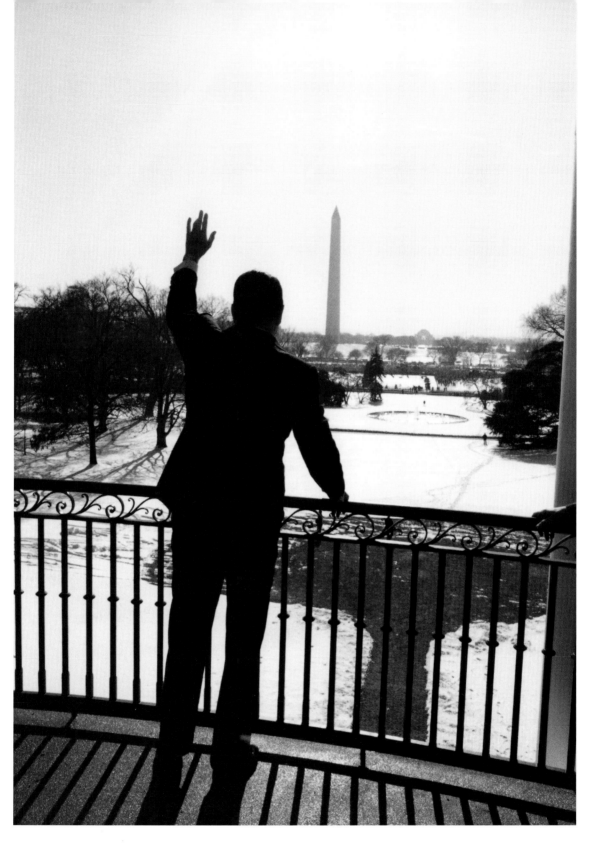

Reagan waves to the March for Life leaders from the Truman Balcony as they prepare for a demonstration against abortion-on-demand on January 2, 1984.

At Camp David on the twenty-second, the President pets one of his dogs, Lucky, as he works on his State of the Union address.

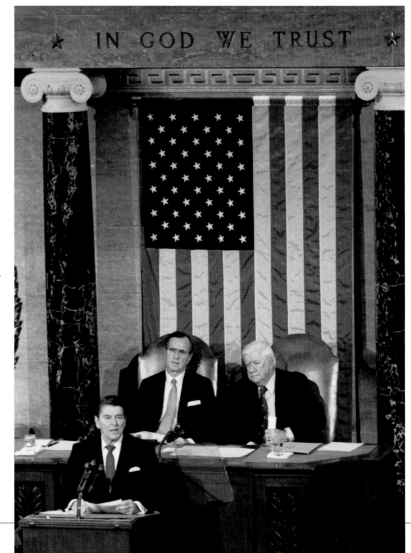

Three days later, Reagan delivers good news to a joint session of Congress: The American economy had begun to turn around; inflation and unemployment were down, the gross national product up. What would be called the "Reagan Miracle" had begun, and the President's popularity was rebounding along with Americans' spirits. Confidently, Reagan also announced that he would seek a second term in November.

February 6: The President seems emotional as Nancy examines some family photographs on the mantel of the Ronald Reagan Boyhood Home in Dixon, Illinois. The house on South Hennepin Avenue had been restored to its 1920 condition just in time for this nostalgic visit on Reagan's seventy-third birthday.

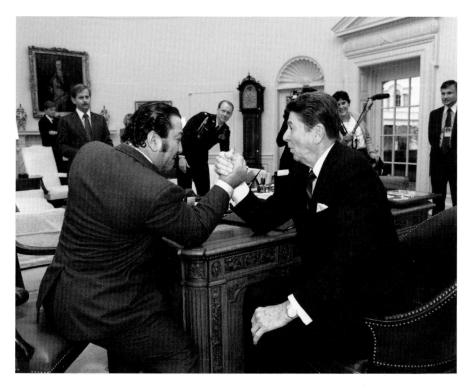

Reagan and Dan Lurie, the editor of *Muscle Training Illustrated*, arm-wrestle in the Oval Office on February 16. Lurie had presented Reagan with a plaque honoring him as "the most physically fit President of all time." Lurie then challenged the President to arm-wrestle. Reagan won twice. "It was a fix," Reagan admitted. "He let me win."

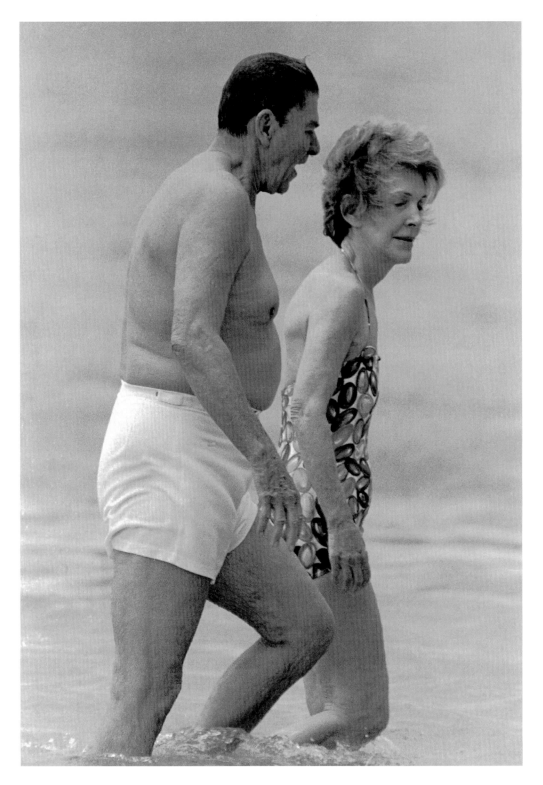

April 24: The Reagans wade through the surf after a midday swim in the Pacific Ocean waters of Kahala Beach near Honolulu. They had stopped over in Hawaii for a few days on their way to China.

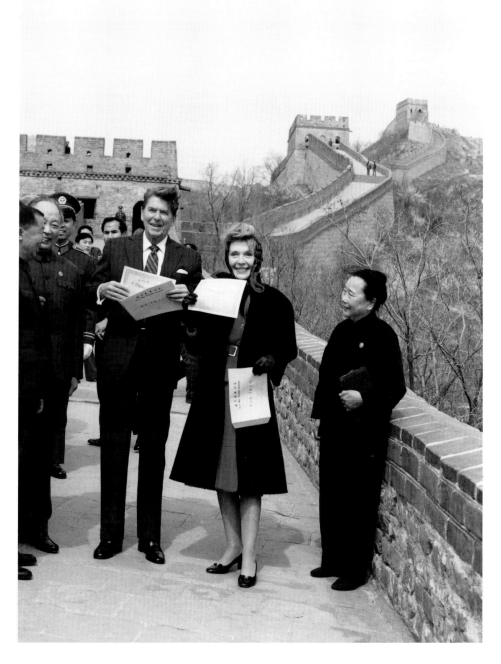

Reagan decided to visit Beijing in an effort to encourage China's moves toward a free-enterprise economy and the acceptance of foreign investment. At the Great Wall on April 29, the Reagans receive documents commemorating their visit. "Although I'd seen photographs of the Great Wall since childhood," Reagan recalled, "seeing it rise up and disappear over the mountains in both directions was a tremendously emotional experience."

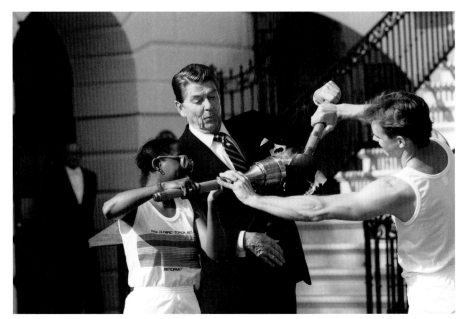

On May 14, Reagan helps light the Olympic Torch as it begins its relay to Los Angeles and the June games.

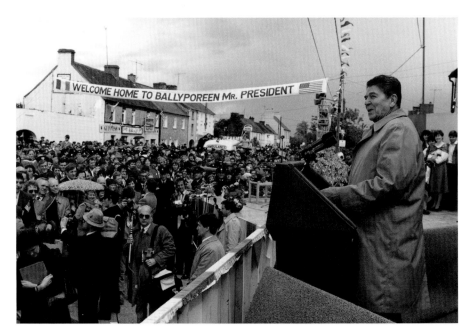

Residents welcome Ronald Reagan to Ballyporeen, Ireland, on June 3. On his way to London for the 1984 economic summit, the President stopped to visit the town of his ancestors in County Tipperary. He drank some local beer at a pub renamed for him for the day, and received a family tree from Burke's Peerage that showed him to be distantly related to both Queen Elizabeth and John F. Kennedy. He also met several distant relatives, including a young man who bore a striking resemblance to Reagan in his youth. "Since it had been over a century since my great-grandfather had left Ballyporeen for America, it was an eerie experience," Reagan recalled.

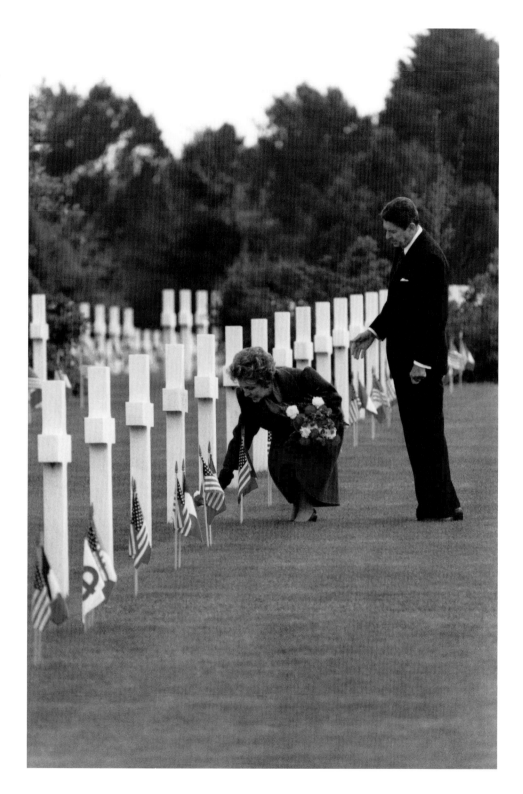

On June 6, the fortieth anniversary of the World War II Allied invasion of Western Europe ("D-Day"), the First Lady places a few flowers on graves in the Allied cemetery at Omaha Beach in Normandy.

The President gives Nancy a big kiss on July 6 as he picks her up at Andrews Air Force Base aboard Marine One. They flew to Camp David for a weekend celebration of the First Lady's sixty-third birthday.

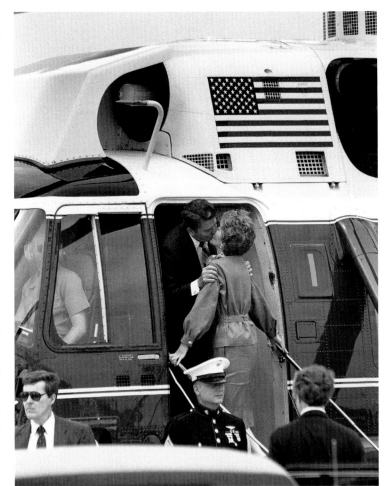

The First Couple share an intimacy while watching the opening ceremonies for the Olympics Games in Los Angeles on July 28. Heightened tensions between the United States and the Soviet Union caused the Soviets and several other communist countries to boycott the event, but still 7,000 athletes from 140 countries participated.

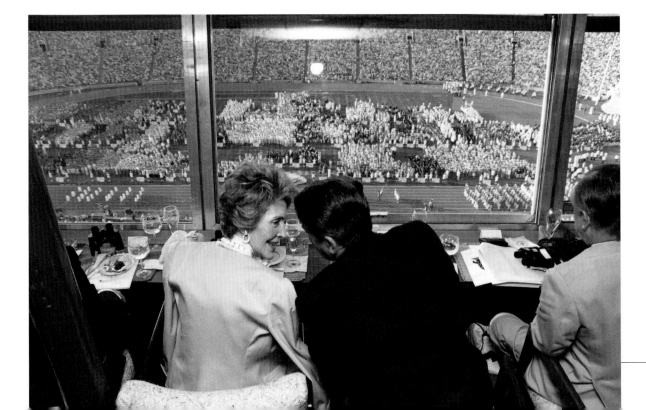

The Reagans then headed north to Rancho del Cielo, where the President chopped down some dead trees on August 10. During preparations for a National Public Radio interview two days later, Reagan was unaware that the microphone was on and joked, "My fellow Americans, I'm pleased to tell you today that I've signed legislation outlawing Russia forever. We begin bombing in five minutes." The comment, injudicious at best, prompted widespread criticism and helped reinforce the perception of many that Ronald Reagan was a warmonger.

The Reagans flank their daughter Patti, thirty-one, and her groom, Paul Grilley, twenty-five, at their wedding reception at the Bel Air Hotel in Beverly Hills on August 14. Although her contrary political views had kept her estranged from her parents for years, Patti asked her father to give her away, and Nancy handled most of the details of the wedding. Although the First Lady wasn't thrilled with Grilley, a yoga instructor who seemed "spacey" to some, she found him far preferable to Patti's last paramour, a rock musician.

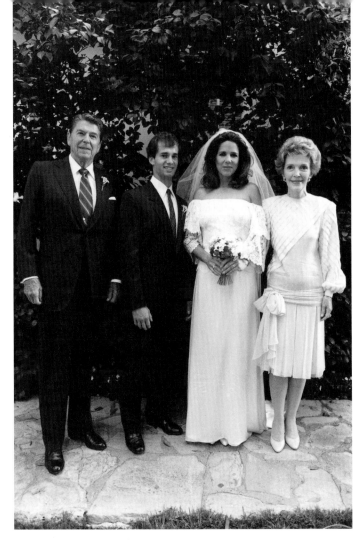

August 22: Vice President and Mrs. Bush look on delightedly as Nancy gives the President a congratulatory kiss in their Dallas hotel suite after his nomination for a second term became assured.

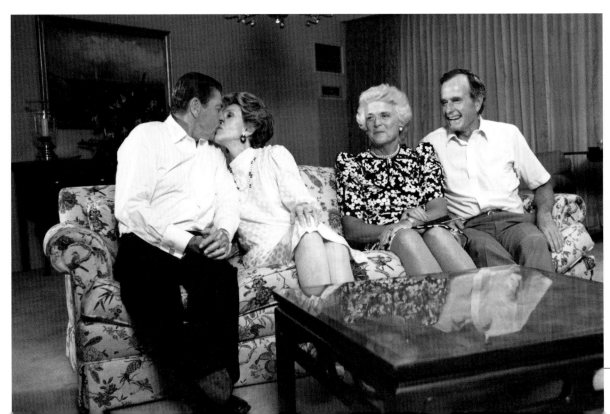

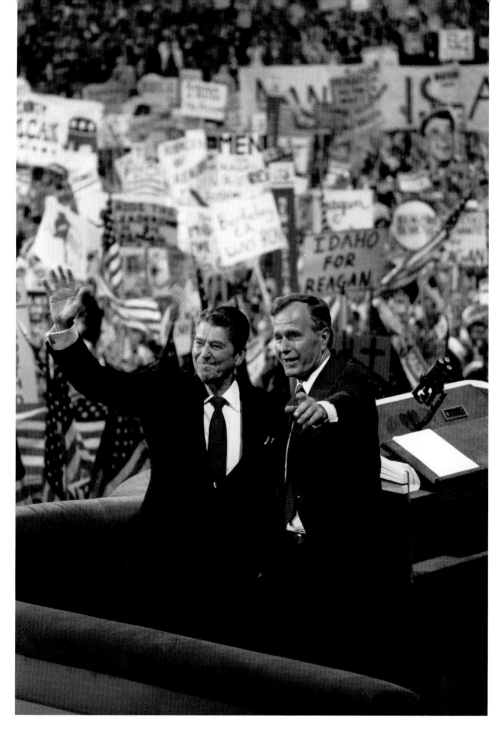

Reagan and Bush acknowledge the adulation of the Republican delegates after accepting their nominations on August 23. "I bet I have a better idea of what it feels like to be a rock star than most twenty-year-olds," Reagan later said. In his acceptance speech, he deftly summed up the reasons that Americans should vote for him rather than the Democratic nominee, Jimmy Carter's Vice President, Walter Mondale: "Let's remind [the Democrats] of how a 4.8-percent inflation rate in 1976 became back-to-back years of double-digit inflation . . . as average monthly mortgage payments more than doubled, home building nearly ground to a halt; tens of thousands of carpenters and others were thrown out of work. And who controlled both houses of the Congress and the executive branch at that time? Not us, not us."

Between campaign stops on Air Force One, Reagan usually slipped into something more comfortable—his sweatpants.

On September 24, the President delivers an address before the General Assembly of the United Nations in New York. The speech, centered on world affairs and once again condemning communism, provided a perfect forum in which the candidate could be not only presidential but statesmanlike.

Reagan greets enthusiastic students at a campaign rally at Bowling Green State University in Ohio on September 26. The President's popularity with millions of Americans young and old confounded his detractors. As Jane Mayer of *The Washington Post* put it, "A strange alchemy had developed between Ronald Reagan and the American people.... They were inspired by his optimism, and they responded to his warmth and humor.... They thought he had backbone...."

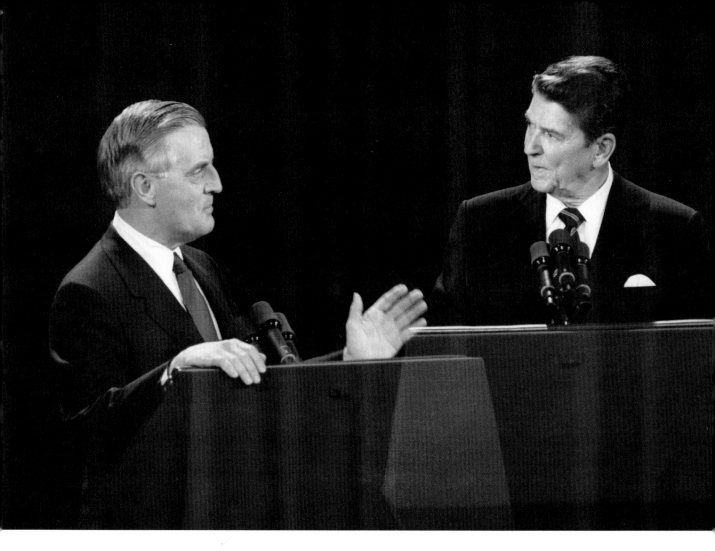

A montage photograph of Walter Mondale and Ronald Reagan during the first of their two debates on October 7. The President did not do well in this initial encounter. At one point he admitted, "I'm all confused now." His rambling closing argument veered dangerously close to incoherence. To Nancy, the debate was "a nightmare. Right from the start he was tense, muddled, and off-stride. He lacked authority. He stumbled . . . it was painful to watch."

The sorry spectacle revived doubts about the President's command of his office and whether, at seventy-three, he could handle the demands of his job. But at the second debate two weeks later, Reagan regained the verbal deftness that had brought him the sobriquet "the Great Communicator." He demolished the age issue with his response to the question "You already are the oldest President in history. . . . Is there any doubt in your mind that you would be able to function in [crisis] circumstances?"

"Not at all," Reagan replied. "And I want you to know that I also will not make age an issue in this campaign. I am not going to exploit for political purposes my opponent's youth and inexperience." Even Mondale broke up with laughter, and Reagan had once again won over millions of Americans with a sparkling one-liner.

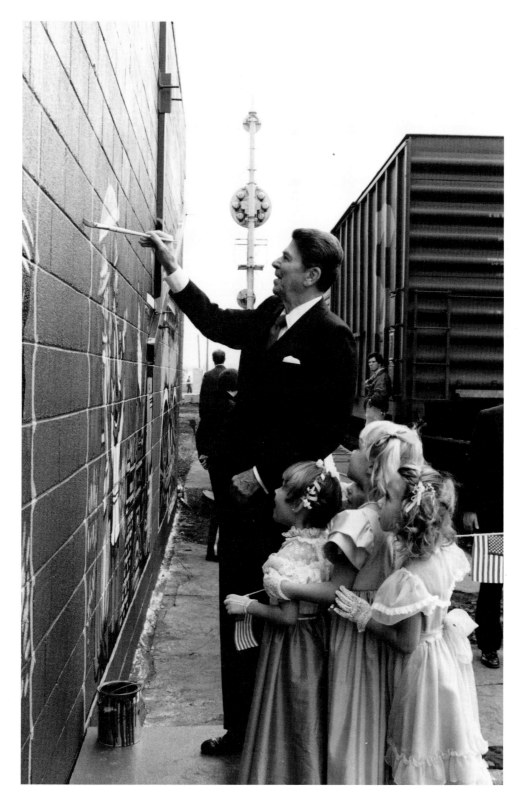

On October 12, during a whistle-stop train tour through Lima, Ohio, the President helps some schoolchildren paint a mural.

TOP On Election Day, November 6, the Reagans get the good news at the Century Plaza Hotel in Los Angeles: The President had been reelected in a landslide, winning 59 percent of the popular vote and forty-nine states for an unprecedented electoral vote total of 526. (Mondale won just his home state, Minnesota.)

BOTTOM Shortly afterward, the First Couple are joined by son Ron and daughter Maureen and her husband, Dennis Revell, at a victory celebration in the hotel's main ballroom.

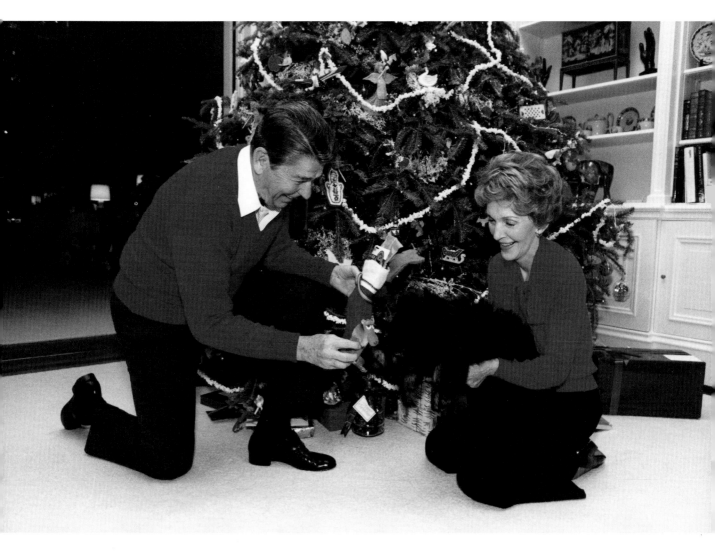

Under the Christmas tree in their private quarters on December 24, the Reagans
show Lucky the goodies Santa Claus left in his stocking.

In his White House study, the President works on his second inaugural address, January 17, 1985.

Mr. President, Act Two

Ronald Reagan's second term as President of the United States brought the best of times and the worst of times. The great enemy of the evil empire—the man who told an adviser, "I still have the scars in my back from when I fought the communists in Hollywood"—forged détente with the Soviet Union and signed the first treaty in history that reduced the number of nuclear weapons held by the two world superpowers. Reagan had begun to bring the long and awful Cold War to an end.

But Reagan's zeal to fight communism outside the Soviet Union led to the Iran-Contra affair, the nadir of his presidency and the sole blot on his reputation as a man who never lied to the American people. He insisted he hadn't known that his administration had made arms available to Iran in exchange for the release of hostages, and that money from the arms sales had been diverted to the anticommunist Nicaraguan Contras—both illegal activities. "Either way it was damning," said Lou Cannon. "If Reagan knew of the diversion of funds, he could be impeached. If he did not, the fact that he was not told was a chilling thought of a rudderless, leaderless White House."

Wry observers had called Reagan "the Teflon President," and this didn't stick to him, either. He was nearly eighty when he left office, and most Americans looked on him as a kindly grandfather figure. They said good-bye to him with genuine sadness.

On January 19, 1985, Reagan helps his grandson Cameron build a snowman in the Rose Garden. Cameron's father is Michael Reagan.

Supreme Court Justice Warren Burger swears in Ronald Wilson Reagan as President of the United States for the third time in the Capitol Rotunda on January 21. The United States Constitution mandated that Reagan be sworn in the day before, and he was, in a White House ceremony. But because the ceremony conflicted with the Super Bowl telecast, the swearing-in was repeated on Monday to allow Americans to witness it. It was also held indoors because of a minus-twenty wind-chill factor that also brought about the cancellation of the inaugural parade.

At the inaugural ball at the Hilton Hotel the evening of January 21, the Reagans dance as a huge crowd of celebrants cheers them on.

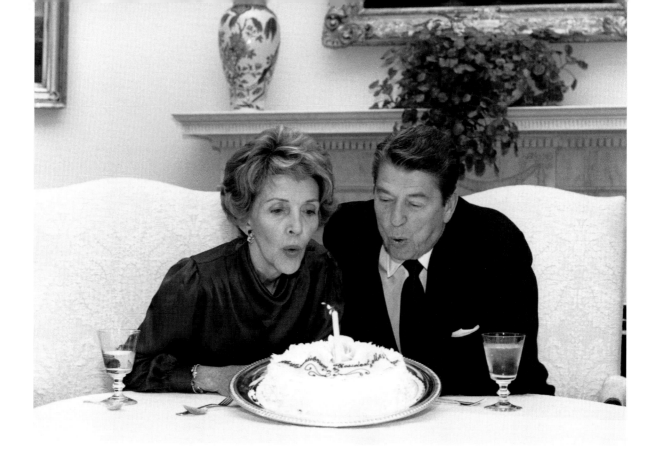

ABOVE On March 4, Ron and Nancy blow out the candle on their thirty-third wedding-anniversary cake.

BELOW A week later, Reagan welcomes John and Caroline Kennedy, who visited the White House for the first time since 1973 as part of their fund-raising efforts for the John F. Kennedy Presidential Library and Museum. JFK was assassinated when Caroline was nearly six and John was nearly three.

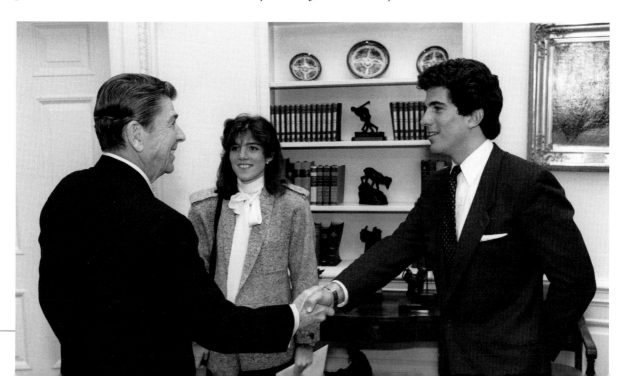

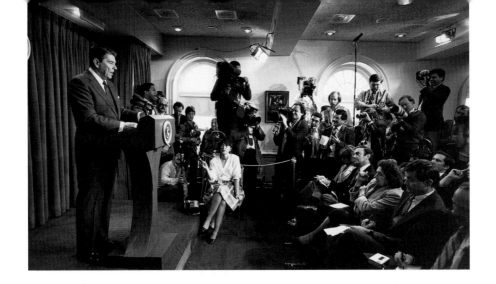

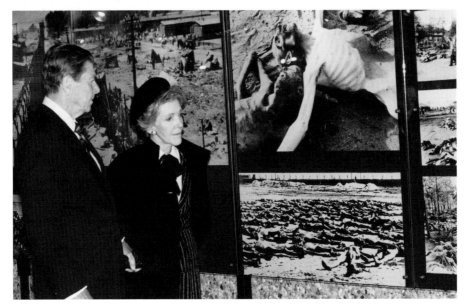

TOP The President faces reporters' questions about his policy toward Nicaragua at a press briefing on April 4. He had committed his administration's support to the Contras, Nicaraguan "freedom fighters" who were determined to win back the country from the Sandinistas, Soviet- and Cuban-backed insurrectionists who had overthrown the dictatorial government of Anastasio Somoza. Reagan saw the Contras as a vital part of an effort to avoid communist inroads in Central and South America, but most Americans opposed giving them U.S. aid, fearing that the country would become mired in "another Vietnam." When the Democrat-controlled Congress passed legislation outlawing aide to the Contras, Reagan was, as author Jay Winnik put it, "so angry he could barely speak." He told his national security adviser, Robert McFarlane, "I want you to do whatever you have to do to help these people keep body and soul together."

BOTTOM Sadness permeates the Reagans as they view photographs of Holocaust victims at the Bergen–Belsen concentration camp museum in Germany on May 5. Reagan had long been appalled by the atrocities Hitler and the Nazis had committed against millions of people, mostly Jews, during World War II. He had, in fact, made his two sons view disturbing footage of concentration camp clean-ups at the end of the war, in the hope that they would be as outraged as he and not let the horrors be forgotten.

Johanner Steinhoff, a German general in World War II, escorts Reagan through the Bitburg cemetery in West Germany. After the President's decision to visit the burying place of German war dead was announced, a huge outcry arose when it was revealed that forty-nine of the men buried there had been Nazi storm troopers. Many people, including Nancy and the writer Elie Weisel, a Holocaust survivor, urged Reagan to cancel the trip. He refused, feeling that to do so would be a slap in the face of his host, Chancellor Helmut Kohl. More important, he said, "I didn't feel that we could ask new generations of Germans to live with this guilt forever. . . . Many of their grandfathers died in that war. They weren't Nazis; they didn't work in the concentration camps; they were just soldiers doing their jobs in fighting a war."

TOP Back in Washington on May 23, Reagan presents Frank Sinatra with the Medal of Freedom award in the East Room. Sinatra and the Reagans had remained close; he regularly helped choose the entertainment for state dinners at the White House. The award proved controversial; many felt it inappropriate for the President to give the nation's highest civilian honor to a man reputed to have had ties with organized crime. Nancy defended Sinatra: "Frank deserved it for all the charity work he does. . . . If you're in a position to give old friends what they deserve, then why not?"

BOTTOM June 24: Nancy chats with former First Lady Jacqueline Kennedy Onassis as the President beams behind her at a fund-raiser for the John F. Kennedy Presidential Library in Boston. Michael Deaver recalled that "Nancy had always respected and liked [Jackie], once was in awe of her, and welcomed the chance to see her. . . ."

On July 2, the Reagans meet with returned hostages from TWA Flight 847. After leaving Athens, the plane had been hijacked by two Arabs who shot and killed one of the passengers, a U.S. Navy petty officer, and commandeered the plane back and forth between Algiers and Beirut before holding it hostage at Beirut Airport for two weeks. They demanded the release of more than seven hundred Shiite political prisoners held by Israel. The crisis was resolved without any further loss of passenger lives.

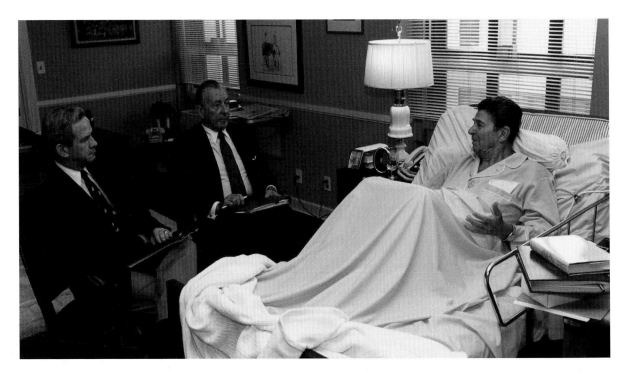

ABOVE On July 10, the President entered Bethesda Naval Hospital for the removal of a benign polyp in his colon. At the same time his doctor, John Hutton, performed a full colonoscopy and discovered a large cancerous tumor. "I stood there weak in the knees," Hutton recalled, "thinking, Why me? How am I going to tell him?"

Neil Reagan had had identical surgery just days earlier, and the President underwent an operation to remove two feet of his large intestine as headlines around the world screamed REAGAN HAS CANCER. "The President *had* cancer," Reagan wrote in his memoirs; the doctors had removed such a large amount of his intestine to ensure that the cancerous cells would not spread. When a doctor who had not examined him said on television that he had at best four years to live, Reagan had exclaimed, "That's ridiculous!"

On July 18, the President met with his national security adviser, Robert McFarlane, and White House chief of staff Don Regan in his hospital room.

RIGHT The Reagans' dog Lucky and a crowd of well-wishers greet the President and First Lady as they return to the White House on July 20.

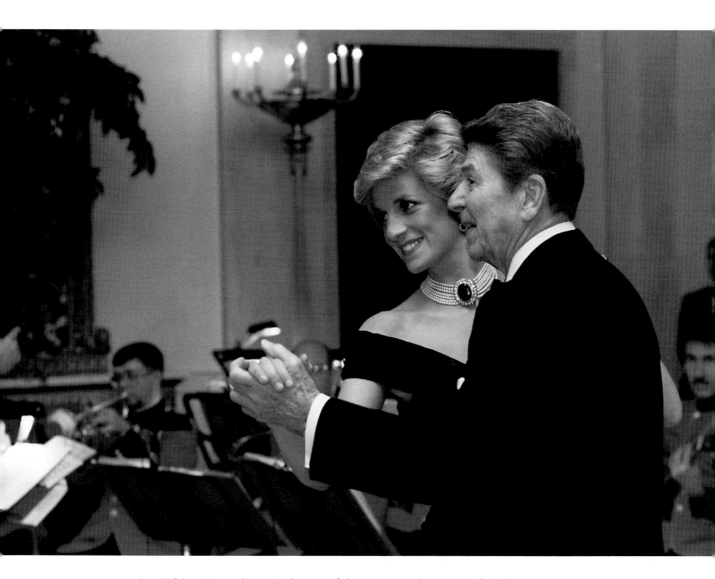

At a White House dinner in honor of the Prince and Princess of Wales in November, Reagan dances with a resplendent Diana. Nancy Reagan had meticulously planned the event and invited a stellar roster of Diana's favorite entertainers, including John Travolta, Tom Selleck, Neil Diamond, and Mikhail Baryshnikov. "My impression was that [Diana] was very impressed with seeing people in the flesh that she had seen on screen," said the actor Peter Ustinov, another guest. "She seemed euphoric."

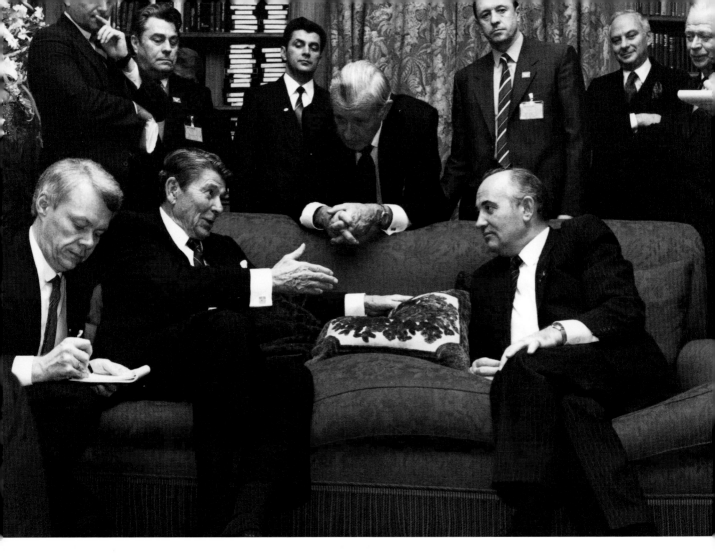

After years of increased Cold War tensions between Washington and Moscow, Reagan felt that Russia's new leader, Mikhail Gorbachev, was a man with whom he could at least meet to discuss the issues separating their two countries. He invited the Soviet leader to join him for a summit meeting, which took place in Geneva, Switzerland, on November 19. "Who would have guessed it?" Reagan said later. "Here I was, the great anticommunist . . . meeting with the leader of the evil empire." He found Gorbachev receptive to his peace overtures and called him "a tremendous force for change" in the Soviet Union. "I eventually would call Mikhail Gorbachev a friend."

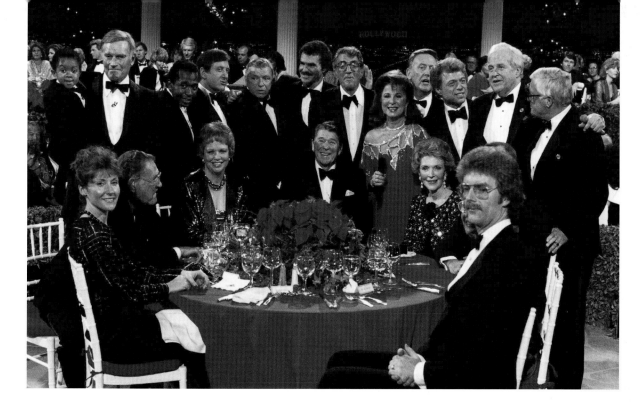

On December 1, the Reagans participated in a star-studded "Salute to Dutch," taped at the Burbank Studios for airing over NBC. Seated with the Reagans, left to right, are Colleen, Neil, Maureen, and Maureen's husband, Dennis Revell. Standing, left to right, are Charlton Heston (holding Emmanual Lewis), Ben Vereen, Monty Hall, Frank Sinatra, Burt Reynolds, Dean Martin, Edie Gormé, Vin Scully, Steve Lawrence, an unidentified man, and Merv Griffin.

On December 6, the President gives Nancy an early Christmas present—a puppy named Rex. Lucky had proven too rambunctious for the White House and was banished to Rancho del Cielo.

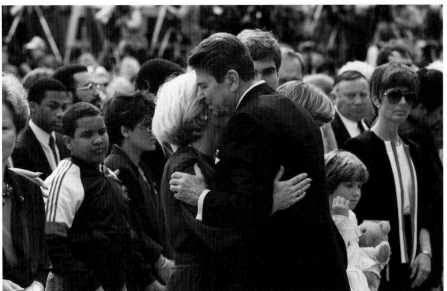

TOP A somber beginning to 1986: The President and members of his staff watch a replay of the explosion of the space shuttle *Challenger* moments after its launch on January 28. All seven astronauts aboard were killed, including a schoolteacher, Christa McAuliffe, who had trained for the flight in order to better educate students and other teachers about the space program.

In an address to the nation that night, Reagan promised that America would "continue our quest for space. There will be more space shuttle flights and more shuttle crews, and yes, more volunteers, more civilians, more teachers in space. Nothing ends here; our hopes and our journeys continue."

BOTTOM At a memorial service for the martyred astronauts at the Johnson Space Center in Houston on January 31, Reagan consoles their survivors.

On February 26, the Reagans submitted to a prime-time interview with Barbara Walters. They wanted to respond to the scathing portrayal of them in their daughter Patti's "autobiographical novel," *Home Front*. The book, which even her agent had urged Patti to put off "until your parents are out of office," paints Nancy as a pill-popping harridan and Reagan as an emotionally distant dolt completely dominated—even controlled—by his wife.

"I thought I was a good father," Reagan said, clearly hurt. Nancy added, "I tried to be a good mother, but then, you know, there's no perfect parent and there's no perfect child."

The following year Michael Reagan wrote his autobiography, in which he also portrayed his parents in less-than-flattering terms (although not as harshly as Patti), and revealed that he had been molested at age eight by a camp counselor who also took pictures of him naked. While Patti's book caused a deeper rift between her and her parents, Michael's actually brought him a little closer to them—because, some speculated, his depiction of his mother, Jane Wyman, who raised him, was devastating. For the first time, he was invited to fly on Air Force One with his father. "Being next to him on a whole flight," Michael told reporters, "means I'll have spent more time with him in the air than I ever have on the ground."

April 15: The President and Secretary of State George Schultz listen intently in the White House situation room as General Gabriel points out the results of an American attack on Libya the day before. Muammar al-Quaddafi had continued his provocations of the American military in the Gulf of Sidra, and when Reagan learned that a terrorist bombing of a West Berlin discotheque, which killed an American soldier, had been traced to Libya, he decided to act. Despite protests from many of America's allies (France refused to allow our planes to fly over its airspace), Reagan ordered the bombing, which wiped out most of Quaddafi's military headquarters but also resulted in the deaths of three Americans and a number of Libyan civilians, who were killed when one of our missiles went astray. "I deeply regretted the mishap," Reagan said, "but I don't think they were lives lost in vain: After the attack on Tripoli, we didn't hear much more from Quaddafi's terrorists."

OPPOSITE During a trip to Indonesia on May 1, the Reagans admire a Komodo dragon statue presented to them at the Putri Bali Hotel. Their outfits were also a gift, and later Reagan joked, "The government of Indonesia gave us these gifts, and they're our *friends*. Actually, I love this shirt. I finally found something louder than Sam Donaldson."

On May 25, millions of Americans joined hands to aid the homeless during "Hands Across America." At the White House, the Reagans kicked off the event with, among others, the actress Cindy Williams, Maureen Reagan and her husband, and Jim Brady, still paralyzed and wheelchair-bound after the 1981 shootings. Reagan critics ridiculed his participation in the event, pointing out that his economic policies were responsible for most of the homelessness in the United States.

The golfing star Ray Floyd looks on as Reagan uses some body English after hitting a golf ball in the Oval Office on June 24.

President Reagan delivers some remarks at the Statue of Liberty Centennial celebration on Governor's Island on July 3. "This was one of the grandest occasions I attended while I was President," Reagan wrote in a collection of his speeches. "What an uplifting experience unveiling the spruced-up lady and relighting her torch."

TOP September 6: Nancy does a little advertising for an upcoming television special about her "Just Say No" antidrug program while horseback riding with the President at Rancho del Cielo.

BOTTOM The President welcomes Margaret Thatcher to Camp David on November 6. Part of the reason the President liked Mrs. Thatcher, according to a longtime friend, was the strength of her personality: "The man is inexorably drawn to tough, fierce women. Don't forget, he had a strong, domineering mother who influenced him greatly."

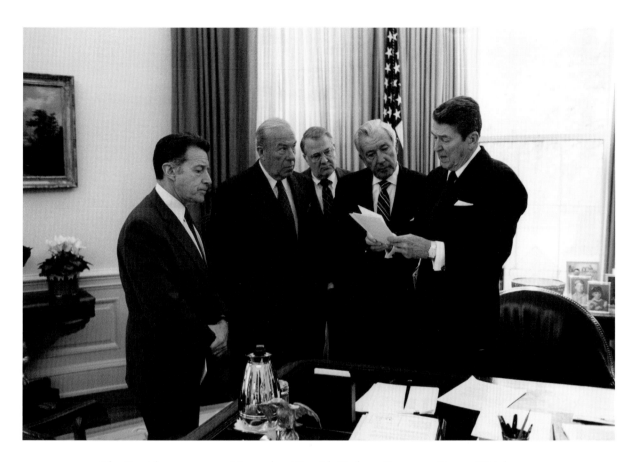

The President meets on November 26 with Defense Secretary Casper Weinberger, George Schultz, Attorney General Edwin Meese, and Don Regan to discuss a situation that would develop into a major scandal for his administration: the Iran-Contra affair. Reagan had told Robert McFarlane to do "whatever it takes" to keep the Contras viable in Nicaragua; what the President's men did was sell arms to Iran in exchange for American hostages and then divert the proceeds to the Contras.

To most Americans, this illegal circumvention of the congressional prohibition against such aid was bad enough, but few could understand selling arms to a terrorist and viciously anti-American country. The White House first denied the Iranian deal, then Reagan claimed that the arms sale was only intended to establish ties with moderate elements in Iran and was not a quid pro quo for hostages. He said he knew nothing of the diversion of funds to the Contras, which had been managed by Lieutenant Colonel Oliver North. Reagan's critics felt he was either lying or woefully out of touch with his administration's actions. Reagan appointed a commission headed by former Senator John Tower to look into the affair, and law makers appointed a special prosecutor to do the same for Congress.

At the ranch for the Thanksgiving holidays, Ronald Reagan faced the very real possibility that his presidency, considered largely successful to this point, might be forever blighted by the Iran-Contra scandal. His popularity rating fell from 67 percent to 46 percent. "For the first time in my life," Reagan wrote in his memoirs, "people didn't believe me." He professed, however, that "I never felt depressed" because "I knew everything I had done was within the law and within the President's powers."

On January 5, 1987, Reagan underwent surgery at Bethesda Naval Hospital to relieve pain caused by an inflamed prostate gland. His doctors performed a biopsy on his prostate tissue that revealed no cancer. "The patient did exceptionally well without discomfort," his doctor, Oliver H. Beahrs, later wrote, "and remained awake and alert during the operation." The next day, Reagan and Nancy waved to well-wishers from his room.

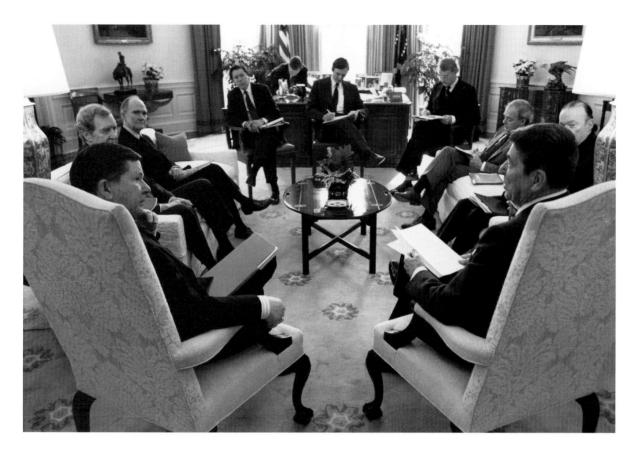

February 11: The President meets with Tower Commission members (leftward from Reagan: John Tower, Edmund Muskie, and Brent Scowcroft) as they prepare to release their report on the Iran-Contra affair on February 26. The scandal had plunged the Reagan White House into despair and confusion. Robert McFarlane attempted suicide on February 9, hours before he was scheduled to testify before the commission. Reagan's official biographer, Edmund Morris, present at these events, wrote in his notebook that the President was "himself showing signs of depression, failing to read even summaries of important work papers, constantly watching TV and movies. Tower Board frustrated by his almost complete inability to remember anything."

The Tower Report did not provide much solace for Reagan. While the commission wasn't able to get to the bottom of the tangled mess that resulted in the diversion of funds to the Contras, it did learn that Reagan indeed knew that the sale of arms to Iran was intended to facilitate the release of hostages. Reagan addressed the nation from the Oval Office on March 4 and gave what many considered a poor defense of his assertion that he didn't know about the arms-for-hostages deal: "My heart and my best intentions still tell me that's true, but the facts and the evidence tell me it is not. . . . There are reasons why it happened, but no excuses. It was a mistake."

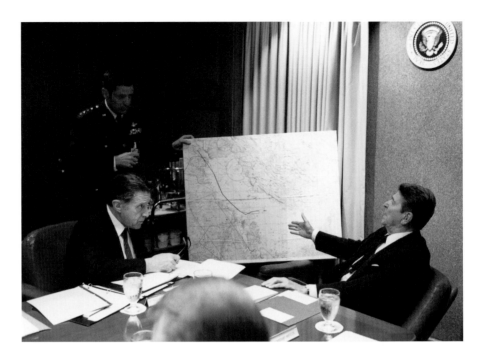

Back at the White House on May 18, Reagan faced an-
other crisis: The day before, an Iraqi war plane had
fired two missiles at the USS *Stark*, an American missile
frigate sent to the Persian Gulf to ensure that oil tanker
traffic would continue through the Strait of Hormuz.
Apparently the Iraqi pilots mistook the ship for a
blockading Iranian vessel. Thirty-seven American
sailors were killed. In this photo, Defense Secretary
Caspar Weinberger and General Robert T. Herres brief
the President on the situation.

At a memorial service for the victims, Reagan
said, "Young Americans . . . gave up their lives . . . so that
wider war and greater conflict could be avoided, so that
thousands, and perhaps millions, of others might be
spared the final sacrifice these men so willingly made."

Reagan and U.S. Army Brigadier General Jack
Woodall salute the troops at Tempelhof Airport in West
Berlin as the President arrives on June 12.

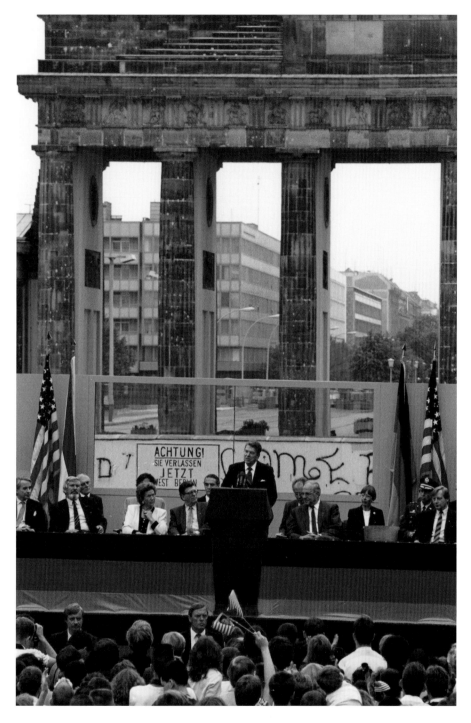

"Mr. Gorbachev, tear down this gate! Mr. Gorbachev, tear down this wall!" In one of the most memorable occasions of his presidency, Ronald Reagan stood in front of the Brandenburg Gate and challenged his Soviet counterpart to extend his policy of *glasnost*—openness—and allow freedom to East Berliners. "We in the West stand ready to cooperate with the East to promote true openness, to break down barriers that separate people, to create a safer, freer world," he went on. "And surely there is no better place than Berlin, the meeting place of East and West, to make a start."

At the National Institutes of Health at Bethesda Naval Hospital with Dr. Stephen Broder on July 23, 1987, the President looks through a telescope to view some of the research into finding a vaccine or cure for AIDS. Two months earlier, he had given a speech on the subject, the first time he had publicly acknowledged the disease, which in America had been affecting primarily gay men since its discovery six years earlier. Nancy had refused even pleas from her friend Elizabeth Taylor to publicly support AIDS charities.

Apparently it took the death from AIDS of their old friend Rock Hudson in August 1985 to persuade both Reagans that the disease merited their attention.

August 3: Reagan gives the thumbs-up to well-wishers at the White House as he leaves for Bethesda Naval Hospital, where he will undergo surgery for skin cancer on his nose.

The next day, the President wears a patch on his nose at a press briefing in the Old Executive Office Building.

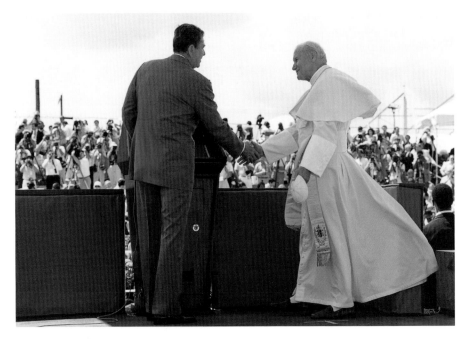

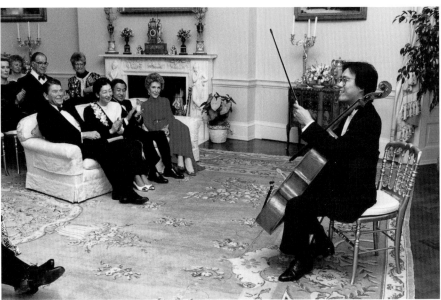

TOP September 10: Reagan shakes hands with Pope John Paul II after introducing the pontiff to a Miami crowd. Later the two leaders met privately.

BOTTOM The cellist Yo Yo Ma performs for the Reagans and the crown prince and princess of Japan in the White House's Yellow Oval Room on the evening of October 6. The day before, the First Couple had learned that Nancy might have breast cancer, and that morning, in Bethesda Naval Hospital, a nurse had held the President in her arms while he sobbed after hearing that her lump was indeed malignant. "For all the powers of the President of the United States, there are some situations that made me feel helpless. . . ."

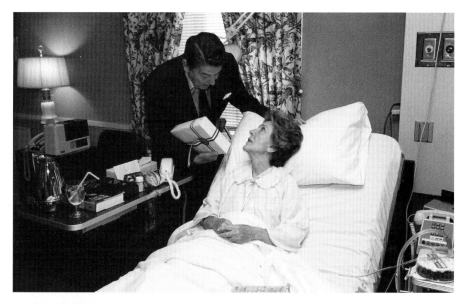

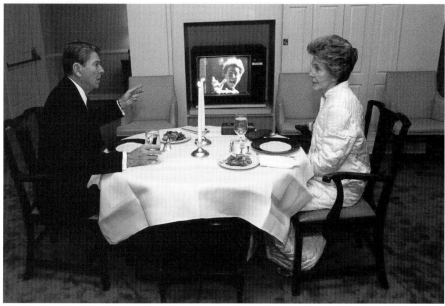

TOP The President brings the First Lady a gift as she recovers from her mastectomy at Bethesda on October 17. "She was devastated by the loss of her breast," Reagan wrote in his memoirs. "She was worried about me and how I would feel about her as a woman. 'It doesn't matter,' I said. 'I love *you*.'"

BOTTOM The First Couple dine in her hospital room on October 19. That day the stock market suffered its worst one-day loss since the crash of 1929, prompting fears of a new depression. Reagan's only private comment— "Maybe they should change their symbol from a bear to a chicken noodle"—left Beryl Sprinkle, chairman of the Council of Economic Advisors, concerned that the President didn't understand the seriousness of the situation. "I confess," Reagan later wrote, "that this was a period of time in which I was more concerned about [Nancy] than I was about the stock market."

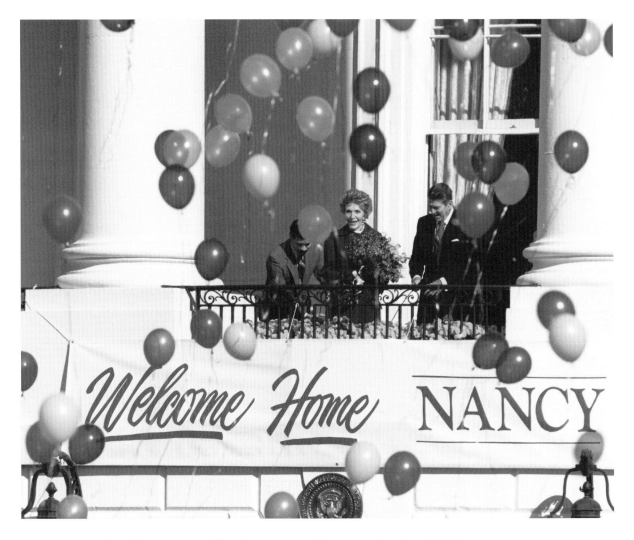

The White House staff welcomes Nancy home on October 22. Her surgery successfully eliminated the cancer, but she had to bear further heartache several days later when her mother, Edith Luckett Davis, passed away. Nancy broke down when she saw her mother's body in the Phoenix mortuary, and the President tried to soothe her. "Once again I felt helpless . . . there was nothing I could do to bring happiness to my wife at a time when she desperately needed it."

At the funeral on October 31, Reagan delivered his mother-in-law's eulogy. Edith's death might have healed the rift between Patti and her parents, but she did not attend the services. For the First Lady, according to her press secretary, Patti's absence caused "another crack in an already broken heart."

"Mother was very nice to Patti," Nancy later said. "I think I was more disappointed for Mother than for anything else."

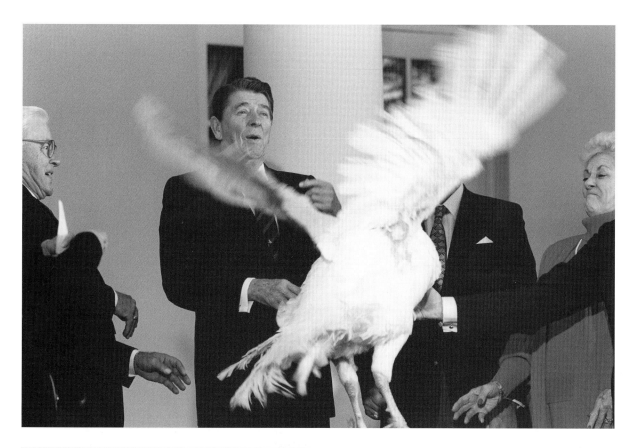

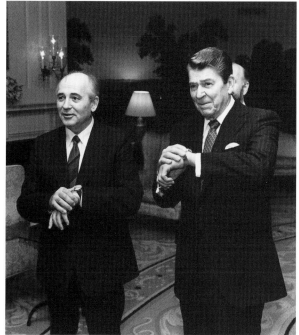

A Thanksgiving turkey flaps its wings at the White House on November 23. Turkey farmers traditionally present the President with a gobbler to kick off the holiday weekend. In 1958 the Reagans costarred in a *General Electric Theater* drama entitled "A Turkey for the President." They played poultry farmers who want their son to give *his* prize-winning turkey to the President for the holiday—but the boy balks, unwilling to give up his beloved pet.

Reagan and Gorbachev make a show of checking their watches as they wait for their wives prior to a diplomatic reception at the White House on December 9. The day before, the two leaders had signed the historic INF treaty, which reduced nuclear arsenals in both their countries. The treaty called for 1,846 Soviet and 846 U.S. warheads to be destroyed over the next three years, under mutual supervision. "I think the whole thing was the best summit we've ever had with the Soviet Union," Reagan wrote in his diary.

January 18, 1988: The Reagans take Rex for a walk at Camp David, where the President has been working on his final State of the Union Address to Congress.

Reagan holds up federal budget ledger sheets to make a point as he delivers his State of the Union address on January 25. Overall, Reagan thought, "the country was strong, our economy prosperous, our spirits high." Toward the end of the speech, he thanked Nancy for her work in the war against illegal drug use. "But in my heart," Reagan later wrote, "I was really trying to say, 'Thank you, Nancy, for *everything*; thank you for lighting up my life for almost forty years.'"

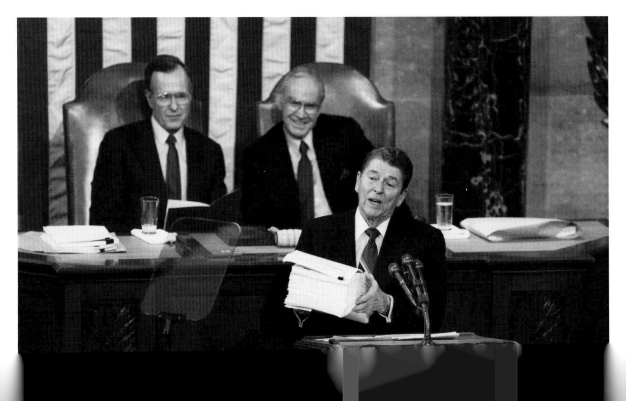

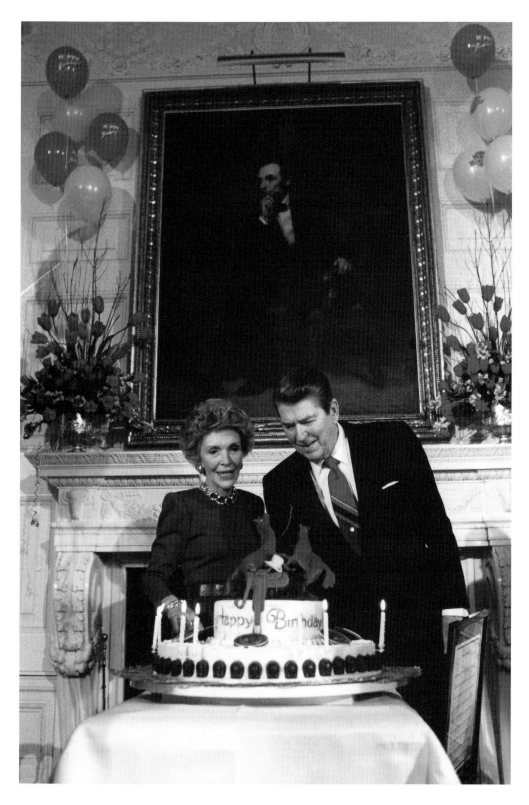

Nancy and the White House staff threw an early seventy-seventh birthday party for the President on Friday, February 5, in the State Dining Room. Afterward the Reagans left for a weekend celebration at Camp David.

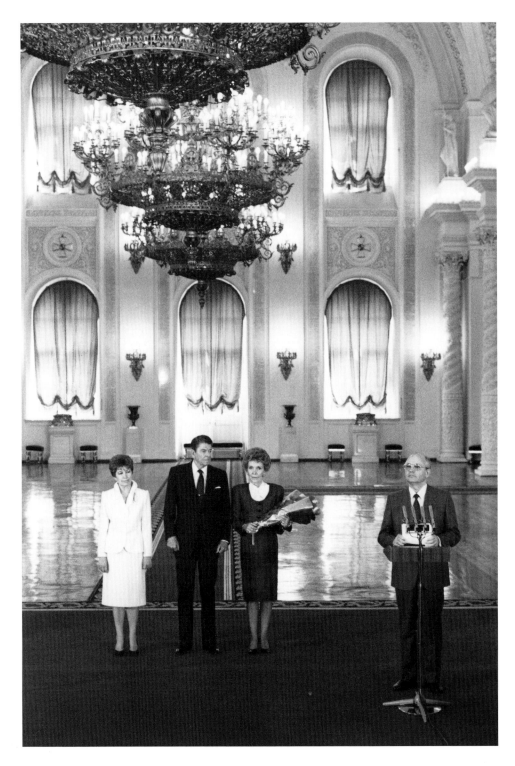

Mikhail Gorbachev makes a few remarks as he and his wife, Raisa, welcome the Reagans to the Kremlin on May 29. The two leaders primarily discussed the START treaty, a further reduction in nuclear warheads, but were unable to agree to anything beyond continued efforts toward a signed document before Reagan's term of office came to an end.

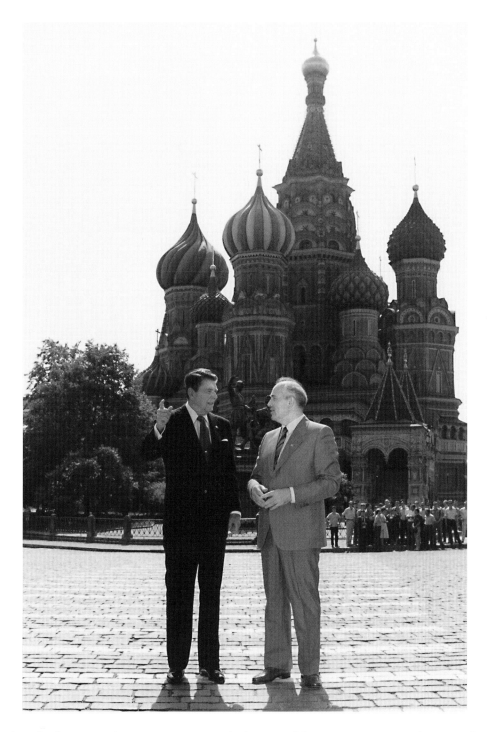

Reagan and Gorbachev in Red Square on May 31. The beauty of the square so impressed Reagan that, returning from dinner at midnight that evening, he stopped the car so that he and Nancy could take a stroll through it. The entire trip, Reagan said, was "memorable," from a Q&A session he had with University of Moscow students to a performance of the Bolshoi Ballet at which the orchestra played "The Star Spangled Banner."

"To hear that song, which embodies everything our country stands for, so stirringly played by a Soviet orchestra," Reagan wrote, "was an emotional moment that is indescribable."

TOP On July 2, the President breaks ground for the new Camp David chapel.

BOTTOM At Rancho del Cielo on August 18, 1988, Reagan makes a point to his official biographer, Edmund Morris, whose controversial book *Dutch* would be released twelve years later. At one point Morris found himself excluded from presidential meetings (he had enjoyed full access previously) and was told, "It's Nancy." The First Lady did not want the President to tell Morris too much because Reagan planned to write his memoirs when he left office. Morris reiterated to the President that his book would not be out until years after Reagan's. Then he confronted Nancy, who denied having anything to do with barring Morris from meetings. "Access, thank God, has improved since then," Morris wrote in his notes.

TOP Although he was at an age when many men have diminished physical capabilities, Ronald Reagan's lifelong love of the outdoors kept him in remarkably good shape for his age. On August 22, he cleared deadwood from some of the trees on the ranch, just as he had done annually for nearly forty years.

BOTTOM On September 30, Reagan paid a visit to Wrigley Field and helped Harry Carey call play-by-play for a Chicago Cubs game. Reagan reminisced about his career as a sports announcer nearly sixty years earlier.

October 3: Reagan poses with a life-size cardboard cutout of himself at a Republican fund-raiser in Washington, D.C. Reagan campaigned for his Vice President, George Bush, in his race against Democrat Michael Dukakis to succeed Reagan as President. "This was the . . . last campaign that I would ever be a vital part of again. I felt a little like a boxer hanging up his gloves." On November 8, 1988, Bush was elected to succeed Reagan in the White House.

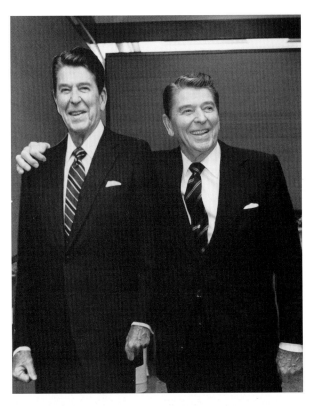

On Veterans Day, November 11, the Reagans visit the Vietnam Veterans Memorial in Washington, D.C. Later Reagan wrote of soldiers who returned from that unpopular war only to be called murderers. He then described a letter he received during his presidency from a Vietnam vet who told him that Reagan had "helped him hold his head up. If I did have anything to do with that, my entire two terms in office would be worth it."

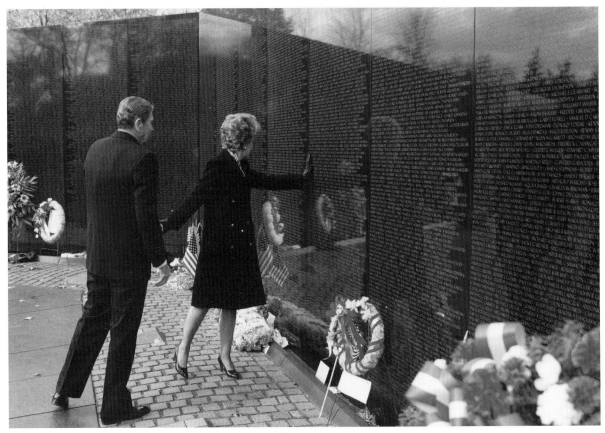

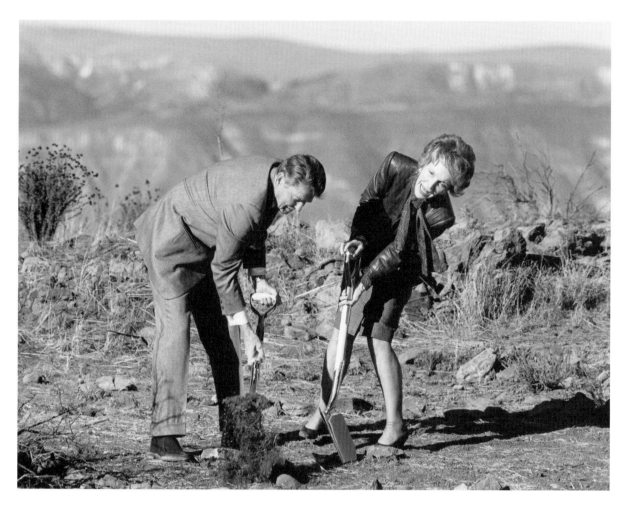

The Reagans break ground for the Ronald Reagan Presidential Library and Museum in Simi Valley, California, on November 21.

As his days as President of the United States dwindle to a precious few on November 30, Ronald Reagan feeds the squirrels on the White House colonnade.

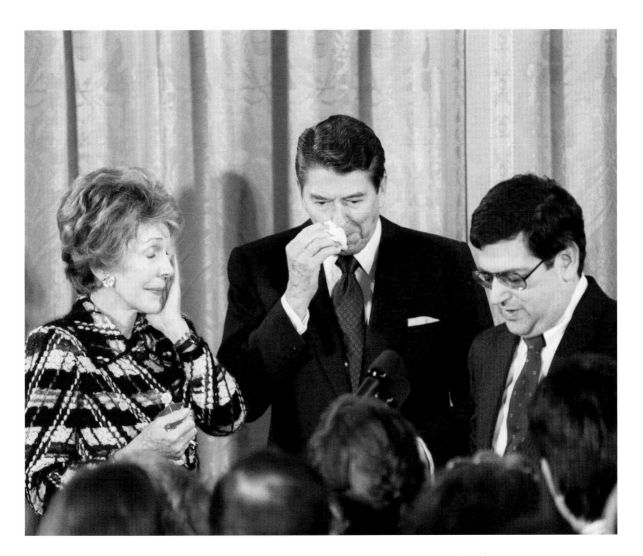

Emotion overcomes the Reagans during a farewell meeting with the White House staff in the East Room on January 18, 1989. "I wanted to say to each one how deeply Nancy and I appreciated them," Reagan said, "but when the band played 'Auld Lang Syne,' we couldn't say much of anything."

On his final morning in office, Friday, January 20, Reagan stands wistfully in the Oval Office, his desk as clear as the day he first sat behind it eight years earlier. "Now it was time to move on, and we all felt sadness about it."

OPPOSITE Following George Bush's inauguration, the Reagans wave good-bye to well-wishers at Andrews Air Force Base as they board Air Force 27000, which will fly them to California.

Former President Reagan takes a morning stroll along the Santa Monica beachfront on August 4, 1996.

Golden State Retiree

At first his retirement was a normal one, honors and awards banquets interspersed with chores and relaxation. But on November 6, 1994, Ronald Reagan released a handwritten letter to the American people. "I have been told," he wrote, "that I am one of the millions of Americans who will be afflicted with Alzheimer's disease."

It seemed a perverse fate for a man whose achievements in life had been based in large measure upon his skills as a communicator—and a particularly sad one in that Reagan grew unable to recall those achievements. In 1995, when a visitor to his office brought him a replica of the White House, Reagan looked at it in bewilderment. "I know I had some relationship to this place," he said softly. "I just can't remember exactly what it was."

Still, the tragedy of his illness brought about one bright side effect: He and Nancy reconciled completely with Patti and Michael. One of the things Michael had revealed in his autobiography was that his father had never hugged him. Now, Michael said, "when I get up to leave, he's standing there with his arms open, waiting to be hugged, when he may not even remember I was there."

Patti, who didn't speak to her mother for years, apologized for "the pain I have caused," and now speaks to Nancy nearly every day. "Our relations then and now are like night and day," Patti said. As for Nancy, Patti's renewed presence had "filled a void in my life that was very empty."

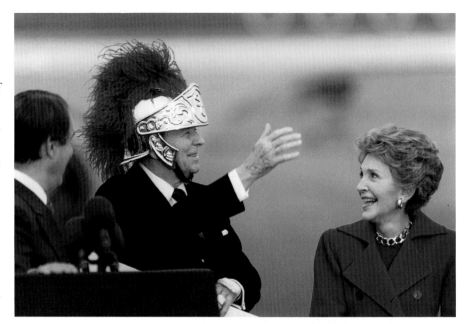

Former President Reagan wears a University of Southern California Trojans helmet as he and Nancy are greeted at a rally upon their arrival at Los Angeles International Airport on January 21, 1989. They then went to their new home in the exclusive Bel Air section of Beverly Hills, purchased as a gift for them by friends.

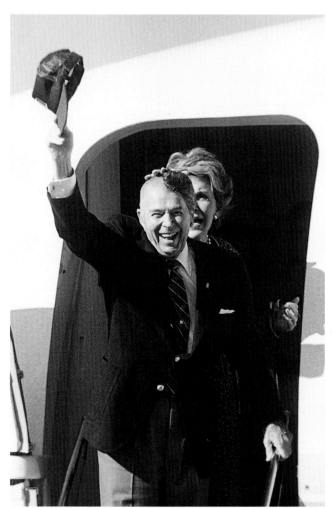

In July 1989, Reagan suffered a head injury in a riding accident at Rancho del Cielo. Two months later he underwent surgery to relieve pressure on his brain. On September 15, as he and Nancy waved good-bye to a crowd before boarding the plane returning them to California from Rochester, Minnesota, Reagan doffed his cap to show his shaved head. Nancy was horrified and tried to cover up the bald spot with her hand.

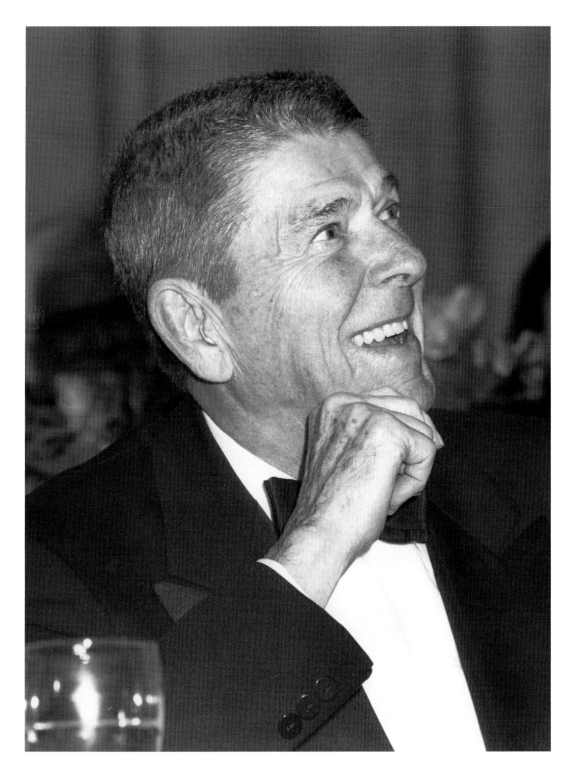

Reagan reacts with delight to his introduction at the American Jewish Committee's 83rd Annual National Executive Council Dinner on November 4 at the Beverly Hilton Hotel in Beverly Hills. He received the group's highest honor, the American Liberties Medallion, in appreciation of his administration's close ties to the Jewish community.

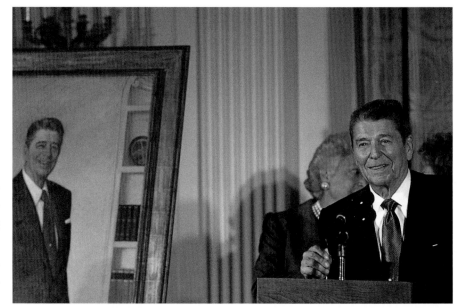

On November 15, Reagan returned to the White House for the unveiling of his official portrait. Barbara Bush can be seen partially hidden behind him.

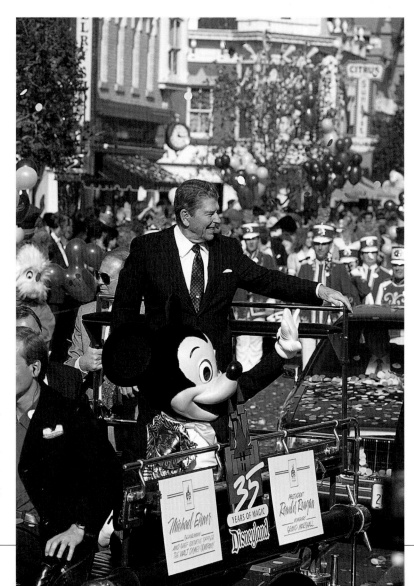

Ronnie and Mickey react to the crowd during a parade along Disneyland's Main Street on January 11, 1990, to commemorate the theme park's thirty-fifth anniversary. Reagan had been among the celebrity hosts at the park's opening festivities in 1955.

Reagan leaves the Los Angeles federal courthouse on February 15 after giving a deposition in the trial of his former aide John Poindexter for Iran-Contra illegalities. Poindexter, Robert McFarlane, and Oliver North were all found guilty, but their convictions were later overturned.

OPPOSITE On a trip to Germany on September 12, 1990, the Reagans peer through a section of the Berlin Wall smashed down by joyous East Berliners on November 9, 1989, after the Communist Party allowed citizens to leave "for private trips abroad." The apparently small concession caused a mass emigration to West Berlin and resulted in the reunification of East and West Germany on July 1, 1990.

Nancy seems to be telling the photographer where to go as she and her husband arrive for the second annual Nancy Reagan Tennis Tournament in Los Angeles on October 6, 1990. The tournament benefited the Nancy Reagan Foundation, created to provide financial help to organizations battling drug abuse. Not long before, Reagan had signed a highly lucrative contract for a series of speaking engagements in Japan.

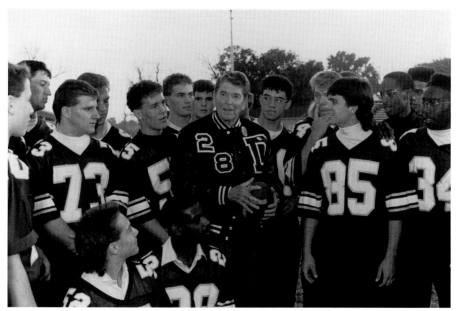

On October 31, Reagan made a sentimental journey to Dixon, Illinois. Here he poses with members of the Dixon High School football team, for which he had played guard and tackle more than sixty years earlier.

March 26, 1991: The Reagans arrive at New York's Waldorf-Astoria hotel for a National Sales Hall of Fame banquet with *Washington Post* chairwoman Katharine Graham, at right. The Reagans presented Mrs. Graham and Bob Hope with the group's Tiffany-designed crystal award.

At the November 4 opening ceremonies for the Ronald Reagan Presidential Library and Museum, the Reagans pose with President and Mrs. Bush, Jimmy and Rosalyn Carter, Gerald and Betty Ford, and Mrs. Lyndon B. Johnson. The complex, a 153,000-square-foot facility with a breathtaking view of the Simi Valley Hills, housed Reagan's presidential papers and artifacts from his administration and its period of history. Reagan told the assembled guests, "Visitors to this mountaintop will see a great jagged chunk of [the] Berlin Wall, hated symbol of, yes, an evil empire that spied on and lied to its citizens, denying them their freedom, their bread, even their faith. Well, today that wall exists only in museums . . . and memories of people no longer oppressed."

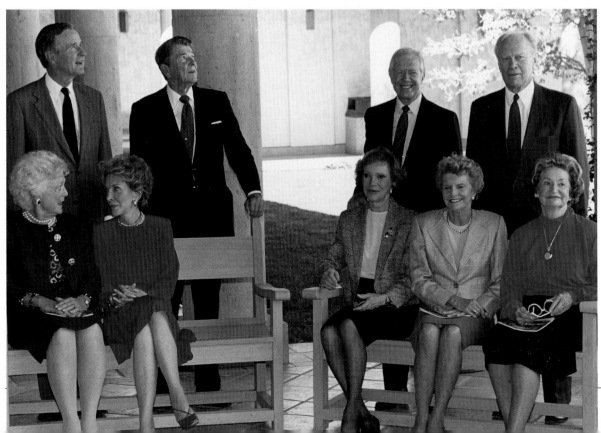

At the Palace Theater in New York on November 11, the Reagans congratulate the cast of *The Will Rogers Follies* after a performance.

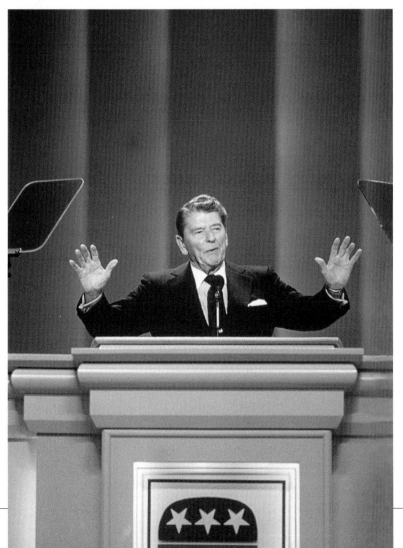

Reagan tries to quiet the delegates as they give him a tumultuous reception at the Republican convention on July 17, 1992. President Bush was nominated to run for reelection against Arkansas Governor Bill Clinton and third-party candidate Ross Perot.

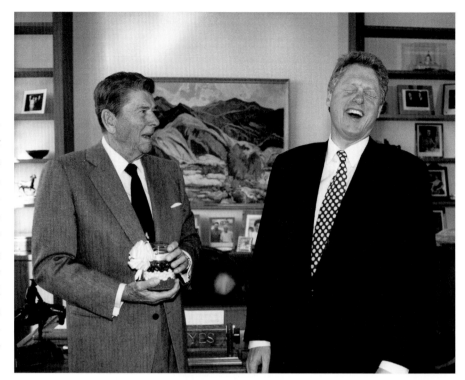

President-elect Bill Clinton howls with laughter as Reagan presents him with a jar of red, white, and blue jelly beans during a courtesy call to Reagan's Century City office. George Bush's popularity—like Jimmy Carter's in 1980—had been damaged by a downturn in the economy, and he received only 38 percent of the vote.

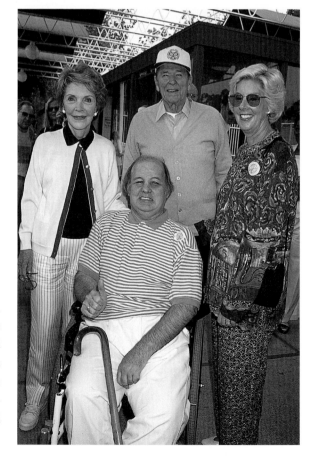

Former Reagan press secretary Jim Brady and his wife, Sarah, join the Reagans at the Nancy Reagan Tennis Tournament in 1993. Since the shooting, the Bradys had become ardent advocates of increased gun control, but found their pleas fell on deaf ears within most of the Republican Party, even the Reagans'. In 1996 they appeared at the Democratic National Convention to plead their cause.

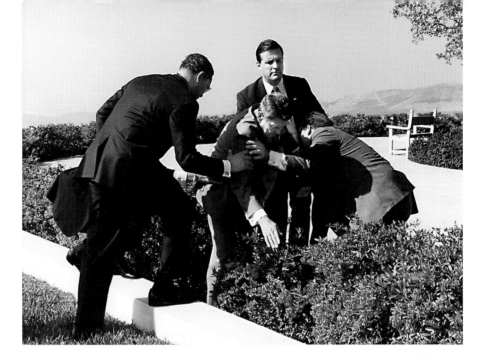

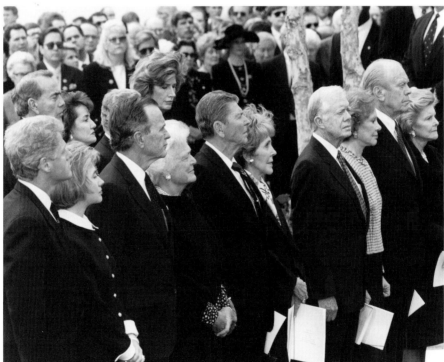

TOP General Colin Powell and others help Reagan right himself after he stumbled as he stepped over bushes at the Reagan library on November 10, 1993. Powell had just received the Ronald Reagan Freedom Award.

BOTTOM The Reagans at Richard Nixon's funeral in Yorba Linda, California, on April 27, 1994. With them, left to right, are President and Mrs. Clinton, Bob and Elizabeth Dole, George and Barbara Bush, Jimmy and Rosalyn Carter, and Gerald and Betty Ford.

RONALD REAGAN

Nov. 5, 1994

My Fellow Americans,

I have recently been told that I am one of the millions of Americans who will be afflicted with Alzheimer's Disease.

Upon learning this news, Nancy & I had to decide whether as private citizens we would keep this a private matter or whether we would make this news known in a public way.

In the past Nancy suffered from breast cancer and I had my cancer surgeries. We found through our open disclosures we were able to raise public awareness. We were happy that as a result many more people underwent testing. They were treated in early stages and able to return to normal, healthy lives.

So now, we feel it is important to share it with you. In opening our hearts, we hope this might promote greater awareness of this condition. Perhaps it will encourage a clearer understanding of the individuals and families who are affected by it.

At the moment I feel just fine. I intend to live the remainder of the years God gives me on this earth doing the things I have always done. I will continue to share life's journey with my beloved Nancy and my family. I plan to enjoy the great outdoors and stay in touch with my friends and supporters.

Unfortunately, as Alzheimer's Disease progresses, the family often bears a heavy burden. I only wish there was some way I could spare Nancy from this painful experience. When the time comes I am confident that with your help she will face it with faith and courage.

In closing let me thank you, the American people for giving me the great honor of allowing me to serve as your President. When the Lord calls me home, whenever that may be, I will leave with the greatest love for this country of ours and eternal optimism for its future.

I now begin the journey that will lead me into the sunset of my life. I know that for America there will always be a bright dawn ahead.

Thank you my friends. May God always bless you.

Sincerely,
Ronald Reagan

A letter to "My fellow Americans," handwritten by Ronald Reagan and reprinted in newspapers and magazines around the world on November 6, 1994. In it Reagan revealed that he had been diagnosed with Alzheimer's disease, an incurable, chronic degeneration of his cognitive faculties. The news did not come as a surprise to those who had seen Reagan's frequent detachment and disorientation over the past several years, but still it saddened millions. As Reagan had been when he learned of Nancy's breast cancer, Nancy was devastated by this news. "After all that's happened to him— the assassination attempt, the cancer, the riding accident," Nancy told Edmund Morris, "I just can't believe this. It's worse than anything. I'm a doctor's daughter, I can handle anything medical, but not . . . *this*." Then she began to sob.

TOP Reagan made few public appearances after the announcement of his illness. Mostly he held meetings in his Century City office, like this one on April 24, 1996, during which Rear Admiral Robert Nutwell, left, and Newport News Shipbuilding president William Fricks presented the Reagans with a model of the USS *Ronald Reagan*. The 1,092-foot, 90,000-ton, nuclear-powered vessel is scheduled for delivery to the navy in 2002.

BOTTOM Republican presidential nominee-to-be Bob Dole and his wife pay the Reagans a visit at Reagan's office on July 3, 1996. Reagan endorsed Dole's effort to unseat President Clinton in the upcoming election, but Clinton beat Dole handily in another three-man contest with Ross Perot.

Aides escort Reagan to his office on February 6, 1997, for an eighty-sixth birthday luncheon with his staff and several meetings with visitors . . .

. . . including a Girl Scout troop from Redondo Beach, California, from whom the former President purchased eight boxes of cookies.

February 6, 2000: Nancy gives Ronnie some cake and a kiss at his eighty-ninth birthday party at their home in Bel Air. The Alzheimer's continued to slowly, inexorably drain the former President of his faculties, and although the Reagans celebrated their forty-eighth wedding anniversary on March 4, Nancy revealed that he no longer recognized her.

BIBLIOGRAPHY

Adler, Bill, and Bill Adler Jr., editors. *The Reagan Wit*. New York: William Morrow and Company, 1998.

Bosch, Adriana. *Reagan: An American Story*. New York: TV Books, 1998.

Cardigan, J. H. *Ronald Reagan: A Remarkable Life*. Kansas City, MO: Andrews and McMeel, 1995.

Edwards, Anne. *Early Reagan*. New York: William Morrow and Company, 1987.

Friedman, Stanley P. *Ronald Reagan*. New York: Dodd, Mead and Company, 1986.

Halliwell, Leslie. *Halliwell's Film Guide*. New York: Harper & Row, 1989.

———. *Halliwell's Filmgoer's Companion*. New York: Scribner's, 1988.

Hannaford, Peter. *The Quotable Ronald Reagan*. Washington, D.C.: Regnery, 1998.

Hannaford, Peter, and Charles D. Hobbs. *Remembering Reagan*. Washington, D.C.: Regnery, 1994.

Katz, Ephraim. *The Film Encyclopedia*. New York: HarperPerennial, 1994.

Leamer, Laurence. *Make Believe: The Story of Nancy and Ronald Reagan*. New York: Harper & Row Publishers, 1983.

Morris, Edmund. *Dutch: A Memoir of Ronald Reagan*. New York: Random House, 1999.

Reagan, Nancy, with Bill Libby. *Nancy*. New York: William Morrow and Company, 1980.

Reagan, Nancy, with William Novak. *My Turn*. New York: Random House, 1989.

Reagan, Ronald. *An American Life*. New York: Simon & Schuster, 1990.

———. *Speaking My Mind*. New York: Simon & Schuster, 1989.

Reagan, Ronald, and Richard C. Hubler. *Where's the Rest of Me?* New York: Duell, Sloan and Pearce, 1965.

Souza, Pete. *Unguarded Moments*. Fort Worth, TX: The Summit Group, 1992.

Spada, James. *More Than a Woman: An Intimate Biography of Bette Davis*. New York: Bantam, 1995.

Thomas, Tony. *The Films of Ronald Reagan*. Secaucus, NJ: Citadel Press, 1980.

Vaughn, Stephen. *Ronald Reagan in Hollywood*. Cambridge, MA: Cambridge University Press, 1994.

Von Damme, Helene. *Sincerely, Ronald Reagan*. Ottawa, IL: Green Hill Publishers, 1976.

The photo research for this book took me from Massachusetts to New York, the Midwest, and Los Angeles, and at all my stops extremely nice and efficient people assisted me. At the beautiful Ronald Reagan Presidential Library in Simi Valley, California, Steve Branch and Josh Tannenbaum were extremely helpful and provided many wonderful photographs for this book. Marilyn Jones of the Ronald Reagan Home Preservation Foundation in Dixon, Illinois, offered wonderful, unpublished pictures of "Dutch" as a boy and young man, as did Amy and Lloyd McElhiney of the Ronald Reagan Birthplace and Museum in Tampico, Illinois. Tony Glass, director of the Eureka (Illinois) College Library Archives, provided images of Reagan at the college, both as a student and a returning alumnus. Valerie Yaros of the Screen Actors Guild in West Hollywood offered me a great selection of photos from the periods of Ronald Reagan's presidency of the Guild. At the *Boston Herald*, John Cronin was his usual pleasant and helpful self. At the New York photo agencies, I was assisted ably by Ron, Howard, and Eric of Photofest; Arlete Santos of Archive Photos; Henry McGee of Globe Photos; Jorge Jamarillo of Wide World Photos; Phil Pappas of Sygma; Tim Feleppa of Culver Pictures; and Marci Brennan of Corbis/Bettmann.

My agent, Todd Shuster, and my editor, Michael Denneny, supported me strongly and well as usual. At St. Martin's Press, I'd also like to thank Christina Prestia, Jamie Brickhouse, Lisa Herman, Matt Baldacci, Patty Rosati, James Sinclair, and Karen Gillis.

My good friend and former assistant Christopher Nickens offered his Hollywood expertise in identifying elements of several early photographs.

Thanks as always to my partner, Terry Brown, for his patience and understanding. To my father, Joe Spada, and brother, Richard Spada, much love. And to my friends Glen Sookiazian, Richard Branson, Ned Keefe, Nick and Kelly Johnson, and Dan Conlon, thanks for your enthusiasm and emotional support—it means a lot to me.

Jack Albin/Archive Photos: 32 (bottom)

AP/Wide World Photos: 17 (right), 28 (bottom), 49, 59, 65, 75 (top), 79, 81-83, 84 (top), 86, 89 (both), 90 (both), 91, 92 (top), 93-99, 101, 109, 111, 113, 116, 130-131, 149 (bottom), 163 (top), 168, 172 (top), 192 (bottom), 209 (bottom), 223, 228 (both), 236 (top), 237 (top), 239 (top)

Archive Photos: 22 (top), 27 (top), 40 (top), 51 (top), 68 (top), 70 (top), 66, 100, 235 (bottom)

J. L. Atlan/Sygma: 230 (top)

Author's Collection: 38, 42, 44 (bottom), 48 (top), 58 (top) 62 (bottom), 63, 72 (bottom), 73, 84 (bottom), 238

Boston Herald: 51 (bottom)

Gary Cameron/Archive Photos: 234 (bottom), 237 (bottom)

Corbis/Bettmann: 75 (bottom), 106, 108, 157 (top), 159 (bottom), 231

Culver Pictures: 5 (top), 20 (both), 22 (bottom), 24–26, 31, 34 (both) 39 (bottom), 41, 43, 45 (top), 50, 52 (top), 55, 56 (top), 69, 71 (top)

DMI: 229, 230 (both), 233 (top), 234 (top)

Eureka College Archives: 13-15

Michael Evans/Sygma: 114, 115, 117

Michael Ferguson/Globe: 236 (bottom)

John Free/Sygma: 226

Globe Photos: 16, 76 (bottom), 77, 80 (top), 92 (bottom), 104, 105 (top)

Steve Grayson/Archive Photos: 240 (top)

Mike Guastella/Archive Photos: 240 (bottom)

Tony Korody/Sygma: iv, 102

Wolfgang Kum/Archive Photos: 206 (bottom)

Henry McGee/Globe: 235 (top)

Jim Moore/Archive Photos: 124 (top)

Jim Nachtwey/Sygma: 105 (bottom)

Photofest: 18, 21, 23, 27 (bottom), 28 (top), 29, 30 (both), 32 (top) 33 (both), 35-37, 40 (bottom), 44 (top), 46 (bottom), 47, 48 (bottom), 52 (bottom) 53, 54, 56 (bottom), 57, 60, 61, 64, 66, 68 (bottom), 70 (bottom), 71 (bottom), 72 (top), 78 (bottom), 80 (bottom)

Michael Probst/Archive Photos: 232

Fred Prouser/Archive Photos: 239 (bottom)

Ronald Reagan Birthplace and Museum: 2, 3 (bottom)

Ronald Reagan Boyhood Home Preservation Foundation: x, 3 (top), 4, 6-12, 39 (top)

Screen Actors Guild: 45 (bottom), 46 (top), 58 (bottom)

Screen Actors Guild/Gene Lester Collection: 76 (top)

Percy Smith/Sygma: 233 (bottom)

Sygma: 62 (top), 76 (bottom), 103, 107 (top)

All other photographs are courtesy of the Ronald Reagan Presidential Library, Simi Valley, California.

JAMES SPADA is a writer and photographer who has authored internationally bestselling biographies of Barbra Streisand, Bette Davis, Peter Lawford, and Princess Grace of Monaco. He has also compiled pictorial biographies of Jacqueline Kennedy Onassis, Marilyn Monroe, Robert Redford, Jane Fonda, and Katharine Hepburn, among others. As a photographer, he has had three one-man exhibitions in the New England region in the last several years. He lives in Natick, Massachusetts.